THE TONGASS

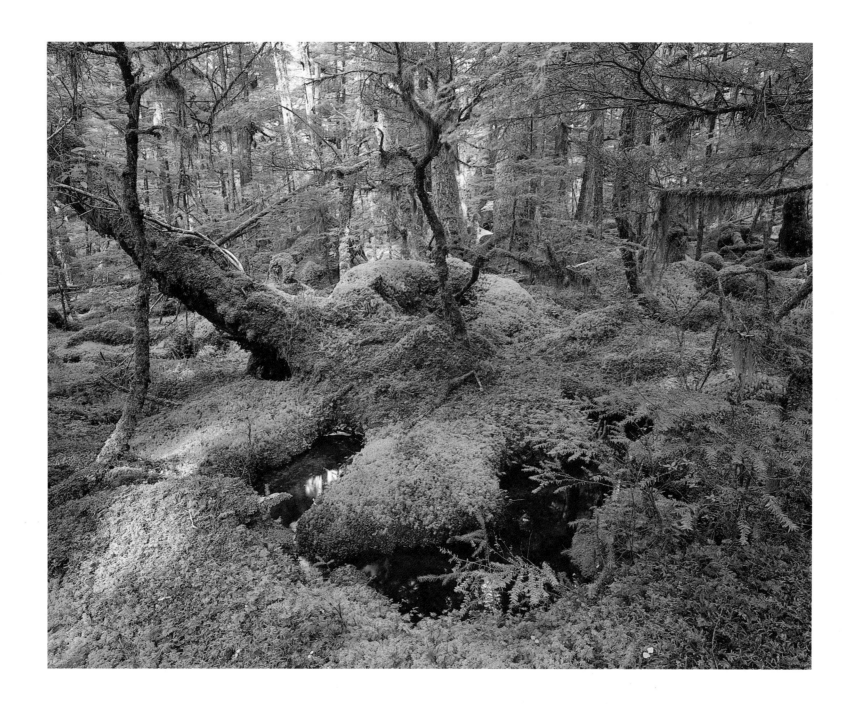

Nerf forest

THE TONGASS

ALASKA'S VANISHING RAIN FOREST

The Photographs of Robert Glenn Ketchum

REVISED AND EXPANDED EDITION, WITH A NEW
PREFACE BY STEVE KALLICK, CAMPAIGN MANAGER,
ALASKA RAINFOREST CAMPAIGN

Text By Robert Glenn Ketchum and Carey D. Ketchum

Introduction by Roderick Nash

AN APERTURE BOOK

To Barney for his belief and commitment.
A great friend to us, the arts, and the environment.

To The Boat Company and The McIntosh Foundation
for their unswerving commitment to conserve
what remains of this Earth's last great temperate rain forest.

The quotations used in this text are reprinted through the kind permission of their publishers: p. 16 Berger, Thomas. *Village Journey*. New York: Farrar, Straus & Giroux, 1986; p. 25 Thunderstorm, Lynne. *The New Catalyst*, Summer 1986; p. 38 Wallace, David Rains. "At the End of the Earth." Washington, D.C.: *Wilderness*, Spring 1984; p. 52 Watkins, T. H. "The Great Land." Washington, D.C.: *Wilderness*, Spring 1984; p.62 Judge, Joseph. "Alaska: Rising Northern Star," Washington, D.C.: The National Geographic Society, 1975; p. 81 Leopold, Aldo. "The Round River," New York: Oxford University Press, 1953; "The Tongass Timber Problem" excerpts, SEACC, Tongass Accountability Project, 1984.

Composition by David E. Seham Assoc., Inc., Metuchen, New Jersey. Printed in Hong Kong. Book Design by Michael Flanagan; Jacket Design by Robert Aulicino.

The Staff at Aperture for *The Tongass: Alaska's Vanishing Rain Forest* is Michael E. Hoffman, Executive Director; Donald Young, Editor; Larry Frascella, Picture Editor; Ina Schell, Director of Sales and Marketing; Stevan Baron, Production Director; Barbara Sadick, Production Manager; Dean Brown and Diana Mignatti, Editorial Assistants.

Aperture Foundation publishes a magazine, books, and portfolios of fine photography and presents photographic exhibitions. A complete catalog is available upon request.

Aperture Foundation, including Book Center and Burden Gallery: 20 East 23rd Street, New York, New York 10010. Phone: (212) 505-5555, ext. 300. Fax: (212) 979-7759. E-mail: info@aperture.org

Visit Aperture's website: www.aperture.org

THE McINTOSH FOUNDATION, THE LILA ACHESON WALLACE FUND, AND BARNABAS McHENRY PROVIDED SUPPORT FOR THE PHOTOGRAPHER AND FOR THE PUBLICATION OF THIS BOOK.

Authors' Note

We would especially like to thank the McIntosh Foundation, the Lila Acheson Wallace Fund, and Mr. Barnabas McHenry for their generous support of our research and of the publication of this book. The commitment shown by Mr. McHenry and these organizations to furthering the understanding and protection of the Tongass has been extensive and unswerving.

We would also like to thank the Pentax Corporation, E. Leitz, Inc., and Angénieux Lenses for their technical assistance in the field, providing equipment and repairs in remote locations at very short notice.

Our deepest gratitude is due all of those who fed us, housed us, guided us, and informed us. Without them, our understanding of the Tongass and what is at stake there would have been woefully superficial. It is not possible to mention everyone who contributed to our effort, but we would like to acknowledge the following for their generous gifts of time, services, and encouragement: in Angoon, K. J. and Peggy Metcalf, and the George family; in Juneau, Karl Lane and Bob Parish, captain, cook, and storytellers supreme of the *Heron*, and guides John Sisk and Jeff Sloss of Alaska Discovery; in Ketchikan, Dale Pihlman of Outdoor Alaska and his staff, for kayaking advice, drop-offs, and pickups, and pilot Dale Clark, who flew us on many of our most spectacular aerial excursions; in Pelican, our guides Earl Prince and Huggy, and Gail Corbin, owner of Lisianski Lodge, and Betty Clauson, who organized and participated in a meeting with other concerned Pelican residents; in Petersburg, the many we interviewed, as well as Bev Richardson and the Bowen family, who coordinated those contacts and allowed us the use of their homes; in Point Baker, the Ziske family and Joe Sebastian; in Port Protection, Merek Mura and Liz Bauer, our hosts and guides; in Sitka, Larry Edwards, owner of Baidarka Boats, who provided us with kayak lessons and waffles, harbormaster Chuck Johnstone and his wife, Alice, who took us many places on the *Fairweather*, Boyd Didrickson, who fed us Indian style and shared his home, friends, and carving skills with us, and Dr. Richard Nelson, who inspired us with his thoughts and words; in Telegraph Creek, British Columbia, members of the Thunderstorm family, for their incredible hospitality and energy; in Tenakee, all of the residents who made us feel at home and allowed us to interview them; in Tokeen, Sylvia Geraghty, who generously hosted and guided us, and Barney Belk, Suzanne Fuqua, and David Woodie, who spent patient hours discussing forestry on Prince of Wales, Alaskan lifestyles, and world politics; and, in Yakutat, Mike and Marie Ivers of Gulf Air, who provided spectacular flights over the Forelands.

Thanks are also due Michael McIntosh, Joe Pierpont, and the excellent crew of the M.V. *Observer* for their generous care. Fellow Decker Flat Climbing and Frisbee Club member Chris Puchner and his wife, Molly, provided us with the hospitality of their home and our first Alaskan bush flight, which proved essential in understanding the scale of the world we were about to enter.

We are especially indebted to Julie Koehler, who helped us organize our itineraries and contacts, and the Alaskan Hotel in Juneau and the Gilmore Hotel in Ketchikan, whose friendly staffs welcomed us frequently during our travels and often stored our barely manageable equipment trunk.

The Alaska Department of Fish and Game, the Southeast Alaska Conservation Council (SEACC), the Wilderness Society, and the United States Forest Service provided us with information, interviews, and statistics essential to our research, for which we are grateful. Despite our criticism in this book of the Forest Service, we admire the commitment and concern of many of its personnel, and we cannot praise its extensive cabin system throughout Southeast enough.

Although the point of view expressed in this text is solely our own and does not necessarily reflect the opinions of any particular individuals or organizations or of our publisher, a great debt is owed a number of people who offered us their assistance with fact-checking and editing. Some have chosen to remain anonymous for political reasons, but in addition, the following people deserve credit: Bart Koehler, John Sisk, and Larry Edwards of SEACC, and Don Young of Aperture. They have knowledgeably led us through a labyrinth of terms and problems that we have tried to simplify without diluting.

Last, none of these pictures would have been possible without the dedicated and purely physical labor of a number of friends who served as assistants and helped carry gear into some difficult places: fisherman and painter par excellence Philip Slagter; fellow photographer Krys Cianciarulo and his wife, Jan, who also coordinated some complex itineraries; and Nevette Bowen, who paddled and steered as much as she carried. Special thanks are due the State of California Department of Parks and Recreation, Sierra District, which allowed Dr. Mark Thompson to advise us and travel with us part of the time. His undefeatable determination and inspirational wildness helped us achieve some of the truly highest points of all our Southeast adventures.

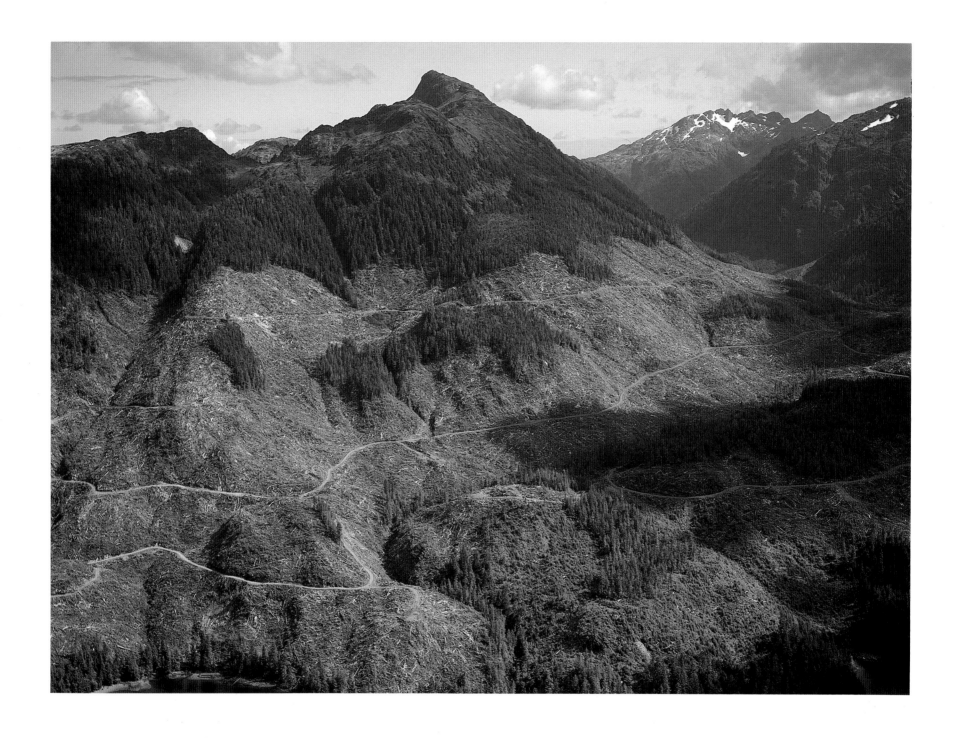

The chainsaws of summer

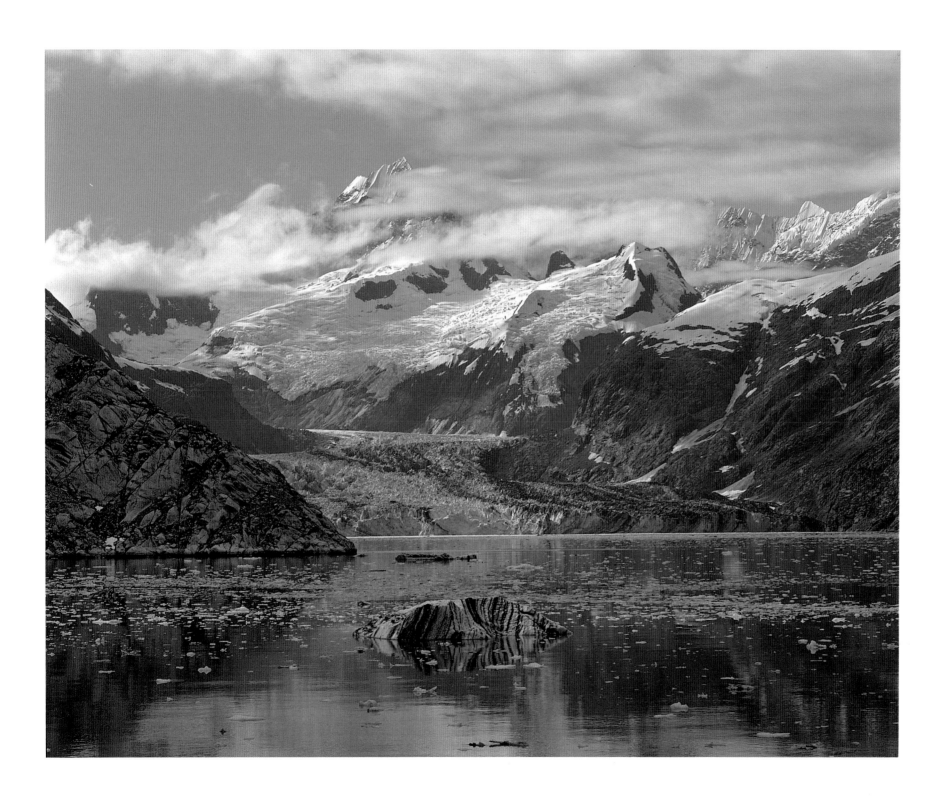

John Hopkins Inlet, Glacier Bay

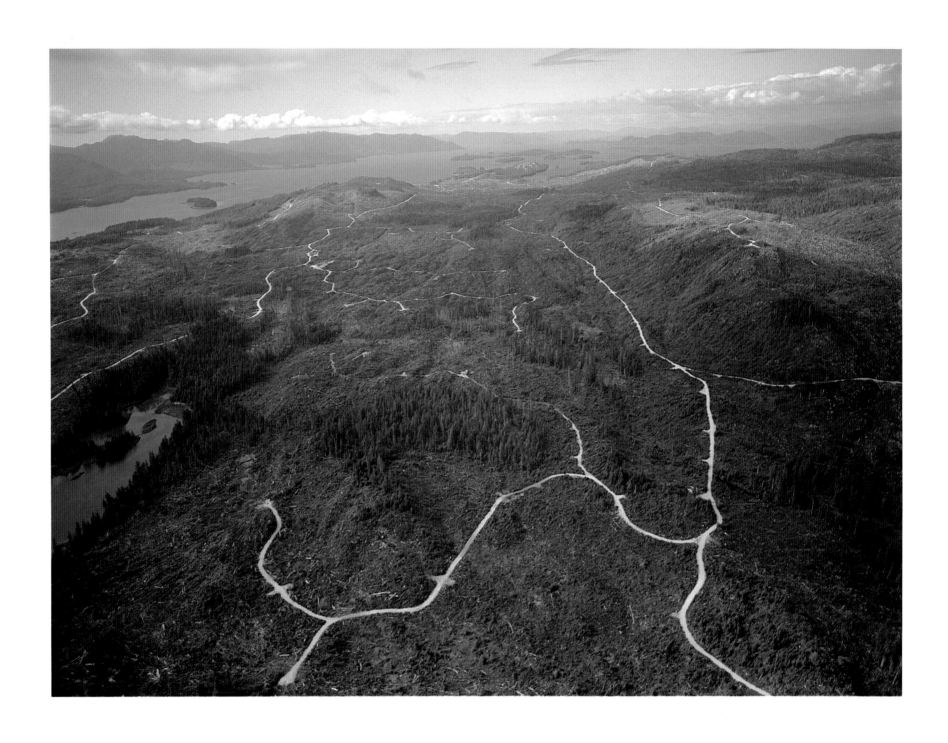

Long Island, one of the largest contiguous clear-cuts in America

THE TONGASS, HEART OF THE ALASKA RAIN FOREST
1988–1994: Starting on the Path to Reform

1987–1990: Tongass Reform Legislation

Seldom in the history of the public lands has the publication of a book been as pivotal to the preservation of a national heritage as it was with *The Tongass: Alaska's Vanishing Rain Forest*. Robert Glenn Ketchum's book of photographs, with text by the photographer and Carey D. Ketchum, arrived at a critical juncture in a public-education campaign, arming conservation activists with a powerful new tool, just at the time when years of advocacy work by the Wilderness Society and the Southeast Alaska Conservation Council brought the fate of the Tongass to the top of the congressional agenda. We huddled over the first shipment of books like freedom fighters over a crate of smuggled rifles.

It was 1987. Ronald Reagan was president. U.S. Representative Robert J. Mrazek had introduced a bill in March to remove the absurd, automatic $40-million annual federal subsidy then guaranteed by law to help fund the clear-cutting of the Tongass forest. In that time, Mrazek's modest legislation was considered "radical." Yet the House of Interior Committee, then under the firm leadership of Chairman Morris Udall, and Representatives George Miller and Sam Gejdenson, took up the cause, starting a series of legislative hearings that built the case for change on the Tongass.

A pioneer in the ever-conservative Senate, Wisconsin's William Proxmire also took up the cause of the distant Alaskan rain forest. Ketchum's photographs were at work there too, in a senatorial exhibition displaying to the members exactly why their colleague was awarding the subsidized logging and roading of the Tongass wilderness his infamous "Golden Fleece Award." That taxpayer protection "award" garnered national press attention for the Tongass problems. It also attracted the attention of Colorado Senator Tim Wirth, who picked up the Tongass reform cause after Proxmire's retirement at the end of 1988.

The issue thus emerged from the chaos of the congressional scene, with champions galvanized by activists and photos, embracing a cause at the other end of a continent. Despite the odds against passing Tongass reform legislation, which virtually every Capitol Hill insider rated as "impossible," a movement began to take shape.

With the expert assistance of a few seasoned conservation professionals, southeastern Alaskans themselves carried that reform movement on their backs, on their strong shoulders, on their hot, blistered feet, through every twist and turn on the tortuous, frustrating path that led over the next four years from House to Senate, from Senate to House, from hearings to reports, from congressional visits to Alaska to Alaskan visits to Congress.

The Ketchums' book traveled the marbled halls of congressional office buildings, carried in the arms of the very people described in its pages. Elected officials met the people of southeast Alaska and learned of the plight of the Tongass, vividly described by the people who were living in it and vividly depicted in Ketchum's images. Dozens of us made the long trek from Alaska to Washington D.C., always carrying in our bags—along with the government reports and the resolutions of village councils—a carefully wrapped copy of *The Tongass: Alaska's Vanishing Rain Forest*.

We nearly succeeded in passing a bill in late 1988 that would have removed the fixed, annual Tongass logging subsidy, ordered a "review" of the Tongass' two unique fifty-year logging contracts, and temporarily protected a handful of key valleys and bays from logging while the Forest Service rewrote the Tongass

forest plan. However, it failed in the last weeks of the second session of that Congress. At first we were demoralized. But close on the heels of demoralization was the realization that Tongass reform had momentum beyond our grass-roots efforts. Our forest was a national issue, the subject not only of the Ketchums' book, but of dozens of articles in magazines in leading newspapers. Many of these were generated by the photographer—including the first major feature in the national press—a five-page pictorial in *Life*. We vowed to return in the next Congress and persevere.

Our perseverence paid off. In early 1989, Representative Mrazek reintroduced the Tongass Timber Reform Act and the House Interior Committee went to work, followed immediately by the House Agriculture Committee. The version that emerged from the House on July 26, 1989, by a landslide margin of more than four to one, represented an entirely new vision for the Tongass. House Resolution 987 contained a package of sweeping reforms that would have dramatically altered the logging-dominated management scheme so tenaciously defended by the Tongass pulp mills and their allies. The bill not only disposed of the Tongass logging subsidy, but terminated the two fifty-year logging contracts (replacing them with standard, short-term timber sales) and added over two million acres, in nineteen areas, of prime Tongass old growth, to the National Forest Wilderness system.

The United States Senate advertises itself unashamedly as a "necessary fence," harkening back to the founding principles of a body set up to temper the passions of the House. It served this function in the matter of the Tongass reform. From 1989 through 1990, the Senate Energy and Natural Resources Committee deliberated the merits of Tongass reform, balancing the increasing momentum of the reformers against the no less significant interests of Alaska's two senators, Ted Stevens and Frank Murkowski, and their logging constituents. The result (brokered masterfully by Committee Chairman J. Bennett Johnston) was a package that disposed of the subsidy, maintained but reformed the contracts, and designated about 600,000 of the most important acres as nonwilderness conservation areas. This compromise passed in the Senate unanimously.

In the Fall of 1990, as the congressional session waned, the House and Senate worked out the differences between their versions of the Tongass reform legislation. The result of that Conference Committee was a compromise—bittersweet to the Tongass advocates on one side, but more bitter to the pulp mills, who resisted reform to the very last day and never accepted the proposition that Tongass management should be changed.

The Tongass Timber Reform Act of 1990 went to the desk of President Bush and became law on November 26 of that momentous year. The law ended the Tongass' fixed annual subsidy, maintained the fifty-year contracts while modifying the most objectionable provisions, and designated just over one million acres of old growth timber as either wilderness or permanently off-limits to logging.

Not unexpectedly, the Ketchums' effort and commitment were internationally recognized. The Sierra Club gave Robert the Ansel Adams Award for Conservation Photography, and President Bush invited him to an audience at the White House, prior to his traveling to Stockholm, Sweden, where King Gustav gave the photographer the United Nations Environment Program's Global 500 Award for Outstanding Environmental Achievement.

The long march for Tongass reform legislation ended. For many of us it was a rite of passage from amateur activist to veteran campaigner. We recall clearly how we learned to lobby, meeting fresh-faced Congressional staffers from Georgia or South Dakota and trying to describe the inimitable sights and sounds of our rain-forest home. We felt intense frustration at times. But we also had the book.

For those who have never seen the Tongass, Ketchum's images give life to the names of places four thousand miles distant, places of such beauty only these photographs could do them justice . . . places like Kadashan River, Yakutat Forelands, Lisianski River, Hoonah Sound, Prince of Wales Island, and Trap Bay. Places that are now protected, by law, forever, and places that remain to be protected. Copies of the Ketchums' book are still treasured possessions in the offices of decision makers all over Washington D.C. For many, it is as close as they will ever come to seeing the results of their struggle to save Alaska's rain forest.

The Tongass Timber Reform Act was law. The result of this synergy of our activism and Ketchum's art was a dramatic change of course in government management of the Tongass. Many of us could rest, at last.

Or so we thought. Almost immediately after passage of the Tongass Timber Reform Act, the Forest Service bureaucracy in Alaska began a scheduled revision of the Tongass Forest Management Plan, commonly known as the TLMP. They also began their task of defining the details of the changes to the fifty-year contracts ordered by Congress. Working hand in hand with the pulp mills and with the assistance of Alaska's senators, the Forest Service began erasing Congress' reforms. For the next three years, logging levels increased, subsidies increased, contract revisions suffered absurd "interpretations" by Forest Service and pulp-mill lawyers, and an onslaught of timber plans targeted most of the areas that congressional compromise had left for disposition in future planning.

Outrage piled on outrage. A team of federal and state wildlife biologists watched the Forest Service suppress a key study setting forth minimum management requirements for sustaining wildlife; a Forest Service timber planner was harassed out of his job for publicly stating that his orders to serve the quotas of the Tongass contracts would destroy the timber economy of Prince of Wales Island; the pulp mills received $14 million in "rebates" and credits for timber receipts allegedly overpaid during the pendancy of Tongass reform legislation. The Forest Service cynically traded prime Tongass forest tracts for Native Alaskan lands that had already been clear-cut. Draft Tongass plans issued from Forest Service headquarters charted a direction more tilted toward logging as the primary use of the Tongass than any previous plans. The dreams of Tongass reform were being mocked by the pulp mills and their captive agency, the Forest Service.

Confronted by this shocking reversal on the road to reform, key conservation leaders struggled to hold ground they had recently considered secure. Those days tried the patience of the Tongass reformers. Ketchum, who had kept close to our cause, returned year after year to continue building his portfolio of Alaska rain-forest photos. He collaborated with his friends to create other forums for exhibiting the grandeur of the Tongass. The conservationists determined to regroup as well.

1993 and Beyond: The Alaska Rainforest Campaign

In the act of meeting to reformulate a response to the Tongass crisis, we realized that the entire Alaska rain forest, covering a thousand-mile arc of coastline from Ketchikan to the Kodiak archipelago, was now under assault by large-scale, multinational timber-export companies. Moreover, new scientific studies concluded that the Alaska rain forest constituted the largest, most pristine temperate rain forest remaining on earth. We stood back a step from our immediate challenge and discovered that the Tongass was at the heart of a larger ecosystem fraught with the same problems and challenges. Each community in the vast coastal forest region faced the same choice: short-term logging followed by ecological and economic collapse, or a pursuit of a new path toward a sustainable future. The context of our fight was redefined.

To that end, the Wilderness Society and the Southeast Alaska Conservation Council, along with traditional Tongass advocates like the Sierra Club Legal Defense Fund and the Sierra Club itself, joined forces in a broader coalition of eight Alaskan and national conservation organizations, called the Alaska Rainforest Campaign. Brought into the fold were the Alaska Center for the Environment, American Rivers, the Natural Resources Defense Council, and Trustees for Alaska. The new campaign's mission is to protect the ecological integrity of the entire Alaskan rain forest and to promote the transition to a sustainable future for its communities, based on a harmonious relationship with the forest. We have been operating since early 1993, focusing first on implementing Tongass reform through revision of the Tongass forest plan and by protecting key private forest tracts in Prince William Sound and the western Gulf of Alaska.

There are already signs of hope for the fate of the Alaska rain

forest. With the entry of the Clinton administration on the scene, Tongass reform has come even to the Forest Service's entrenched bureaucracy.

Ketchum has been equally unrelenting, and once again his efforts are contributing significantly to the campaign. Recognizing that still far too many people have not heard of the Tongass, Ketchum wanted to create a traveling exhibition that would reach millions of people and begin awakening them to the very existence and rich biological value of this extraordinary place, one of America's rarest natural resources. Working as an independent curator for the Smithsonian Institution Traveling Exhibition Service, he assembled a forty-two-print show focusing on this biological magnificence. Combining work from six other photographers with his own images, he compiled an exhibition that would underscore the habitat value and rarity of this old-growth rainforest system, rather than the charged political issues surrounding the Tongass. The Smithsonian also had reason to be cautious; previously they had come under sharp attack from the Alaskan Senator Stevens for exhibitions they had organized, and both he and Murkowski sit on the Senate Appropriations Committee, which controls budgetary allocations for Smithsonian programs.

The attempt to remain neutral, however, became impossible to realize as the exhibition approached its opening, on Earth Day, Friday, April 22, 1994. At that time a synchronicity of events once again propelled the work that Ketchum had done to the forefront of the political battle. Days before the opening, as the exhibition was being installed at its premier location at the National Museum of Natural History in Washington D.C., Assistant Secretary of Agriculture, Jim Lyons, canceled one of the two fifty-year contracts that drove the Tongass timber program. Following this, the conservation group American Rivers hosted a Capitol Hill press conference and named the Thorne River, at the heart of some significant proposed cuts, one of the most endangered rivers in America.

Suddenly the Tongass was once again in all the papers, and the exhibition was no longer a low-profile project. Senators Stevens and Murkowski demanded a full review of all the captions and text, the removal of the one clear-cut photograph, and changes in seven text panels (although the panels had passed through a rigorous six-month review at the Smithsonian to confirm the scientific validity of their statements). Ketchum refused to remove the photograph, but he allowed text changes which he felt did not compromise his intent.

With the seven new text panels installed just hours before the opening, all concerned felt that things had begun to calm down. The reception hosted five hundred people, some of whom had flown all the way from Alaska to show their support. Featuring Alaskan food, such as salmon, crab, venison and a locally made (Juneau) beer, the reception was a great success and a wonderful start to a four-year national touring schedule, but the reception proved to be only part of a continuing saga that was unfolding. On Monday, the *Washington Post* ran an article about the text- panel changes, and on Monday afternoon, the Alaska Regional Forest Supervisor Mike Barton was replaced by biologist Phil Janik.

The story contained in the Ketchums' book is really the first chapter of a work in progress. Vast new clear-cuts appear in the canopy of the Alaska rain forest every year. Ketchikan Pulp Corporation is still destroying Prince of Wales Island (the third largest island in the United States) under the terms of its still intact fifty-year contract. Places that appear in the book and places Ketchum continues to document today—places like the winding canoe passage of Honker Divide and the lush spruce-clad shores of remote Kulu Island—still await protection. The fight to finish the job of reform, saving the Tongass and the rest of the great Alaska rain forest for the Alaskans who call it home, and for all Americans who claim their rights as owners of the public lands, is more important now than ever—in part because the initial battle has been won.

Steve Kallick,
Campaign Manager,
Alaska Rainforest Campaign

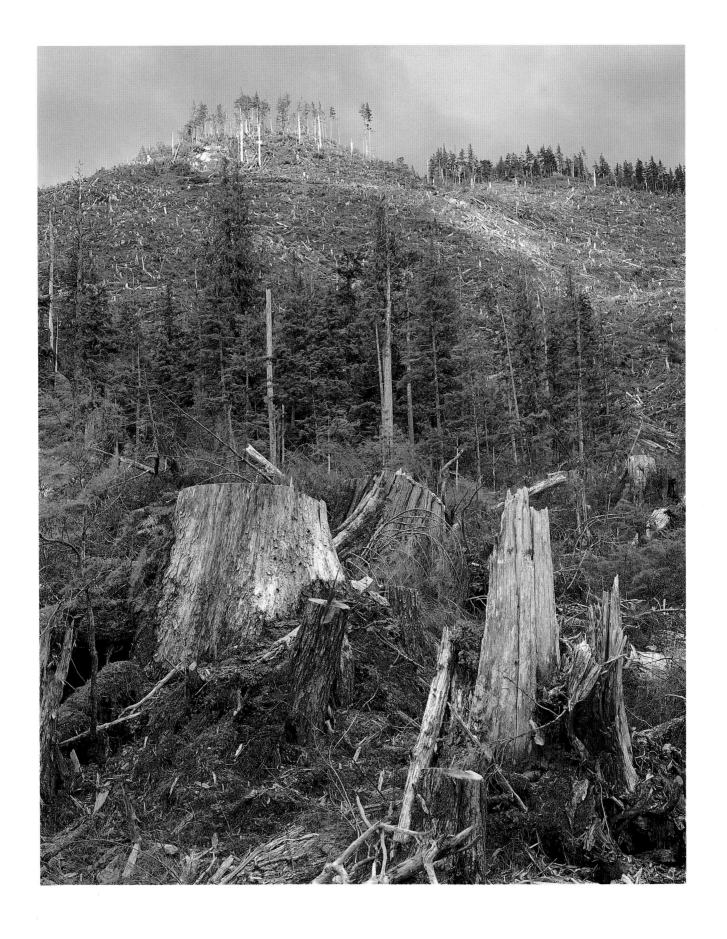

Smokey the Bear's real agenda

Introduction by Roderick Nash

On June 7, 1879, in Yosemite Valley, John Muir met Sheldon Jackson, a Presbyterian minister from Sitka, Alaska. A tireless wanderer in what he called "the university of the wilderness," Muir had already explored some of North America's most spectacular landscapes. For the last decade California's Sierra Nevada had been the focus of his travels, and he might have spent the rest of 1879 tracing ancient glacier courses, leaping waterfalls, and scrambling up unclimbed summits. But something in his Alaskan visitor's eyes changed Muir's plans. Within a month he was with Jackson on the steamship *California*, heading north.

Southeast Alaska overwhelmed John Muir. His journals noted its unrivaled "purity" of wildness and referred to ten Lake Tahoes strung end to end and one hundred-mile-long Yosemites. Alaska's forests seemed "trackless" to him and its mountains "never before to have been looked at." He described "snowy falls booming in splendid dress; colossal

domes and battlements—their bases laved by the blue fjord water; green ferny dells . . . and glaciers above all.'' In such a wilderness he felt himself near to ''the very paradise of poets, the abode of the blessed.'' What is now the Tongass National Forest appeared to Muir just over a century ago to be ''still in the morning of creation.''

But even in the 1870s there were signs of trouble. Muir recorded his distaste for the ''lawless draggle of wooden huts'' that was Wrangell, Alaska, and its resident loggers and miners struck him as oblivious to the ''grand wild country in which they lived.'' A similar observation could have been made about every generation of American frontiersmen—with the United States Forest Service being the latest and most destructive. Wild country held little appeal for the pioneer mind except as a source of raw materials. Paradoxically, wilderness appreciation depends on the rise of a civilized perspective.

Understandably, then, the first appreciators of southeast Alaska for what it was—rather than what it could become— were people of culture and refinement. Inspired by Muir's writings and Sheldon Jackson's, they began in the 1880s to cruise what came to be called the Inside Passage. In 1890, the year the census takers pronounced the frontier of the lower forty-eight states and territories dead, five thousand tourists made the thirty-day round trip from San Francisco to Alaska. Glacier Bay, the ice-choked fjord with tidewater glaciers that Muir had discovered in 1879, was the highlight of the voyage. But cruising past a thousand miles of pristine rain forest left the visitors spellbound. There was, as Robert and Carey Ketchum abundantly document, no place like this on the planet. Henry Gannett, the geographer who cruised the Inside with financier Edward H. Harriman's entourage in 1899, knew this well and offered a ''word of advice and caution'' for potential Alaskan tourists: ''If you are old, go by all means, but if you are young, stay away until you grow older. The scenery of Alaska is so much grander than anything else of the kind in the world that, once beheld, all other scenery becomes flat and insipid. It is not well to dull one's capacity for such enjoyment by seeing the finest first.''

Gannett understood something apparently lost on those who would unravel the complex, forest-based ecosystem of southeast Alaska: wilderness could be the region's most important export. The economic value of Alaska's ''grandeur . . . measured by direct returns in money received from tourists, will be enormous.'' Pristine country, Gannett continued, ''is more valuable than the gold or the fish or the timber, for it will never be exhausted.'' Here is the real definition of sustained-yield management in southeast Alaska. It is based on the fact that no other rain forest coastline in the world is so wild, so scenic and so vast. Gannett knew it could become ''the showplace of the earth'' to which ''pilgrims, not only from the United States but from far beyond the seas, will throng.''

The economics of ecosystem preservation and nature tourism are straightforward. A clear-cut rain forest makes money (actually, *loses* it, as the Ketchums show!) for one season and is gone for more than a century. A standing, or carefully harvested, one can delight visitors, provide habitat for nonhuman lifeforms, and generate income on a perpetual basis. In Kenya's Serengeti National Park, for example, a lion is worth five hundred thousand dollars over the course of its lifetime as an attraction to tourists. Its hide and meat in the hands of a poacher would yield no more than one thousand dollars. The lesson, obviously, is that wild nature today is worth more alive than dead. The trees of the Tongass should not be clear-cut because it makes economic sense.

But there are other, some would say ''higher,'' grounds for respecting the biotic integrity of the Tongass. Its value is not only instrumental (to tourists, lumber companies, and fishermen) but *intrinsic*. The great Alaskan rain forest and all its components are good in and of themselves—valuable, that is, simply because they are there. It is time, as the Ketchums imply, for human beings to recognize that they are members, not masters and managers, of the life community. It is time for planetary modesty; for restraint; for loving custodianship of the earth; for a broader ethic that extends beyond human-to-human relationships and includes the human-to-nature dimension. It is time to take a stand.

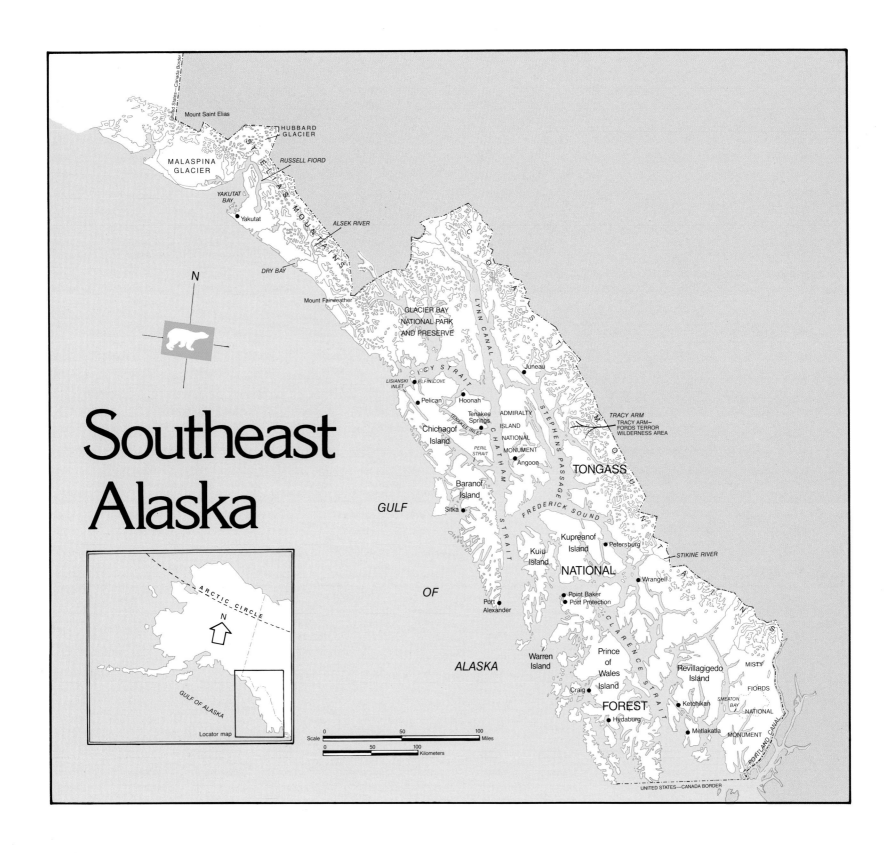

Southeast Alaska

United States—Canada Border

Mount Saint Elias

HUBBARD GLACIER

MALASPINA GLACIER

RUSSELL FIORD

YAKUTAT BAY

ALSEK RIVER

Yakutat

DRY BAY

N

Mount Fairweather

GLACIER BAY NATIONAL PARK AND PRESERVE

LYNN CANAL

Juneau

ICY STRAIT

LISIANSKI INLET

ELFIN COVE

Pelican

Hoonah

Tenakee Springs

TENAKEE INLET

ADMIRALTY ISLAND NATIONAL MONUMENT

STEPHENS PASSAGE

TRACY ARM

TRACY ARM—FORDS TERROR WILDERNESS AREA

Chichagof Island

PERIL STRAIT

CHATHAM STRAIT

Angoon

TONGASS

Baranof Island

GULF

Sitka

FREDERICK SOUND

Kupreanof Island

Petersburg

Kuiu Island

STIKINE RIVER

NATIONAL

OF

Wrangell

Point Baker

Port Protection

Port Alexander

ALASKA

Warren Island

Prince of Wales Island

Revillagigedo Island

MISTY

FIORDS

Craig

Island

FOREST

Ketchikan

SMEATON BAY

Hydaburg

NATIONAL

Metlakatla

MONUMENT

CLARENCE STRAIT

PORTLAND CANAL

UNITED STATES—CANADA BORDER

ARCTIC CIRCLE

N

GULF OF ALASKA

Locator map

Scale

0 50 100 Miles

0 50 100 Kilometers

The Refuge of the Rain Forest

WITH THE ESTABLISHMENT of the world's first national park in 1872, America has led the way in protecting vast natural areas of great beauty and biological significance. Our affluent and mobile society has allowed many of us to experience the wonders of such diverse places as the Adirondack Mountains, the Everglades, and the Grand Tetons. Moments spent staring down into the Grand Canyon, gazing up at the towering walls of Yosemite, or trying to measure with outstretched arms the girth of a redwood repeatedly force us to alter our sense of scale. Nonetheless, for sheer magnitude, most of these scenic wonders more than meet their match in Alaska. As remote to most Americans as Siberia, the reality of Alaska, the forty-ninth state, is rivaled only by the stories told about it. Everything there is said to be bigger, higher, and farther than anything else in this country. On a map of the United States, Alaska often gets slighted; stuck in an inset with Hawaii, it is diminished in stature. But, as its residents like to point out, if you divided Alaska in half, Texas would become the third largest state.

We were drawn to Alaska by our curiosity and the promise of a superlative landscape. The portion we explored is called the Panhandle or, more commonly, Southeast. We found ourselves overwhelmed by its wild beauty and humbled by its physical demands. In our travels, distances proved deceptively greater in the clear air, trees grew startlingly larger as we approached them from afar, and rock faces we had imagined we could scramble across rose more steeply once we reached their base. When we finally came to understand these greater proportions, we had to adjust every calculation and decision we made to accommodate such expansiveness. The tall tales justly appraise a great land.

On most maps, Southeast is shown as a narrow strip of islands—the Alexander Archipelago—and mainland paralleling the western slope of the Coast Mountains. In reality, there are more than a thousand islands, some of them huge, and the highest coastal range in the world separates them from interior Canada. The apex of this divide is Mount St. Elias, eighteen thousand feet of rock and ice rising from sea level.

The climate and natural environment of Southeast do not conform with what most of us perceive Alaska to be like. The interior of the subcontinent, the Alaska most people picture in their minds, could be a desert, as it often receives less than five inches of rain a year. But the water is trapped on the surface and prevented from draining by the permafrost, so it pools, fostering an environment of muskeg and tundra that supports one of the world's largest surviving animal populations. At the opposite extreme, some places in Southeast are inundated by two hundred inches of rain annually, creating one of the lushest and most beautiful nonequatorial rain forests in the world. The massive front of the Coast Mountains acts as a barrier to incoming weather from the Pacific, and storms spend themselves when they hit it, dumping enormous amounts of water on the lower elevations and leaving the peaks perpetually clad in snow.

From Icy Bay in the north to the Portland Canal in the south, a distance of about five hundred miles, Southeast encompasses more than seventeen million acres. Of that, more than 90 percent is managed by the United States Forest Service as the Tongass National Forest, easily the largest of the 155 national forests. This "unit," as Forest Service management calls it, is roughly eight times the size of Yellowstone National Park. Oppressive as the gray skies and rain may seem to those of us from drier climes, 57 species of fish and shellfish, 83 species of mammals, 303 species of birds, and a mind-boggling variety of plants are perfectly suited to this perpetually damp place. The sixty thousand or so humans who inhabit the area have had to adjust.

The excessive precipitation has marked the landscape with spectacular displays of geophysical power. Blanketing much of the higher elevations, ice fields accumulate several hundred feet of new snow every year. Even during the summer months snowfall may continue at these heights with no melt loss to the snowpack. The aggregate weight of all this snow compresses it into a dense sea of ice from which the tallest summits rise like islands from an ocean of whiteness. Born of gravity, glaciers are often the fingers of an overflowing ice field that has crossed a low pass or a divide. As the glacier creeps inexorably down, its sheer weight begins to sculpture the land. Southeast, one of the most glacially active areas in the world, is crowned by one of the largest ice masses on the North American continent. The Malaspina Glacier near Yakutat is larger than the state of Rhode Island.

During the great ice ages, Southeast was covered by vast ice fields. When they began to retreat, the seas rose and filled the channels the ice fields left, creating the straits and fiords we know today. In a textbook display, broad U-shaped, glacier-carved valleys extend

from the terminal moraine of the remaining active glaciers all the way to the coast. From the high basins to the valley floors, the rock walls are sheer. When it rains, uncountable waterfalls stream down the steep faces, and mosses and lichens thrive in the paths that mark the water's descent. After a storm, the brilliant glare of the sun reflects off the wet rock, glacially polished smooth as metal.

The shroud of clouds and the heavy precipitation have brought life to even the most impossible niches. As we flew over this monumental landscape in a tiny bush plane, the greenness of the world below commanded all our attention. Green of a richness unlike any shade of this color you have ever known. Green of more varieties and nuances than you can imagine. Green in every crack in every wall. Green covering the floors of the valleys. Green even in the milky waters flowing out of the glaciers. And everywhere it is green, life abounds.

Alpine meadows, seasonally abundant with wildflowers, occur on or near the summits, and all the ledges have small gardens. In the cracks, organic detritus sustains much larger plants. Trees have established themselves, emerging from their rootholds in the wall, then turning abruptly toward the sky. These are not incidental trees scattered across bald rock faces as in most alpine regions but small dense forests of sizable trees jammed next to each other in some tiny space and exploding from it with a vigorous intensity. In many places less severely glaciated, the trees flourish all the way to the summits. On the lower portions of the mountains, the flora grows bigger and more diverse, finally spilling out on the valley floor as a great forest.

Old-growth temperate rain forest once dominated the West Coast from northern California to Kodiak Island in Alaska. Remnants of old growth, such as the Hoh Rain Forest on the Olympic Peninsula of Washington state, are scattered along the Pacific Coast. But, beautiful as they are, they are only remnants. The Tongass is a world unto itself, and for centuries it has remained virtually undisturbed. Now a forest that has achieved full maturity, it has reached a steady state, encompassing trees of all ages, dominated by old monarchs of large size. Beneath their canopy, younger trees grow toward the light, ready to replace any of the giants that might succumb to wind, rot, insects, or disease. In the understory, herbs, shrubs, and vines grow in profusion. Old trees that die and fall open windows to the sky that are filled by the most vigorous younger trees. Lichens and moss grow everywhere on the forest floor as well as in the canopy. The decaying trunks of trees that have fallen become ''nurse'' logs, simultaneously decomposing into soil and serving as seedbeds for new growth. Biologists refer to this as a

forest of *un*even age, and consider it to be the most productive and diverse.

The Tongass consists primarily of hemlock, Sitka spruce, and a variety of cedars, which in many places have grown gigantic. Sitka spruce eight hundred years old, supported by trunks sometimes ten to twelve feet in diameter, soar two hundred fifty feet in the air. Equally ancient hemlock, although not as high, have recorded trunk diameters in excess of fifteen feet. Alders grow as a dense thicket along the banks of streams, and sometimes rival in height and girth the aspen and birch of forests in the Lower Forty-eight. In the large upper branches of the biggest evergreens, organic soil accumulates and entire communities of plants and animals dwell in lofty microstates. These same branches also buffer the internal forest community from the severity of Alaskan weather. The forest covers Southeast like a great coat. In winter, the canopy bears the weight of the snow, preventing too much from accumulating on the forest floor and covering the forage available to the animals. Within the closure of the trees, all living things are sheltered from the chill and temperature extremes are mitigated. At sea level, the ocean is also a moderating influence. All these factors, working in concert, create a unified ecology in which life flourishes.

As one approaches the forest, the tangled perimeter under the great trees forms a barrier. In especially wet sites, this screen is rife with devil's club—a tall, graceful plant with broad, bright green leaves—every inch of which, leaf and stalk alike, is covered with sharp thorns. Once beyond that, visitors encounter an unrivaled panoply of growth. In this cool, moist place, patches of light are scattered through the shade of the trees. Blueberry, huckleberry, and numerous other berry plants abound and provide an excellent food source. Thriving in the dampness, moss carpets everything, absorbing both sound and passing footprints; in some places, it is so thick that it seems bottomless. The floor is a harmonic evolution of life and death. Nothing is wasted or lost. All things feed other things in the continuum. The rotting trunks and stumps of fallen trees bear luminous mushrooms. Blackwater sinkholes bring forth primeval-size skunk cabbage, glades of delicate ferns quiver in the stillness, and lichens grow inches high, putting on electric color displays in the cool green light.

Dependent on all of this are the principal inhabitants of the Tongass, the animals. Trails, tracks, scat, and evidence of browsing indicate that they are present in great numbers, but the dense cover and the camouflage of mottled light conceal them. Grizzly and black bears, deer, mink, land otters, squirrels, shrews, marten, and in some locations foxes, lynx, wolverines, coyotes, and porcupines,

to name just the prominent species, all share in this luxuriance. In places suited to their needs, beavers, moose, and mountain goats are also abundant, as are more varieties of birds than we knew or could name. It cannot be emphasized enough that such diversity is unique to old-growth forests and that this internal forest complexity is unmatched under any other conditions.

Some of the largest fish runs in the world occur in Alaskan waters, and the fishing industry has always been an important contributor to the Alaskan economy. Fresh water pouring down through the valleys from rain and melt gives birth to great, undeveloped rivers like the Italio, Dangerous, Alsek, Chilkat, Taku, Stikine, and Chickamin. These carry thousands of gallons of fresh water and sediment to the ocean every minute, and up such drainages spawning fish migrate in numbers beyond comprehension. The five species of salmon that visit the interior through these water arteries benefit from the cover and protection of the forest. They return year after year because of the excellent spawning and rearing conditions evolved through time. Fallen trees and limbs establish pools and gravel riffles, providing stability to the river system and preventing washouts of the spawning beds. The cover is also essential for rearing, encouraging algal food growth and a complex variety of habitats that allows for increased fish densities. Just as they moderate the temperature and snow depth on the forest floor, the great overhanging branches also protect the water from freezing extremes.

Adult salmon spent from the rigors of spawning die and decompose on the banks and beds of the streams. Food for eagles, bears, and other inhabitants, the dead bodies are often carried into the forest. High in nitrogen, the remains of these salmon fertilize the trees that protect their spawning grounds. Biologists studying Southeast have discovered that the most vigorous parts of the forest, containing the biggest trees, are those closest to tributaries that have significant runs of fish. It has led some to conclude that the heart of the forest is literally built on the bodies of dead salmon. Old-timers call the largest monarchs in the forest ''salmon trees.''

The delta formed when a river meets the ocean creates a beautiful abstraction from an airplane. Sediment carried from the mountains is deposited in a fertile alluvium that spreads out and builds up until the main channel of a river is broken into a maze of braids. Between these everchanging ribbons, vegetation takes hold, creating dense meadows of tall grass and intertidal sedges. Bears browse, play, and fish in the channels or just lie about in the sun. Eagles perched in treetops, ever alert for prey in the expanse below them, communicate with their shrill cries, and deer graze in the transitional edge of the forest, moving only warily into the open. For deer, the tidal flats are particularly important in winter. With forage more limited, hunger precedes caution, and they fully reveal themselves in order to eat the kelp exposed during low tide.

A great portion of the meadowland is the intertidal zone, inundated twice each day by tides that average eleven feet—that is eleven vertical feet! Because travel by boat is central to the lifestyle here, a tidebook is the Bible of Southeast. Everything is dictated by the rising and falling sea. Homes and parts of cities are built on pilings. People living off the land—hunting, gathering plants, and fishing—need access to shallow deltas. They must time their comings and goings carefully to avoid being stranded. Eleven vertical feet of tide can cover all but the highest parts of delta meadows, yet six hours later, when the tide has reversed, miles of untraversable tidal flats—slippery with kelp and ripe with the methane stench of organic decay—will become exposed.

Camped on the lower Stikine River, we met an Alaskan who had just spent a very cool September night in his open skiff, beached in the muck of the Stikine's vast delta system. After a late start on the previous evening, he had tried to race the tide across the flats. In midtrip, having only partly traversed the intertidal area, he had to watch mournfully as the water drew out from under him. He had no recourse but to wait for its return the next morning to float him free. Things could have been worse. A storm would have soaked him, but, as it turned out, the night was clear.

Days later, after five hours of hard paddling in kayaks, we approached the same delta and found ourselves racing a similar tide across this vast shallow expanse, hoping to reach the deep channel of Le Conte Bay. With each stroke of the paddle pumping more adrenaline into us, we watched through the clear water as the muddy bottom grew closer and closer. Our timing was right, and our transit was not interrupted. A night in the cramped space of a loaded kayak would have been impossibly uncomfortable.

Many people exploring Southeast do so in canoes and kayaks. On such a boat camping trip into Rudyerd Bay, one of the great, sheer-walled fiords of Misty Fiords National Monument, we encountered another curiosity of the tidal zone. In this vertical environment, there are few shelves or beaches on which to pitch a tent. Because we were visiting at maximum flood stage, all available areas were under water. But again, we were fortunate; the peak condition lasted only for a few daylight hours, and we were able to wait it out afloat.

Yet another tidal phenomenon is a salt-water river that runs full and flat at high flood but, when the tide reverses, creates falls in steep and narrow places. In a small boat these can be exhilarating

whitewater chutes, or downright impassable. Clearly, handling a boat is an essential Southeast skill. A resident who is not comfortable in a boat is as helpless as a Southern Californian who refuses to get into a car. All the original Native groups in Southeast traveled extensively by boat. Outside major urban areas, boats are still the principal means of transportation. Even the ubiquitous small aircraft must land on floats. Southeast is, first and last, a place of water. The landforms are riddled with it and surrounded by it, edged with ten thousand miles of coastline.

The complex of waterways that links all the islands is often referred to as the Inside Passage. Buffered somewhat from the turbulent weather and swells of the open Pacific, these waters are a marine highway for ferries, barges, cruise ships, commercial and sport fishing crafts, and numerous small boats. The vessels share the passage with whales, porpoises, salmon, halibut, and many other species. The Inside Passage is the summer home of migrating whales, and selected bays are the rookeries of bottom dwellers such as the Dungeness and king crab. The waters teem with some of the most abundant life in the world, and the ebbing tide reveals a shore covered with mollusks and shellfish. The Tlingit, aboriginal dwellers in Southeast, have a most appropriate saying: "When the tide is out, our table is set."

Although the climate of Southeast varies from east to west and north to south, the warming offshore presence of the Japan Current checks the brutal chill from the arctic interior and gives the islands a relatively temperate northern climate. Living at sea level is cool and wet, but snowfall is limited and thermometers seldom drop below zero. Even in winter, the mid-thirties are considered normal and the oceans never freeze. Pack ice, igloos, and dogsled transportation, which many of us associate with the Alaskan winter, are seldom, if ever, part of the Southeast lifestyle.

With pictures and words we are trying to explain a complex and unique niche on this planet. The flora and fauna of Southeast, adapted to this very particular environment, exist only because of interdependence. This forest was already well established when the Pilgrims were landing at Plymouth Rock. Its beauty rivals that of any place on earth. This is a national treasure, and the Forest Service's own research branch describes it as "rare." Small populations of humans squeeze out a living here as they have done for centuries, their villages and cities clinging to strips of land between the mountains and the edge of the ocean. They share the area's bounty and splendor with millions of plants, animals, and fish. But as the presence of man increases and his demands go unchecked, the impact is forever changing the face of the Tongass. The time is at hand when we must decide what value this complex ecosystem has and weigh its worth against the other economic pressures that now confront all of Alaska.

In the Grip of Management

ALTHOUGH MUCH OF THE STATE appears to be untouched, Alaska has been inhabited by man for centuries. Anthropologists believe that the first residents came across the Bering Strait in pursuit of game ten thousand to fourteen thousand years ago. As they spread through the interior and eventually into Southeast, British Columbia, and the Pacific Northwest, different groups claimed specific regional hunting areas for themselves. This differentiation has left widely varied Native cultures in virtually every portion of the territory, including the most remote and inhospitable.

Brilliantly adaptive, each community established itself in an intimate relationship with the land on which it depended for survival. In Southeast, the Tlingit, Haida, and Tsimshian, as they are now known, were the primary residents. Throughout the islands they built villages and fishing and hunting camps, which they visited in the appropriate seasons as they followed the cycles of availability. In this northern latitude, whose growing season is considerably shortened by the long, dark winters and the cool climate, they harvested only what they found the land would give them, taking some portion of their needs from widely diverse areas. In so doing, they prevented the depletion of any one location. Anthropologists state that the Native communities of Southeast were the most sophisticated totally subsistence cultures to inhabit the earth. With such a bountiful land, managed so well, they never developed agrarian practices but lived exclusively off hunting, fishing, and the gathering of plants.

The Tlingit, who dominated the region, evolved an elaborate and highly structured social and economic system centered on the cyclical fish and wildlife resources. Establishing thirteen primary villages throughout Southeast, they ranged widely and were renowned as great warriors, traders, artists, and seamen. They traveled as far as the Pacific Northwest in massive canoes made from cedar logs to hunt, raid other villages, and take slaves. Their arts sprang from their clan-oriented culture, and the images they carved and inscribed

identified their individual families and their gods. These designs were abstracted from the world around them and, for the most part, represented the animals they encountered in their daily lives. Their art, completely integrated with their day-to-day existence, decorated their clothing, weapons, boats, and architecture. Widely recognized today—but, unfortunately, often lumped together with other native work as "Northwest Coast"—Tlingit design has its own distinct style and preference of materials. Although the Tlingit are now well known for their silverwork in bracelets and other jewelry, their most widely recognized artistic legacy is soaring carved-cedar totem poles.

Before the arrival of European explorers and traders, the heaviest concentration of Native inhabitants on the North American continent was in the Alaska Panhandle. Recognizing that their survival depended on sustaining their resources, they existed with a minimum of impact on the forest ecology until the intrusions of the first white settlers. The new people confronted the aboriginal dwellers with economies that sought to exploit the very products on which their existence depended. The land's wealth—particularly at this time, its fur-bearing animals—was exactly what the new visitors valued most. The native Alaskans have been attempting to coexist with such intrusions ever since.

The Russians, the first to colonize Southeast, fought the Tlingit numerous times, eventually establishing Sitka as the center for their lucrative fur trade. When not in conflict with the Native residents, the Russians often enslaved them, especially the more northern Aleuts, taking advantage of their knowledge of sea otters and their skills as hunters and trappers. The fur market also attracted American traders, and the demand for products from Southeast continued to grow. In 1867, the United States purchased the Alaskan territories from Russia. Because we knew so little about the value of such an acquisition, the purchase was popularly known as Seward's Folly, mocking Secretary of State William Seward, who was instrumental in the negotiation.

The fur trade remained the main economic interest for a short while, but the declining market and diminishing numbers of fur-bearing animals eventually signaled an end to the enterprise. In the classic pattern familiar to places colonized by those who have no spiritual or moral attachment to them, a resource was overused to depletion and the exploiters moved on to something new. The next wave of entrepreneurs saw the vast quantities of fish, especially salmon and herring, as the commercial commodity that they could exploit. Salmon were present in incredible numbers, and it was said that a man could cross a stream by walking on their backs. In 1878, a fishing industry got under way as numerous canneries sprang up throughout the islands. Both natives and colonists began extensive harvesting of the sea and rivers. For many years, the astounding concentrations of fish withstood this relatively uncontrolled take, which peaked in 1941 at 256 million pounds. But a steep decline followed, and the catch fell to only 8 million pounds within a decade. Federal mismanagement such as this fueled Alaskans' desire to take control of the resources and served as a major impetus for statehood.

Thanks to the resiliency of the fish and the undisturbed watershed habitats protected by the forest, the species were not wiped out. Today, the industry is still a great part of the Alaskan economy. Salmon alone contribute $150 million a year to the state coffers, and 30 to 40 percent of the total Alaskan catch is taken from Southeast. Cities such as Petersburg have been established entirely on fishing economies. Fishing still sustains the traditional way of life for the Native communities, and it remains one of the primary food sources for subsistence living. Some 90 percent of all the people in Southeast rely at least in part on subsistence hunting, fishing, and gathering.

Unfortunately, the end of overexploitation does not seem to be in sight. Fishing is a highly profitable business in good years and attracts more and more people to the area. Meanwhile, huge mother ships from many nations ply offshore waters, laying out miles of drift nets. The nets intercept the spawning runs before the salmon even reach the coast, and also kill large numbers of "incidental" wildlife. At the same time, current forest management is affecting critical stream habitats and spawning areas with extensive clear-cutting.

Some people believe that what is being diminished can be renewed, and aquaculture programs have been initiated by the State Department of Fish and Game and several nonprofit corporations. Nonetheless, it is biologic fact that wild fish and animal populations are genetically better adapted and more disease resistant than farmed species. The United States Forest Service, hoping to restore what logging has affected, has also established "salmon-enhancement programs," but the destruction and rehabilitation of this ecosystem is costly to taxpayers. Millions of dollars are spent to cut the forests, damaging the streams in the process, and then millions more are spent to rehabilitate what was lost. It would be far wiser to manage this resource efficiently in the first place. As fishing accounts for 10 percent of all employment in Southeast, any downward fluctuations also impose economic hardships on the communities in which the fishermen live.

Of all Southeastern resources, however, minerals have always had the greatest allure, and it was the discovery of gold in 1878

that brought the first populous wave of outsiders. Gold fever drove unprepared miners into some of the most extreme conditions they had ever faced, and created boom towns at every trailhead to a gold field. Gold discoveries in Canada, which were accessible from the Stikine River and Windham Bay, introduced more prospectors to the Southeast islands. With the help of Natives, who had first discovered ore in the area, major strikes were established in Juneau and nearby Douglas. The proximity of these towns and, north of them, the infamous Chilkoot and White passes, the established gateways to the interior, created a large enough concentration of wealth and power to get the capital moved from Sitka to Juneau. As with fur and fish, the gold eventually began to diminish, and with the advent of World War II all mining was halted. The operations of some claims have recently been revived, and mines have opened on Baranof, Admiralty, and Yakobi islands. Surveys have established the presence of a broad array of other minerals of value as well, including copper, lead, zinc, silver, palladium, and molybdenum, which is used as an alloy to harden steel.

What is thought to be a substantial deposit of molybdenum is at the center of a controversial development near Ketchikan. United States Borax and Chemical Company intends to convert a vast alpine area within Misty Fiords National Monument into the world's largest open-pit mine. When monument status was conferred on the surrounding lands, a huge parcel was withheld as ''non-wilderness'' to accommodate mining interests. The site is encircled by some of the most spectacular scenery in all of Southeast, and the area contains some of the most important salmon streams. To develop the claim, a road from Smeaton Bay has been established. Smeaton is a pristine, deep fiord culminated at its head by a river drainage and tidal delta. The road has been built across sections of the tidal flats and traverses inclines so steep that construction has caused erosion and landslides. The owner of a similar operation in Canada told us that it was a very dirty industry and that he expected the site, its connecting roads, and its deep-water transport station to be a source of numerous environmental problems, such as tailings being dumped into the bay. If that were to occur, Smeaton and the surrounding mountains will be irretrievably altered, and the wilderness qualities of the region could be severely diminished. Ketchikan faces the difficult choice between the economic boost this will bring and the negative impact it may have on tourism. Besides fishing and hunting, flying over Misty Fiords and boating into the sheer-walled bays are among the most popular tourist attractions.

Quarries are also found throughout Southeast, providing marble, limestone and gypsum for building materials. Amazingly, gravel and shotrock (crushed boulders) for roads represent the primary ''mineral'' extracted in all of Alaska.

Again and again, those living here are confronted with the option of high-impact industrial development of finite resources offering immediate economic advantages versus lower impact, more slowly emerging businesses, such as tourism, that offer less predictable long-term benefits. Successful economic survival for those in Southeast will be determined by such complicated decisions. ''Boomer'' mentality must be carefully balanced with great foresight and a clear perspective on the future.

Around midcentury, the focus of Southeast's economy began to shift toward the development of forest products. Since the early 1900s, attempts had been made to capitalize on the vast timber reserves of the region, but planning and sale always seemed to fall victim to economic setbacks, such as the Great Depression. With World War II, major changes occurred in Southeast. The Japanese invasion of the Aleutians and the subsequent onset of the Cold War with the Soviet Union emphasized the strategic importance and vulnerability of the subcontinent. Legislators considered development schemes that would increase the population of Alaska and stabilize its economy with full-time employment. The pulp and paper industry had long hoped for this moment. Spurred by tremendous postwar housing demands and prodevelopment Alaskan legislators, Congress in 1947 passed the Tongass Timber Act, authorizing timber-sales contracts for the Tongass National Forest.

The first of many legal maneuvers perpetrated on the Natives that divested them of power over their land, the act permitted timber harvesting at the Forest Services's discretion. For years, sensing the oncoming storm of settlement and industrialization, the Tlingit had attempted to gain title to their traditional territory in Southeast, based on their historical subsistence use of the forest. They had received token recognition and limited title under acts adopted in 1906 and 1926, but a substantial legal cloud still hung over unresolved disputes, all of which were sidestepped by the Tongass Timber Act. It directed that the receipts from sales in the forest were to be held in escrow until the issue of title was settled. It thus removed the Tlingit from playing any role in determining land use of their ancient ancestral home, now proclaimed a national forest by a government that hardly recognized them.

All of Southeast was then divided into forestry regions, and it was intended that each region would be serviced by a pulp mill to be constructed by the companies cutting the timber. In return for such investments on their part, unprecedented fifty-year contracts were awarded to the successful bidders. Under pressure from the

state's timber allies, using economic growth as their leverage, the United States Forest Service conceded complex guarantees, all of which amounted to what has been called "virtually equivalent in practice to a policy of free use."

The USFS had committed the Tongass to what would prove to be an increasingly controversial program of management, a legacy we are living with to this day. Although subsequent revisions have softened much of the wording, the first USFS management plans issued in the late 1950s made clear the Service's position with regard to the value of the forest it was being entrusted to manage. The plan doubled the allowable cut, stating that "the primary goal of timber management is to convert as quickly as possible, the old-growth climax stands to a new forest." It also claimed that timber harvesting was beneficial to habitat, with the only possible conflicts arising from impacts on fisheries, so it suggested "mitigation measures" such as preventing logging trucks from *driving up stream beds*. It also suggested that "cutting restrictions are presently considered to be more severe than are necessary to protect the resources." Few questions were asked in this period of expansion as the timber industry promised to devleop a "full-time" residential work force, something all hoped would stabilize the region.

Prodevelopment forces also pushed for statehood in order to control resource exploitation and eliminate restrictive federal land policies based on Alaska's status as a territory. Achieving this in 1959 entitled the new state government to legally withdraw from federal ownership 104 million acres, 400,000 of which were selected from national-forest lands, mostly within the Tongass. In doing so, the state acknowledged the Native claims as well, but it did not suggest how to resolve them. Statehood also conferred authority to manage fish and wildlife on state and federal lands and fueled government jobs. This became a new factor of growth as waves of new workers affected every aspect of living from transportation and communication to retail trade and real estate.

The boom was on, signaled primarily by the sound of trees hitting the ground. Some timber companies failed to meet commitments to build mills, so their contracts were canceled or reduced, but mills were completed in Sitka and Ketchikan. Through the sixties and into the seventies, environmental awareness grew tremendously in America and led to the passage of several important legislative acts, including the Wilderness Act in 1964 and the National Environmental Policy Act in 1969. NEPA required federal agencies to file a detailed Environmental Impact Statement on each major federal action; for the first time, the public would have a voice in the planning process and could enjoin an activity until an adequate EIS was prepared.

This legislation, however, did little at the time to alter the timber industry's control of the Tongass.

The Alaskan Natives, whose claims by now had been long delayed, saw their efforts gain considerable momentum when the largest oil field ever discovered in North America was found at Prudhoe Bay on the Arctic Ocean. This strike led to an act of Congress that would change forever the natives' lifestyle, significantly altering their ways of dealing with the land and committing them to a course of "corporatization." Because everyone wanted a piece of the now richer Alaskan pie, serious negotiating began, and in 1971 Congress passed the Alaska Native Claims Settlement Act. ANCSA eliminated all aboriginal claims to Alaskan lands and in exchange gave legal title to about forty-four million acres to the collective native communities. It also provided for a cash compensation of nearly one billion dollars. Then, under the guise of easing the Natives' entrance into this new economic system based on extraction and development of resources, the act required the establishment of village and regional corporations to help direct Native affairs following the settlement. It also set the stage for conflicts between village corporations that wanted to protect lands they relied on for subsistence use and regional corporations that chose lands they hoped would be commercially profitable. In Southeast, this created a new timber-industry group, because the withdrawals reflected the Natives' growing awareness that timber was big money. The corporations selected some of the most valuable timberland in the Tongass, but in so doing some chose sites on other villages' subsistence lands in an attempt to avoid destruction of their own part of the forest.

Such divisions, where they occur, are not just between corporations. These choices fragment the basic principles of land use on which the Natives have structured their societies, and as the years pass they become entrapped in more complicated ways. ANCSA stipulates that the common holdings of the corporations are treated like stock and that each Native is a shareholder in that stock—until 1991. At that time, the stock will be made public and can be bought or sold like any other on the exchange. For small villages that see such machinations as bizarre, legal preparation for such inevitability is beyond their financial means. For the more successful corporations that have capitalized on their land's resources, the law's requirement simply makes them targets for takeovers, further jeopardizing any unity they may hope to retain by pitting stockholder against stockholder.

One last twist helps seal the Natives' fate. Some corporations, especially those at the village level, hold land with minimal economic potential whose greatest value lies in its continued use for subsist-

ence. However, under ANCSA, twenty years after these lands are conveyed to the corporations, they are subject to tax, whether or not they produce revenue. In a living relationship with the land where the dollar value has no meaning and therefore little cash is extracted from the property, how will these taxes be paid? The creditors— both the state and the federal governments—are going to come after the land. So, under the guise of treating the Alaskan Natives in a more sophisticated and sensitive way than their counterparts in the Lower Forty-eight, whose lands we simply took, the laws have euphemized such seizure, calling it part of "self-determination." The Natives have simply been put in corporate reservations. It is encouraging that the One-hundredth Congress is considering amendments to address some of these issues. Regardless of the outcome, nothing will ever be the same.

ANCSA has placed at risk a people's way of life and has clearly altered a successful land ethic that kept all of Alaska ecologically intact for centuries.

Mary Miller, of Nome, as quoted in Thomas Berger's book *Village Journey*, summed up the dilemma facing the Natives today:

When you look through the corporate eye, our relationship to the land is altered. We draw our identity as a people from our relationship to the land and to the sea and to the resources. This is a spiritual relationship, a sacred relationship. It is in danger because, from a corporate standpoint, if we are to pursue profit and growth, and this is why profit organizations exist, we would have to assume a position of control over the land and the resources to achieve economic gain. This is in conflict with our traditional relationship to the land, we were stewards . . . we had respect for the resources that sustained us.

In the midst of all this, the timber industry continued to expand. Congress forced redrafting of the long-term management intentions several times, but little halted the clear-cutting, and with the native logging operations entering the picture, even greater pressures were placed on the forest. Politics in the Tongass were heating up, and in 1970 a Sierra Club suit prevented a large timber sale on Admiralty Island to U.S. Plywood Champion. In 1975, a suit by Reid Brothers, a small independent logging company, charged Ketchikan Pulp Company (now called Louisiana Pacific–Ketchikan Division) and Alaska Lumber and Pulp Company (now Alaska Pulp Corporation) with conspiring through price fixing and other various collusive practices to put the Reids and other independent loggers out of business. In 1978, President Jimmy Carter and Secretary of the Interior

Cecil Andrus used emergency powers to withdraw 166 million acres of public land from development and established Admiralty Island and Misty Fiords as national monuments. Curiously, however, both these monuments were left under the management of the U.S. Forest Service rather than being transferred to the Department of the Interior, which traditionally manages monument lands. In 1980, Congress passed the Alaska National Interest Lands Conservation Act, giving an additional 104.3 million acres some conservation protection and adding 57 million acres to the national wilderness-preservation system, effectively tripling its size. The net result of this disbursement leaves but 1 percent of Alaska in the hands of private concerns; the rest is divided between the federal and state governments and the native corporations. Regardless, through all of this, logging persevered as a substantial influence on the future of Southeast.

In 1973, the annual timber harvest peaked and the market began to decline, leading to greater and greater subsidies from taxpayers to keep logging operations afloat. In the late seventies and early eighties, the economic balance of the region began to shift once again, as new emphasis was placed on resource management. Public awareness of the need for habitat protection led to demands for more accountability from Forest Service programs. Costs were estimated at $200,000 for every working day, and fiscal reports indicate that taxpayer losses on federal timber sales in the Tongass were $57 million and $54 million in 1983 and 1984, respectively. Deficits totaling more than $260 million between 1977 and 1984, and some cuts losing 93 cents on every taxpayer dollar spent, suggest that reevaluation of the entire program must be considered. It is amazing that these losses continue at a time when the Reagan administration is talking so much about the need to reduce the huge federal budget deficit, which has justified slashing important domestic programs to the bone.

Because good economics and political pressure may bring an end to the timber boondoggle, Southeasterners are looking for economic alternatives. Tourism may finally become a factor. While sport fishermen, big-game hunters, and wilderness recreationists have favored Southeast Alaska for years, general-interest tourism has been low. High prices, caused by the cost of importing most goods, and a lack of well-developed facilities have been a problem. Lately, the expense of world travel and the threat of international terrorism have prompted many Americans to look for vacations closer to home. The state of Alaska has responded with a high-profile advertising campaign. Accommodations have been refurbished, native corporations have built new hotels, family bed-and-breakfasts are opening, and outfitter and fishing-charter businesses are growing. Economic planners say

tourism is the only primary industry expected to show major growth in the 1980s; since 1970, tourism-related employment in Southeast has doubled. Many cruise lines have removed ships from politically unstable European waters and are now sailing them through the magnificent scenery of the area. From 1975 to 1983, there has been a 47 percent increase in visiting ships and a 61 percent increase in the per-capita capacity of those ships. For the most part, cruises are a low-impact facet of tourism. But a daily parade of ships unloading thousands of people for a few hours of souvenir buying can turn a small town into a temporary amusement park, to the chagrin of some residents.

Even the Forest Service has been forced to weigh aesthetic and recreational considerations in the Tongass, something previously considered insignificant in regional economic assessments. It asserts in a recent draft report that "the single most consistent trend one can follow in the visitor trade in Southeast has been the persistent demand for the natural scenic beauty. . . ." The USFS also states that "opportunities of the kind Southeast Alaska offers are not available anywhere else in the U.S." and estimates that the recreational use of the Tongass has increased 85 percent from 1980 to 1985. Although certainly not the exclusive solution for the future, tourism will help fill any economic vacuum caused by a reduced role for logging and, with thoughtful planning and coordination, may be one of the least environmentally destructive uses to which the area has yet been put.

If the measure of its worth can be judged by the scramble to exploit it, then Southeast must be very valuable. To many, it is priceless. Yet it will not be preserved without a fight. Perhaps we shall all finally have the chance to participate as voters and taxpayers in the redirection of its future, and guide toward more enlightened ends those who would manage it. Legislative reform important to the region will be decided in the next few years. This national-forest land is a national issue. Conscientious residents of Southeast have correctly observed that the small representation of their sparse population in Congress—by congressmen who are strong timber supporters—gives them little power to decide the future of the Tongass, their home. Its use or misuse will be determined by the interest that the rest of us show.

Elitist, Jet-Set, Hippie Backpackers

WE INITIALLY HEADED NORTH weighed down with the usual baggage of opinions and preconceptions about Alaska that we had collected over the years. Alaskans had the reputation of being colorful characters of epic proportion. They battled hardships and suffered the climate with gusto. They were rugged, independent, and for the most part lived in the middle of nowhere. The remote towns were peopled with social dropouts and refugees, out of touch with the greater world. Outsiders were seen as greenhorns burdened with the affectations of the city and tolerated with bemusement. Environmentalists were clearly suspect, an impression echoed by a newspaper story on the Tongass timber controversy. In it, an Alaska politician stated that the only people interested in preserving the Tongass were elitist, jet-set, hippie backpackers. We were also told "Sierra Club Go Home" bumper stickers were common.

We did not believe all that we had heard; our travels would confirm some of it, deny most, and refine the rest.

Our journeys took us to virtually every corner of Southeast, where we met and talked with many people. Getting to know the human beings behind the stereotypes was one of the greatest aspects of the trip, and to us the quality of the people, molded by the demands of their lifestyle, is one of the richest resources the country offers up. Many times we stayed in their homes, relying on their boats and on their familiarity with the area to get around. We also taped interviews with them so that we could retain precisely their words, opinions, and the details of their lives. We learned much about them from the reasons they gave for being there and began to appreciate the benefits of their unique and special lives in a relative frontier.

Except for the wilderness surrounding them, Juneau, Sitka, and Ketchikan are not unlike small cities anywhere. Most Alaskans who have chosen to live in urban settings have done so for economic reasons and because of their desire to combine the best of frontier living with the conveniences of the modern world. They are gainfully employed, live in houses built by contractors, and wear fashionable clothes. They watch television, get a daily newspaper, eat in restaurants or buy their food in markets, and drive cars much like the

rest of us. Many of them have moved north recently seeking jobs, and would move again if a better job came along. A disproportionate number of them work for some form of government agency.

Juneau, once a raucous gold-mining town, sits precariously against the sides of the towering twin summits of Mount Roberts and Mount Juneau, deluged by the weather their presence generates. It is the state capital as well as Southeast's largest city with a population of about 26,000 when the legislature is in. Its primary business is government. On the occasional sunny day when raincoats come off, three-piece suits crowd wool shirts on the sidewalks, and people in hiking boots stroll past secretaries in high heels. Juneau has suburbs and commuters who create a rush hour clogged with rusty pickups and shiny BMWs. It also has a gleaming night club with a state-of-the-art sound system and video screen, where loggers best lawyers on the dance floor. In Sitka, we saw a beautiful Tlingit girl with a fashionable punk hairstyle and makeup accentuated by handcrafted silver jewelry on her arms and symbols of her clan decorating her pierced ears. Ketchikan's sidewalks and bars are often filled with rugged and weather-worn loggers and fishermen, and with cherubic-looking young adults who have come up to hunt for summer jobs on fishing boats or at the canneries. These intermingle with hundreds of others, speaking a multitude of languages, who have just debarked from cruise ships or ferries.

We befriended and sometimes traveled with residents from many walks of life. Commercial bear hunters and economists, forest planners and wildlife researchers, politicians and tour guides, bartenders, waitresses, and retail clerks all had the opportunity to bend our ear. We found a consensus that they had chosen to live in Alaska because it offered an alternative to the ways people lived elsewhere. Some were born in the state, but most immigrated because they wanted the independence that they associated with Alaska. Many acknowledged the irony that the material demands they brought with them fostered cities just like those they had left. Some moved up hoping to get rich, lured by the rumor of high wages in construction, logging, and fishing. What they usually found was seasonal employment, an oversupply of unskilled workers, and the highest cost of living in the country. Lots of these people drift back to the Lower Forty-eight.

As we moved to smaller towns, the trappings of fashion evaporated, but occasionally, in locations where some live happily without plumbing or telephones, gasoline-powered generators operate satellite-dish television sets. Modernity is inescapable in the last decades of the twentieth century, but rural residents are only too aware that as Southeast becomes more urbanized its real values become more obscured. They are also concerned that man's detachment from the land that supports him ultimately leads to a struggle between those who perceive nature as a resource to exploit or enhance and those who think improving on nature is merely a conceit.

Most of those living off the land have developed a keen sense of their relationship to it. They appreciate the true riches of Southeast—its breadth, diversity, and conditional bounty. Their wealth is of a nonmaterial kind, as they live largely outside the wage economy. But low incomes and remote locations are a political liability, and these people, akin in this way to the native groups, are being confronted with sweeping changes in the name of progress. Their livelihoods and futures depend on what the rest of us will allow industry and government to do. Reminded too often that "You can't stop progress," the writer Colin Fletcher has stated, "No, but you can help redefine it."

There is a common trait among certain individuals we have come to admire the most. These people have chosen to put their roots down in Southeast because they love its natural environment, respect its integrity, and have great hopes for its future. They are also concerned about what they see as colonial-style abuse to which they and the land are being subjected. We will introduce a few of them whom we perceive are contributing as much as taking. For each person we have chosen, we have omitted numerous others. A number of people asked to remain anonymous. They fear the ruthlessness of those they might criticize and are concerned that in job-poor towns any criticism of the employed could turn neighbor against neighbor.

Perhaps the most important unifying element for those who choose to live in the more isolated parts of Southeast is the ingenuity and pure hard work required to do so. The monumental difficulties of just establishing a home are followed by the daily chores of providing heat and food. Some people buy or inherit existing houses like the rest of us. Others start from the ground up, building out of necessity and not always with any great plan. A few do it with skill and cunning, in love with every facet of the work process.

Such a man is Earl Prince. We met Earl when we visited Pelican on Lisianski Inlet. Pelican is a fishing village, built on pilings right at the tideline, and all the houses are connected by boardwalks. The ferry stops there, but people also come and go by smaller boats and by charter planes. Pelican began as a cold-storage operation that served fishing boats working the Fairweather fishing grounds and eventually grew to its present robust size of about two hundred permanent residents. Only a portion of these live in town; the others have built houses on what little available land is spread along the shore of the rest of the inlet. Not liking the bustle of life in town

too much, Earl is one of these latter. Because the inlet is huge and we needed a boat to get around in, we arranged with Earl to use his skiff and guidance while we explored.

Earl, who is middle-aged, recently moved to Pelican from Juneau where he had previously lived for the last sixteen years. Having held a variety of jobs, from within the state bureaucracy to working on a boat, Earl favored commercial fishing until his health forced him to quit. He and a few friends had already decided that they would ultimately retire to Pelican because they liked the location, so they came to the inlet, selected some land as it became available, and began to build their houses. The shores of the inlet are steepsided for the most part; finding a good site, beyond the reach of the tide and weather-driven water, is no small feat. The terrace Earl chose sits in a beautiful cove about seventy feet above the beach. Ironically, people living in Southeast must order all their lumber from Seattle, because almost all wood commercially processed in the region is exported to Japan. This was not Earl's style, so he bought a Volkswagen engine adapted to work as a small sawmill. He collected beached logs and towed them to the cutting site with his skiff. Once the board was created, a winch and slide became the primary method of transport from the beach to the construction site. That device still gets plenty of use.

Because of the weather, Southeast's construction season is limited. It took about five years for Earl, working alone, to reach the nearly finished state we observed on our visit. His only regret is that, once he arrived with his tiny sawmill, he was so deluged with requests for its services that he had hardly any time left for his own projects. A good and patient carpenter, Earl built a relatively traditional house, starting with a platform on pilings to lift it off the soggy forest floor. The design and the well-crafted details incorporate all the necessities for life in Southeast Alaska, including, in the main room, a window with a superb view. With good insulation and a great stove, the house was tight, dry, and warm, a most comfortable residence in a very remote place. Four soaked people and one wet dog shared that warmth after a rainy day in an open skiff, and we could all appreciate the care Earl had put into his home.

It is hard to speak of Earl without mentioning his dog. Huggy was given to the family as a stray puppy, and they optimistically named him Husky. Full grown, he was less than a foot high and looked suspiciously like a Chihuahua with thick fur, so they changed his name slightly and life continued. Huggy is fanatically devoted to Earl, and Earl claims that Huggy is the best "bear dog" he has ever owned. They go everywhere together, and in the wilds of Lisianski Inlet Huggy runs in front of Earl along the beach, patrolling the edge where it meets the forest. His barks, growls, and general behavior tell everyone within earshot whether a bear left its tracks five minutes ago, or fifty. This can be especially appreciated when you are thrashing around in overhead grass and have no idea what is ten feet away. On cold, wet days, such as the one of our visit, Huggy slips inside Earl's rain jacket while riding in the skiff and, ever vigilant, pokes his head out from between the snaps.

While our rain gear dried by the stove, we wandered through the house, enjoying various touches reflecting Earl's sense of need. As evening fell, Earl went out to fire up the generator and provide some electric light. After the lamps flickered on and he returned, we realized we could not hear the expected drone of the engine. At his suggestion we followed his boardwalk through the woods behind the house to the shed that enclosed his system. In it we found a gigantic generator unit and a second, smaller backup unit. The latter, by itself, would have been adequate for most people's total power needs. The well-built housing had a door and extensive insulation that reduced the audible portion of the output to a purr. Having already asked Earl how many people helped him during construction, and having had him take great objection to the question—responding that *no one* had helped do anything except shingle the roof—we had to know how these thousands of pounds of gas-driven machinery got all the way to Lisianski Inlet and now found themselves on a ledge, a hundred feet or so above the shore.

Earl said it was easy, it just took time. He had ordered the big generator, even though it was more expensive, because it was so efficient. With it he could meet all his needs for one year on just two hundred gallons of gasoline. The generator had been shipped to him on the ferry, and in preparation for its arrival he had dragged a number of logs off beaches and built a raft. Towing this with his skiff, he met the ferry by himself, without any lifting devices. He and crew members pushed the crated engine off the ferry onto his raft through the loading bay, and then Earl hauled it back to his beach. To get it up the face of the steep property and into place, he ran a cable to a big tree on the construction terrace, and then, using winching action powered by the generator itself, he let it pull its own weight up the hill on skids. From there it was easy to move the generator through the forest to the final location by the same method. The dragging left unsightly scars on the forest floor, so Earl built his boardwalk and staircase over them and allowed the forest to heal whatever evidence was left.

Most of us are never faced with these concerns, and if we were it is doubtful we would ever tackle them single-handedly or with such attention to aesthetics. But Earl, and many in Southeast like

him, are not us, which is probably why they have chosen to live there. We all have much to learn from his kind of resolution in the face of adversity.

In the same way that such ingenuity unites many of the residents, so does their concern about the Forest Service plans to allow clear-cutting in the Lisianski River Valley, which opens into the mouth of the inlet. Like the majority of those living in rural Southeast, locals gather a great part of their food from fishing, hunting deer and waterfowl, crabbing, and berry picking. If the Forest Service were to log the river valley, they would obliterate critical wildlife habitat, cause siltation damage to one of the top five pink-salmon spawning areas in all of Southeast, and open a very unwanted road corridor to Pelican, connecting the inlet with Hoonah Sound. This would also facilitate access by outside hunters, further increasing the pressure on wildlife. The residents realize that commercial tourism will not become a factor in their economy if the aesthetic qualities of the area are lost and its abundant wildlife driven out. The people of Pelican overwhelmingly oppose any such Forest Service plans, and at this writing the cut has been deferred until 1990. It is worth noting, however, that even under constant petition to halt its progress, the Forest Service has slowly but surely continued construction of a road that would ultimately connect the roadless community of Tenakee Springs to Hoonah, all the while denying their intentions to do so. The roadhead is now less than two miles from Tenakee.

Nevette Bowen was born in Petersburg, also known as Little Norway, one of the principal fishing towns of Southeast. Her parents were trollers for twenty-five years and her father now teaches school. A distinguished educator, Paul Bowen was named Alaska Teacher of the Year in 1978. When Nevette was a child, the family, including another daughter, would move from the city out to Kuiu Island, where they would set up a tent camp at Tebenkof Bay. When they were still too small to fish on board, the children would stay with their mother while their father went trolling for a week at a time, but as they got older, both girls also fished as part of the crew. Nevette, now twenty-six, studied natural resources and economics in college. In the spring she works for the legislature in Juneau. In the fall, she does part-time work for the State Department of Fish and Game.

We met Nevette while we were exploring the Kadashan drainage, where she was counting salmon for Fish and Game. In a skiff, we crossed Tenakee Inlet from Tenakee Springs and, using a tidal influx, boated a substantial way up into the Kadashan River, floating over its tremendous submerged delta. We had read in numerous reports by field researchers that the Kadashan drainage was one of the most valuable habitats in Southeast. It harbored plentiful wildlife and some of the largest and oldest trees. The huge size of the vegetation in the forest was a classic example of the idea that dying salmon nurtured an extravagant lushness, because the Kadashan has one of the largest recorded salmon runs.

Nevette and her partner, Bev Richardson, were staying in a research cabin in the forest. For several weeks, they maintained a fish weir and counted the spawning migration. A weir is a sort of fence that is built across a stream and has a single gate. You sit on a chair in a bear-protected cage, right in the stream, and as the fish come through the gate, you count them one at a time. In the two days we were in the area, the women counted more than 100,000 fish.

We talked with Nevette and Bev at some length and found them most informative about the exceptional size and unique beauty of the flora in the Kadashan drainage. They were also only too aware of the Forest Service's interest in clear-cutting it. All the research done on the watershed, some of which they had helped to collect, recognized the Kadashan's very high habitat value, but it was being ignored. The Tongass Land Management Plan and the five-year timber-sale plans of which the Kadashan is part are not exempt from the federal requirement that an Environmental Impact Statement be filed. But, as with all sites in the Forest Service planning areas, it appears to be the case that the agency attempts to circumvent strict environmental review by preparing only an abbreviated document, an Environmental Analysis, and typically concludes this with the summary statement "finding of no significant impact." This rubber-stamped approval allows the cutting to proceed even though it often contradicts conclusions by the Service's own researchers.

People from Tenakee Springs also use the abundance of the Kadashan drainage for their subsistence, and they have repeatedly petitioned the Forest Service to eliminate it from their long-term management plans, but they have been no more successful with this than they were at preventing the road from Hoonah. In fact, sensing growing opposition to the Kadashan cut, the Forest Service used a technique called preroading to open the unit. Claiming it needed the access for hauling logs from other locations, the Service pushed an eight-mile road deep into the forest to a bridge that cost $130,000 to build. The road terminates at one end of this bridge, which crosses a gorge but leads to nowhere. So much money spent on this "preparation" makes it much easier for the USFS to argue for completing the cut, as opposed to deleting the area from its plans. This kind of tactic is increasingly used and typifies the Forest Service's mode of operation.

Nevette counts the salmon of Kadashan, and files her reports hop-

ing such research information will make some difference, but she fears otherwise and realizes the problem is not occurring only in Tenakee Inlet. Although the Tebenkof Bay of her childhood is protected by wilderness status, most of the rest of Kuiu Island is slated for clear-cutting.

Sitka is a small city on the Pacific side of Baranof Island. Beneath steep summits, Sitka Sound is protected from the open ocean by numerous small islands, some large enough to accommodate houses. Sitka is home to a large fishing fleet and a mill operated by Alaska Pulp Corporation, owned by a consortium of Japanese concerns. It is also the home of Baidarka Boats, a small business owned by Larry Edwards. We wanted to learn more about kayaks, and friends in Southeast said Larry was the man to see. As the first dealer specializing in sea kayaks in Alaska, he has attracted clients nationwide who depend on his familiarity with the area.

Finding Larry is difficult, because he is always busy. He works as a fisheries technician for the State Department of Fish and Game, takes wilderness boat trips when he has the opportunity, and spends his free time building his house on one of the islands in the sound. When we finally made contact, we found him to be quiet and cautious initially, probably trying to figure out what *these* outsiders wanted; but once we got to know him, we greatly enjoyed his directness and his perspectives.

Larry came to Alaska from the Lower Forty-eight, where for a time he worked on a ranch and was a project engineer for Bechtel Corporation in Wyoming. In the mid-seventies, when he decided to move north, he interviewed for an engineering job with Alaska Pulp Corporation through its Seattle office. Because one of his motivations was to improve the quality of his life, Larry says he asked the head of the engineering department of APC if the mill in Sitka was in compliance with air - and water-quality standards. According to Larry, the interviewer stressed that APC was very environmentally concerned, was already in compliance with air-quality standards, and was building a second-stage water-treatment facility to meet other commitments. When Larry arrived in Sitka to assume his new post, he says he found that the mill had never been in compliance with the air-quality regulations and that it was operating under a succession of variances. As of early 1987, it still was.

As Larry learned more and more, he grew increasingly unhappy at the mill, and finally quit in 1978. Since then, he has devoted his energy to his current endeavors, and has also become a member of the board of the Southeast Alaska Conservation Council. In conjunction with SEACC's efforts to halt the devastating expansion of clear-cutting and more closely regulate the industry that once em-

ployed him, Larry has gone to Washington to testify at congressional hearings. He has also spent countless hours reviewing and commenting on the confusing mass of documents from the Forest Service that appraise and classify areas proposed for intensive logging. Like Earl Prince and the citizens of Pelican, Larry expresses concern about what he sees as a gross abuse of a valuable resource and feels that the timber ''mining'' underway on these islands will ultimately destroy the forest's interconnected web of life. As a local businessman he is appalled that, so far as he can tell, for decades the mill has never operated at a profit; using the lure of stable employment, it has been able to force tax concessions from the town, all the while forestalling compliance with air - and water-quality standards. A growing number of residents consider the mill a bad neighbor and some fear the increasing pollution as a threat to future tourism. During our last visit in the summer of 1986, the ''bad neighbor'' profile of the mill was even higher because striking workers had been replaced by scabs, and this union-busting tactic made clear to Sitka residents that APC's supposed loyalty to local workers was nonexistent.

In the same curious fiscal management displayed by the mill, the Forest Service conducts most of its Alaska operations at substantial losses, augmenting paltry stumpage fees with substantial tax dollars to build more roads and cut more trees. Larry feels that these things have been allowed to happen only because Congress and the people are just now becoming aware of the massive, subsidized destruction of resources in the Tongass National Forest.

Eventually our travels brought us to Petersburg during a closure, the downtime period during which by law no one may fish commercially. Most of the fleet was in harbor, and the captains and crews were engaged in repair and maintenance. We met over coffee one morning with Charlie Christensen and Sig Mathisen, both of whom are from families that have lived in Petersburg and fished the waters of Southeast for several generations. Sig, who is forty, has been president of the Petersburg Vessel Owners Association since 1977. He has been fishing since he was a child, and when he was nineteen he bought his own boat and took over the business from his father, working the year-round cycle of herring, halibut, salmon, and crab. Similarly, with family ties that date back to the gold rush, Charlie, who is thirty, is a member of the Vessel Owners Association, and he, too, earns his livelihood entirely from fishing. These men represent the ''big'' business of fishing. Their permits, operations, boats, and maintenance cost them hundreds of thousands of dollars. The success of these and other fishermen has helped build Petersburg into one of the most prosperous towns in all the

islands. It is a community of people who live in close dependence with the land and sea that support them.

The Vessel Owners Association was created in the 1920s. Its ostensible purpose was to perpetuate the social and economic viability of the fishing community. Political activity was limited at first, but since the 1950s the organization has found it necessary to become much more involved in planning as it relates to all the area. In particular, the members have found themselves greatly at odds with the Forest Service over the issue of habitat protection. The vessel owners recognize the danger of losing their entire economic system if the destruction of the forest in turn destroys the fish population, and they hope that through their lobbying and advisory efforts they will be able to persuade USFS management to exercise greater care when planning clear-cuts near important watersheds.

In our conversations that morning, it was apparent that both men believe that the organization is having some effect on the process, but both also feel unsettled about the outcome. For all the lip service they have been paid, they have found that the USFS will avoid them when it can. Over the objections of the members of the association and the State Office of Management and Budget, the Forest Service has spent more than one million dollars in a collaborative venture with Goldbelt Corporation, a Native company, to pre-road and log the slide-prone banks of the salmon-rich Chuck River and build a log dump at Hobart Bay. This area is one of the prime spawning streams of the region and highly valued by the Petersburg fishermen.

We flew out to Prince of Wales Island in a pall of rain and low clouds. Prince of Wales is the largest island of Southeast and the third largest island in the United States. The enormous scale of this landmass, encompassed by a wild, ragged coastline, gives Prince of Wales an astounding circumference of shore, part of which faces directly into the Pacific. Statistics in tourism brochures indicate that the interior supports a vast forest, rich with game, and rate the fishing as some of the best in Alaska. The island is home to the village of the Haida clan, numerous other small communities, and somewhat larger towns like Craig. It is also the center of some of the most active logging in the entire region and has been so extensively clear-cut and roaded that Southeast locals refer to it not as Prince of Wales but as Prisoner of War. Because the issue of forest management arose so frequently in many of our previous interviews, on this trip we were looking forward to meeting people in various logging operations; we anticipated hearing some quite divergent opinions.

Bad weather delayed our departure from Ketchikan for several days, and when we finally got out the ceiling was so low that our floatplane had to take the long way and follow the coast to our destination. About halfway into our flight, the clouds parted briefly, and for the first time we were able to view the shore and the interior of the island. It was a glimpse of a nightmare landscape. As far as the eye could see, it appeared as though a nuclear bomb had been dropped. The only trees stood in a few steep and inaccessible ragged patches or in what few buffers had been left along the banks of streams. Downed trees lay everywhere, often in great piles of discard, and a lattice of roads led in circles and out onto spurs that abruptly dead-ended. More appalling yet was the nearly twenty-five remaining minutes of flying time, during which we moved from cut to cut. Occasionally a lake, large enough to serve as a boundary between two logging sites, would break up the cleared areas, but for the most part all that we flew over had been denuded and stripped to the soil. The ground was littered with hundreds, if not thousands, of felled trees considered so substandard that they were not even removed. Drifting in and out of the cover of weather, the recurrent vision of devastation below us began to give significantly more meaning to the words of concern and fear we had previously heard. If this was the future of Southeast, there was to be no future at all.

Our first stop was Point Baker and Port Protection, neighboring communities that have attracted much attention for their outspoken stance against the Forest Service plans. Both are being threatened by cuts that will affect their primarily subsistence lifestyles, and Point Baker has for ten years been fighting the advance of a road that is now less than three miles away. Like many of the other small towns we visited, Point Baker wishes to remain isolated from roads. A group of the residents here participated in a landmark lawsuit against LPK and the Forest Service to enjoin clear-cutting on the island, citing the 1897 Organic Act, which did not give the Forest Service the authority to clear-cut in national forests. Although the suit was successful, one year later the new National Forest Management Act overturned the decision and granted the USFS authority to continue logging. One of the litigants named in the case was Point Baker resident Herb Ziske. Now seventy-seven years old, Herb is the reluctant dean of the local objectors. He graciously recounted history for us, and added that he believes his community's outspoken resistance to the USFS plans only doubled the latter's effort to push the road through and bring the cutting to his back door.

Port Protection made national news in the spring of 1986 when it seceded from the United States and established the "Nation of the Tongass." A gimmick to draw attention to congressional hearings on forest-management problems, the secession was supported by residents of Point Baker, Goddard, Edna Bay, Tokeen, and Tenakee Springs. In a statement sent to President Reagan, the former mayor

of Port Protection accused the federal government of "years of neglect, misrepresentation and colonial-style mishandling of the resources of the Tongass National Forest." He concluded: "This is not a greeny movement—a conservation movement. This is a movement by the people who depend on the resources. Our qualities of life are just being destroyed."

We found both communities remarkably hospitable for such a remote and weathered corner of the world, with houses cleverly utilizing what few locations were afforded. As in so many other places that we encountered on our journey, aesthetic considerations play a surprisingly large part in the community image, and the citizens of Port Protection, operating as a true collective, have built one of the most attractive and useful networks of forest boardwalk that we encountered in all Southeast. With their lives and incomes centered mostly on fishing and subsistence gathering, even this far from civilization they are informed about and involved with current politics. They have created a community in the most real definition of the word. They enjoy the rewards of their lifestyle, and they recognize that survival demands interdependence. They have little crime, allowing for some overindulgence after a good catch, and they have worked very hard, committing themselves to a viable existence at the northernmost tip of the island. These people are hardly dropouts, and they are only too aware of what the future portends as the cuts and the roads move ever closer.

From Port Protection we flew south over vast interior landscapes left completely barren in the wake of "forest management." What sort of alternative habitat does the government offer to all those displaced animals that lived among the trees? In most circumstances, the law would mandate that human beings receive just compensation or be permitted to seek justice in the courts, but because animals and trees have no legal standing they are simply relocated by force. The powers that be assume they will just move someplace else. Imagine R. Max Peterson, Chief of the U.S. Forest Service, waking one morning to the sound of bulldozers and chainsaws felling the trees surrounding his home and crushing in its walls. Unfortunately, he has not received the benefit of such a learning experience.

Our next touchdown point was Tokeen on El Capitan, one of the many smaller islands clustered along the western coast of Prince of Wales. Once used for cold storage of fish, Tokeen's rambling buildings are now operated by Sylvia Geraghty as a general store for the area. Using it as our base, we could skiff to numerous locations and visit neighbors dispersed in coves and inlets throughout the maze of waterways that connect them all. Some people live on the boats they fish from, keeping them in protected anchorages. A few live in homes built on log floats and anchored in accommodating coves, and we found one business operating that way as well.

In Southeast, logging has two scales of operation, one quite large and the other small. The economics of corporate logging, which is a fairly recent development, purport to justify clear-cutting and road building. The other face of the timber industry is represented by small operations that often work from the shore, build few roads, and take most of what they can, based on the ability of their crew to gain access to the cut and get the wood out. This part of the industry has long been part of the Alaskan economy, and most of the small operations are wholly owned by residents.

One such owner is Barney Belk, one of the last small loggers working in the area. Neither of us had any idea what to expect on our visit to his operation. On approaching it, our first surprise was finding the primary structure of the business, the A-frame, constructed on a log float. As we were to learn, the float permitted the structure to be towed from location to location by boat, and this floating hoist facility would be anchored at the point on the beach through which the timber would be yarded out. Barney's is a classic small outfit employing only four to six men who live in a floating camp near the anchorage of the A-frame. Once the trees are cut down, the logs are attached one by one to a cable suspended from overhead rigging that runs back from the cut to a diesel motor housed in the A-frame. The cabled logs are then swung down the hillside and into the water, where they are shorn of ragged limbs, cut into short lengths and lashed into bundles. A certain number of bundles makes up a raft, which when completed is towed by tug to the processing mill. A very few good men can work a substantial amount of acreage in this fashion and never have need of a "terminal transfer facility" or millions of dollars' worth of heavy-duty equipment and the roads constructed to accommodate it.

As our skiff pulled up to the float, all eyes turned to us, curious to know who the visitors were. We climbed out, laden with cameras, feeling very conspicuous in our bright-colored high-tech rain gear. Face to face with dirty, hard-working loggers, we felt embarrassingly clean, suspect even, and hoped they did not view us as "more Hollywood journalists doing colorful stories." While we sized each other up, introductions were made, but our greetings were brief. Everyone had work to do, and with little comment the men went back to their jobs. We took much care to explain our purpose to Barney. He appreciated that we wanted to see a small operation and gave us the run of the float, so we moved closer to where the logs were being unhooked from the cable and dropped.

The rigger, Dave Sanchez, had the dangerous duty of unhooking

the logs and letting them fall; he would then shoulder a long-bladed power saw and walk their length, trimming off protruding branch stumps. He also augered holes in selected logs through which cable would be run to create the booms that would enclose the log bundles as a raft. When he had a chance to take a break, he wandered over to us and began to ask questions like ''What are you doing all the way out here?'' and ''What do you think of this operation?'' Recalling those ''Sierra Club Go Home'' bumper stickers, we were careful not to let our answers provoke him over a job he obviously held very close to his heart.

After our carefully worded sentence or two in response to his inquiry, he stared at us and said, ''Bullshit, what do you *really* think of this operation?'' Caught off guard, we hesitated, not quite sure where this conversation was going. Sensing our reticence, he answered his own question. He wanted to know if we appreciated the difference between an operation such as this one and one that was corporate in scale. Citing the shortcomings of the megacutters, he constantly pointed out that Barney and company were low impact, required no roads or big equipment, left little slash, and took, for the most part, only usable trees. We listened, in stunned silence, to a logger who prided himself on his operation's low profile and minimal impact, which he saw as essential ingredients in timber harvest. He was aware of the destruction caused to habitat by larger and more consumptive, careless cuts, and he emphasized that the money made by Barney's outfit went to Alaskans and stayed in the state. There was little left for us to say, so we mostly nodded in affirmation. On the way back to Tokeen, we reiterated Dave's statements to our companions, two of whom also worked ''thinning cuts'' for the Forest Service, and all of them concurred with his views. Suggesting that we should not be so surprised to find everyone well informed about what was going on, one of them said, ''After all, we don't live in a vacuum.''

Our host at Tokeen, Sylvia Geraghty, is part of a family that has lived in Alaska since 1912. Her grandparents and great-grandparents are buried in the state, and a son and daughter, as well as a granddaughter, live there as well. She is a fourth-generation Alaskan who comes from a family that has always lived a subsistence lifestyle, and her father is a big-game guide with a camp on the Alsek River in the Yakutat area. Sylvia operates a grocery, liquor and fuel store at Tokeen, and she has held thinning contracts with the Forest Service, been a fish buyer, and done occasional trapping. We expected her to be an outspoken critic of the Forest Service, but she also gave us some valuable insights in the ways Alaskan families survive.

Sylvia is articulate and, as far as the Forest Service is concerned,

dangerously well informed. At the time we visited, her oldest daughter was home for the summer from college in Louisiana, where she was about to get a degree in chemistry. We wanted to know how Sylvia remained so remote and yet tuned in to all the things affecting her life, and especially what kind of schooling her daughter might have had in the bush that would have carried her to a degree in a much more competitive setting.

All three of her children had studied under the Alaska Home School Program, and Sylvia enthusiastically swears by it. This program of progressive assignments and goals comes in the form of a monthly mailing. In some places, it is supplemented by television programming, although at Tokeen there was no television. Sylvia feels that this kind of studying, under a supervisor who sees that the work gets done, is far better than any public education because it affords learning without classroom distractions: whispering schoolmates, class cutups, peer pressure, and cliquish social structures. It gave her more time to help her family with their problems, and it allowed them to concentrate extra energy on subjects they liked best. In fact, Sylvia decided that if they really liked a subject and wanted to complete the entire month's work in just a few uninterrupted sittings, it was acceptable as long as they completed all their other work as well. She criticized the traditional school structure that breaks the day into numerous short classes dedicated to a wide range of subjects. ''Just when you are getting into something interesting about history, the bell rings and you have to go to math. How can you hold anybody's attention in a system like that?''

Sylvia's daughter said that after graduating, she plans to take a pharmaceutical job to pay back her student loans. Then she hopes to return to Tokeen and help her mother run the store. Thinking she would miss what she had discovered elsewhere, we asked if she might change her mind, and she replied that she found nothing of greater value in any of the other places and lives she had observed and wanted to come back to Tokeen because of the quality of life there.

We decided to return from Prince of Wales to Ketchikan by ferry. Picking up a car at a logging camp in Naukati, we began a sixty-seven mile trip to the terminal on roadways built as part of the forest-management master plan. The journey confirmed the complete failure of that plan and gave us an unforgettable ground-level view of the devastation that we had seen from the air.

After months of working on this project, we felt we understood the nuances peculiar to the ecology of each of the islands. They are separate worlds with differing levels of exposure to rain and cold, and their flora and fauna have developed in a slightly different way

at each location. The country across which we had previously traveled had greatly expanded our understanding of the diverse luxuriance of this rain forest, always abundant, always beautiful, but never quite the same. In contrast, the land we drove through on our way to the ferry was very much the same, the abundance and beauty lost for at least hundreds of years, and probably forever. In the grayness of a falling rain, the dirt roads led us past unending countryside, stripped of its protective coat and the tiers of life from the crown of the forest to the floor. Gone are the giant spruces and hemlocks that made up the very heart of the complete forest ecology; gone are the great sheltering branches that supported arboreal cities and kept deep snows from burying the forage available below; gone is the protection afforded the salmon spawning streams; gone are most of the animals and the understory they lived in and all the mosses and lichens they walked across. What has not been cut and dragged away has been crushed under the weight of the fallen trees or heavy equipment. Everything has vanished. Prisoner of War Island is left with only root wads, debris piles, and splintered, unusable timber strewn like silvered toothpicks across a vast landscape. The ecology has been irreparably undone.

We drove on in silence and anger. With each bend in the road, further vistas opened and the destruction continued to unfold before us. Miles of roads connect nothing to nothing. Spurs loop off to nowhere. Lakes, once beautifully rimmed with trees, sit at the bottom of denuded valleys and hillsides like remnant puddles in a post-holocaust landscape. Who would come here to hunt? Or camp? Or fish? Who would ever want to live amid such desolation?

We have no answer to those questions, and we doubt that those who helped create such a landscape have answers, but in the frustration of the moment words of a very different perspective came back to us. Nava Thunderstorm, who with his family has built a self-sustaining organic farm out of the wilderness, gave us some hope that we are not all blindly careless with these words in an article in *The New Catalyst:*

As I'm clearing trees, one by one, to make a new field to grow food on, I have lots of time to think. I think how I must make sure that these tree-lives aren't wasted. I have to use the trees and care for the new field and its newly exposed soil. I know I am responsible for its fertility and its life. I think how slowly the clearing grows. The day's progress is barely perceptible. But in Earth time, in the context of the millions of years nature takes to change, to evolve, the disappearance of this wood is too fast.

I think how the survival of the human race will depend upon our intrinsic nature, on the genetic inheritance we have as a species, on what we have already inside of us. What decides our fate in the world won't be the great acts of nations, but rather how each person, one at a time, relates with the world. I think how the billions of us, cutting our own trees, planting our own gardens, acting in our own small ways that accumulate through time, are changing the earth at an incredibly fast pace compared to its four billion year history. And how, if any of us acts wrongly and destroys systems or parts of the whole from which we have recently sprung, the Earth will shrug us off, and it will heal once again in its own unhurried Earth speed. And as I stand among the stumps, I know that what I am doing now is important, as every act is important. The entire future of the world depends upon it.

Prince of Wales has no role to play now except that of a tree farm. Something of great value has been taken from us all, and we financed its removal with our taxes. The return in no way compensates for the loss. Unaverted, the present tide of destruction will consume some part of all these islands, annihilating this place and the future of its people. This should not be the fate of Southeast. There is too much at stake. Growth and resource use can be adapted to more harmonic and productive ends that benefit the whole rather than a few people. We have entrusted a government, which we created, to administer them in our best interest, and now that administration is woefully in need of redirection. The people are already here and have the intelligence to transcend these errors and to build a complementary, living relationship with one of the loveliest gifts of evolution. We are the solution and it is time to take a stand.

Year by year we shall add still further to our knowledge of this once distant country. We shall find the sources of its mighty rivers; we shall follow the shore of the wondrous northern sea; on every hand we shall make acquisition of new and abundant treasures of science, which shall enrich mankind when our lost millions have been long forgotten.

Charles Raymond, 1872

When the American people get hold of a country there is something about them which quickens, vitalizes and energizes it . . . Let American enterprise go there, and as if by electricity all that country will waken into new life and possess value.

Rep. William Higby, California, 1868

I see the Alaska of the future . . . an Alaska that is the storehouse of our Nation, a great depository for minerals and lumber and fish, rich in waterpower and rich in the things that make life abundant for those of us who live in this great Republic.

John F. Kennedy, 1960

Sylvia's, Tokeen

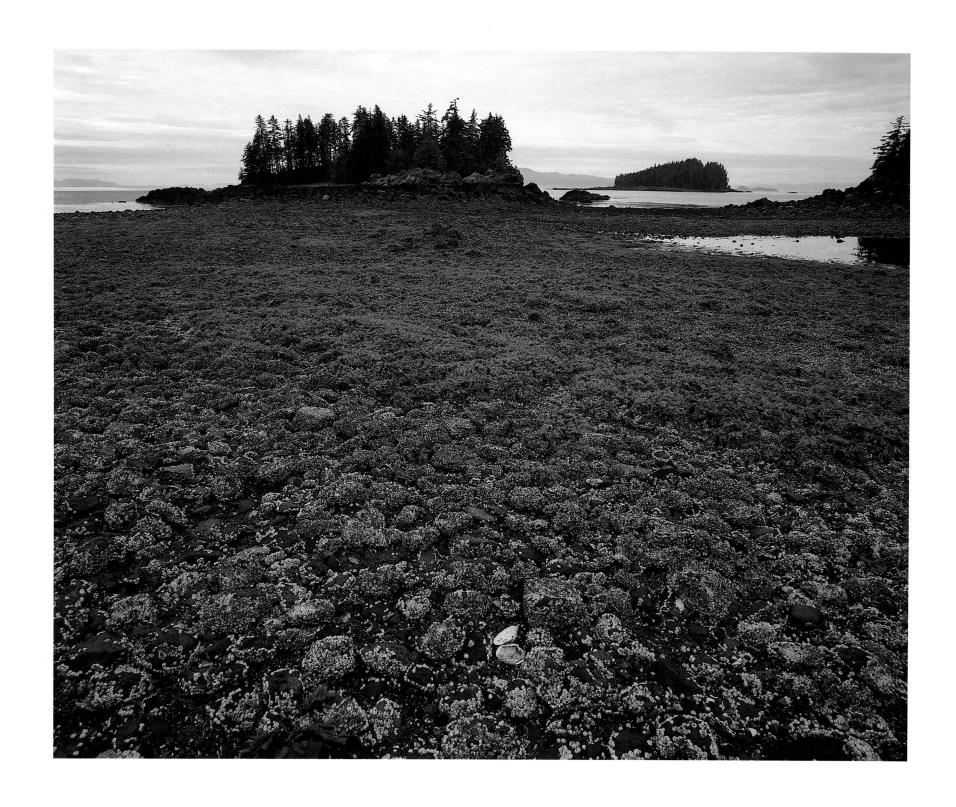

"When the tide is out, our table is set."—The Tlingit

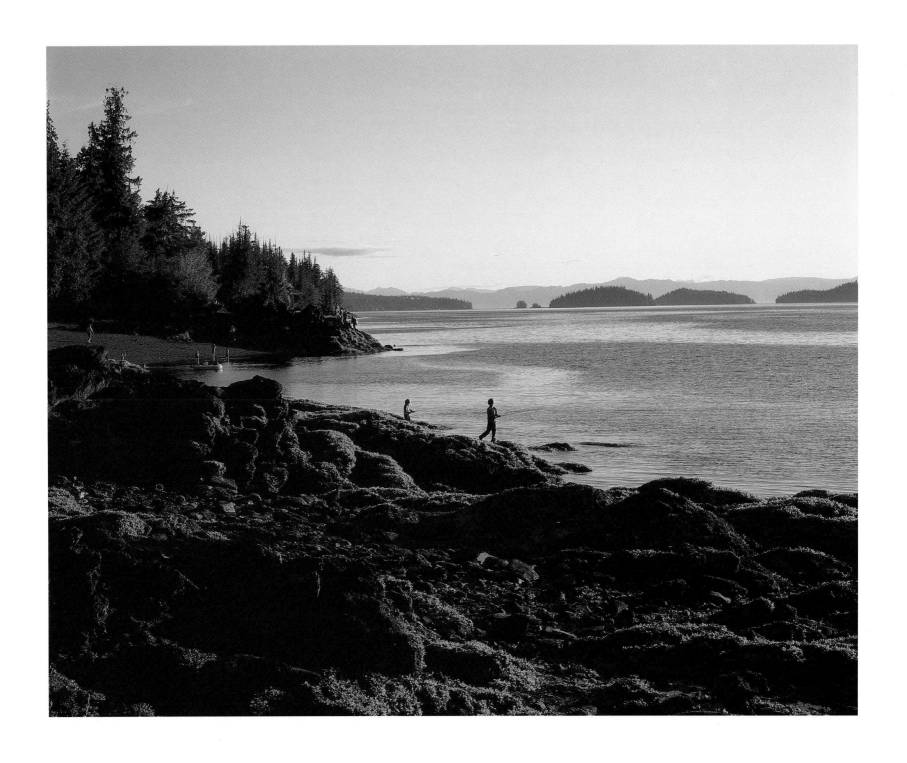

Near Ketchikan

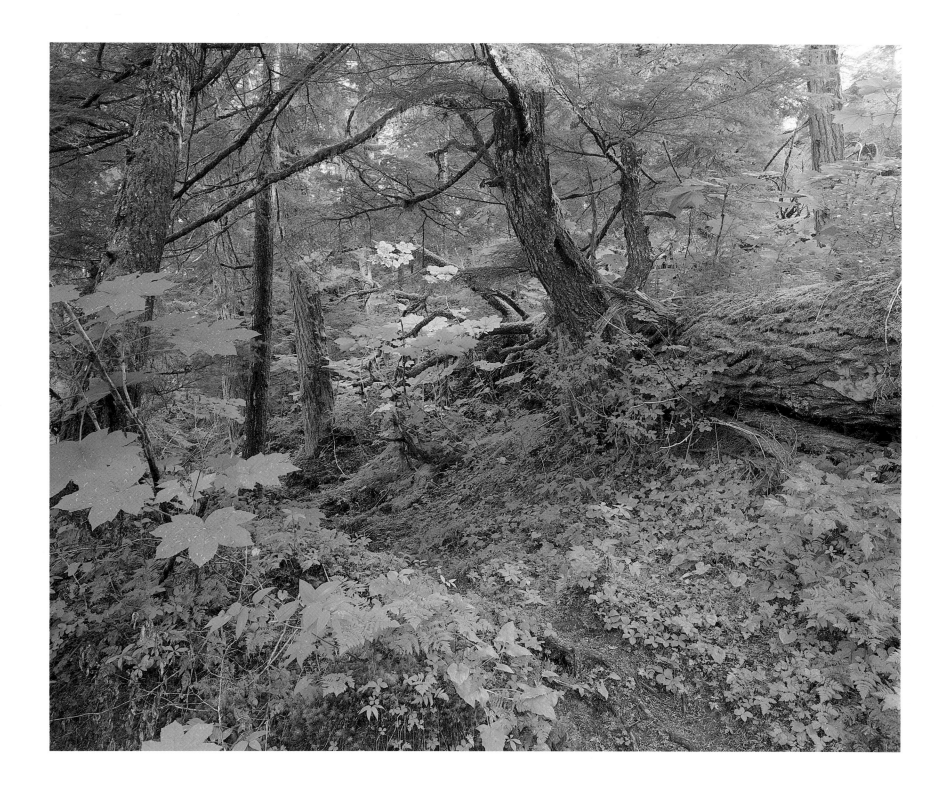

Bear trail in old growth, Admiralty Island National Monument

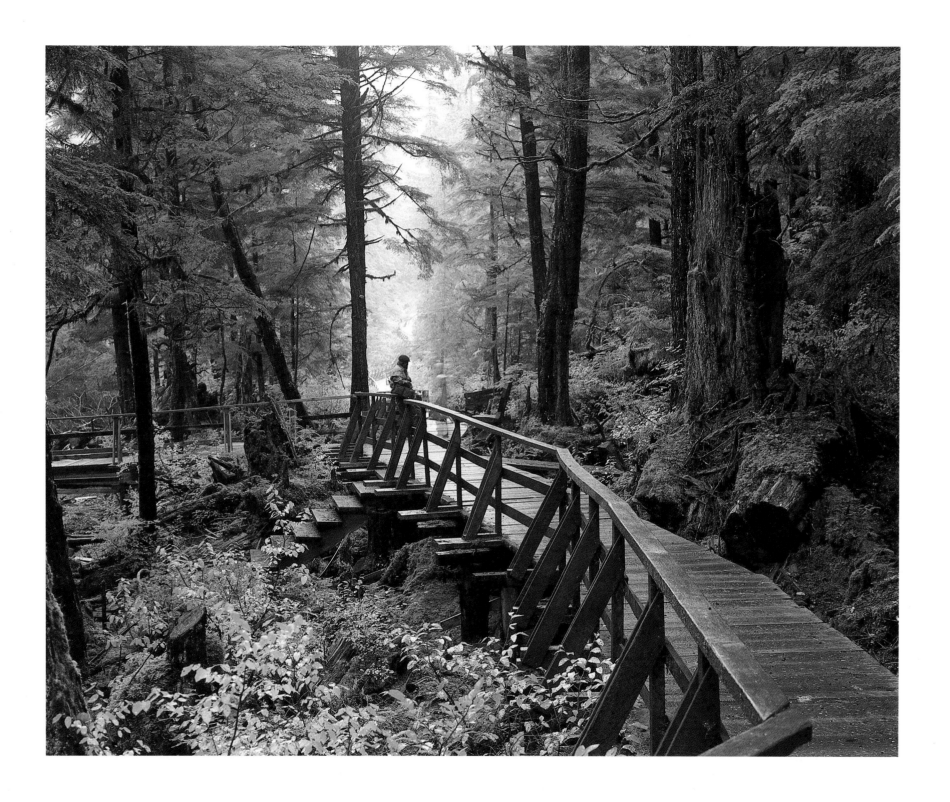

Community boardwalk, Port Protection

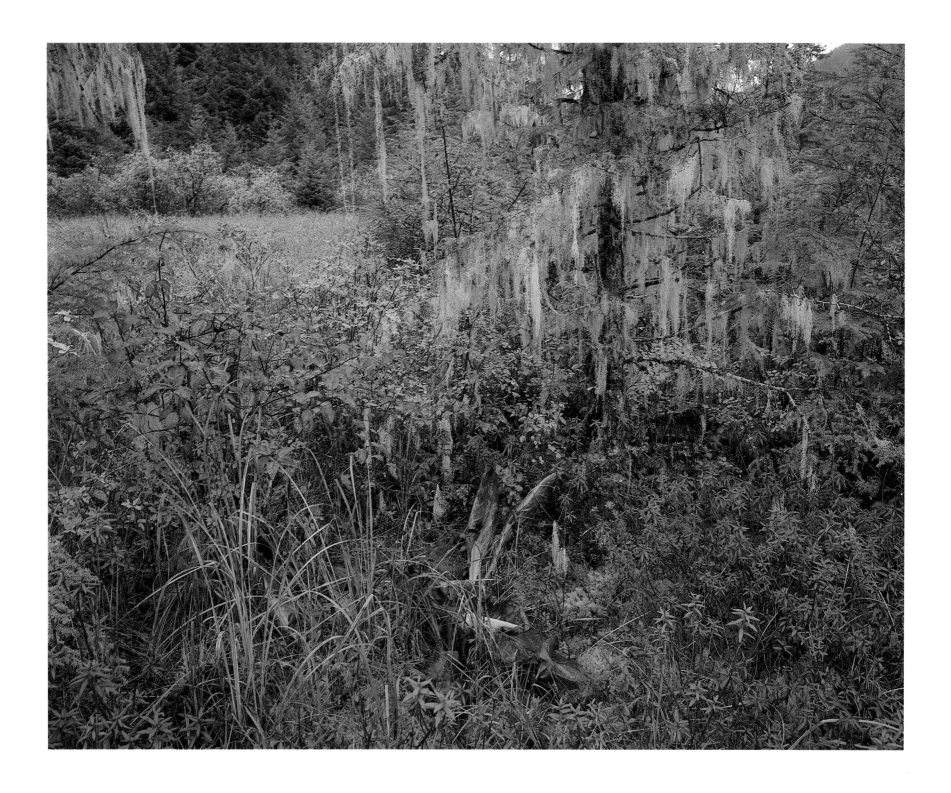

Usnea *(old man's beard), near Juneau*

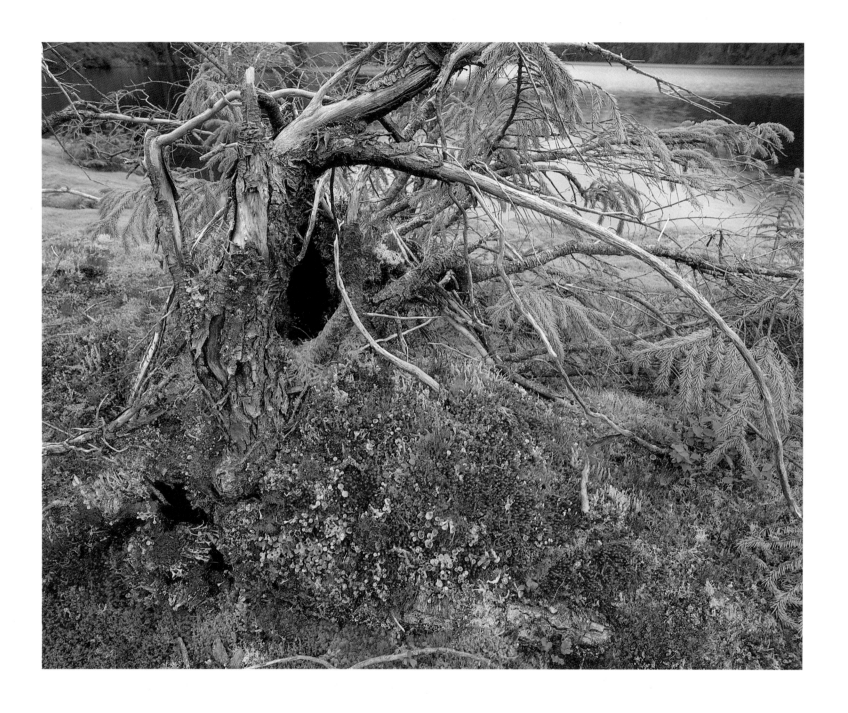

Lichens and moss on the shore of an alpine lake, Misty Fiords National Monument 33

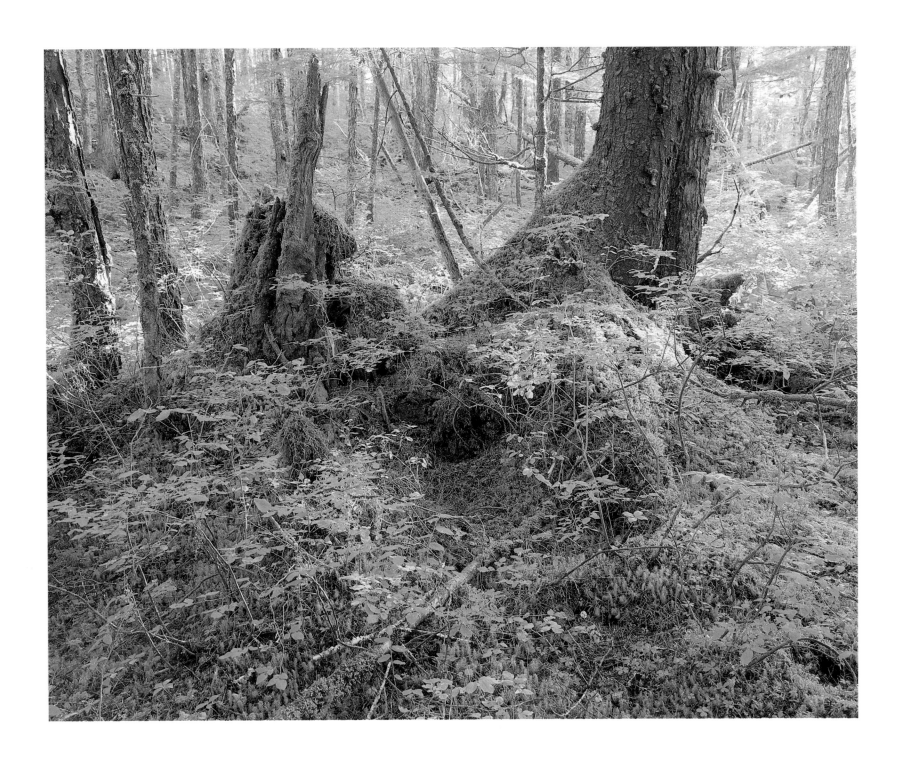

Old-growth understory, Admiralty Island National Monument

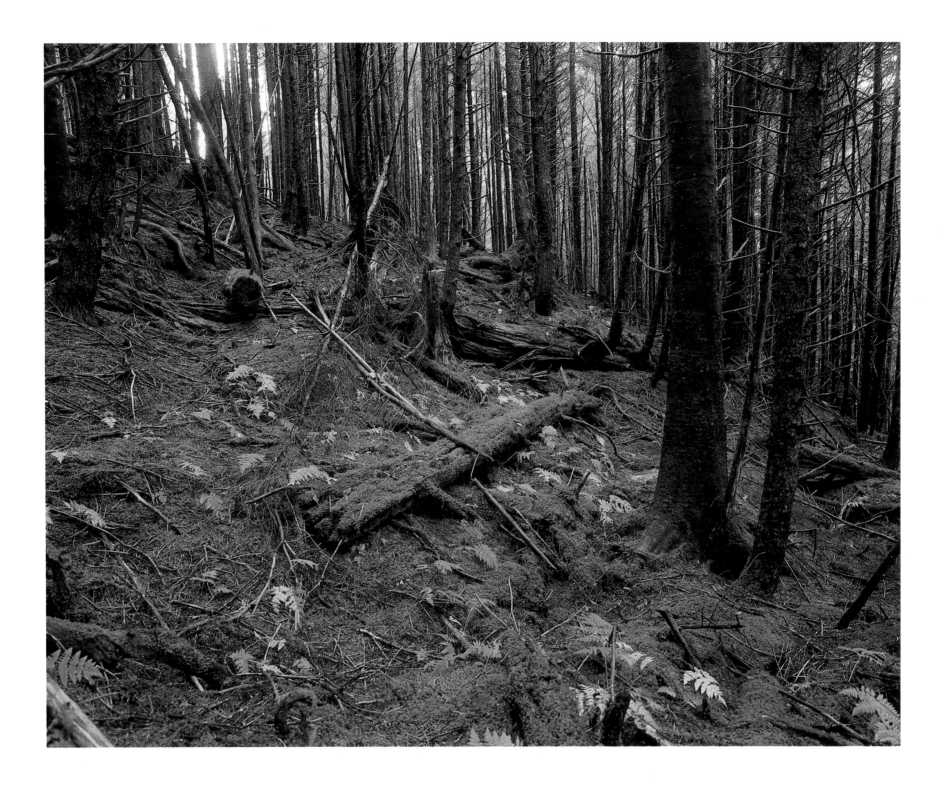

Forty-five to fifty-year-old second growth, Lemon Creek, Juneau

View from Rosie's, Ketchikan

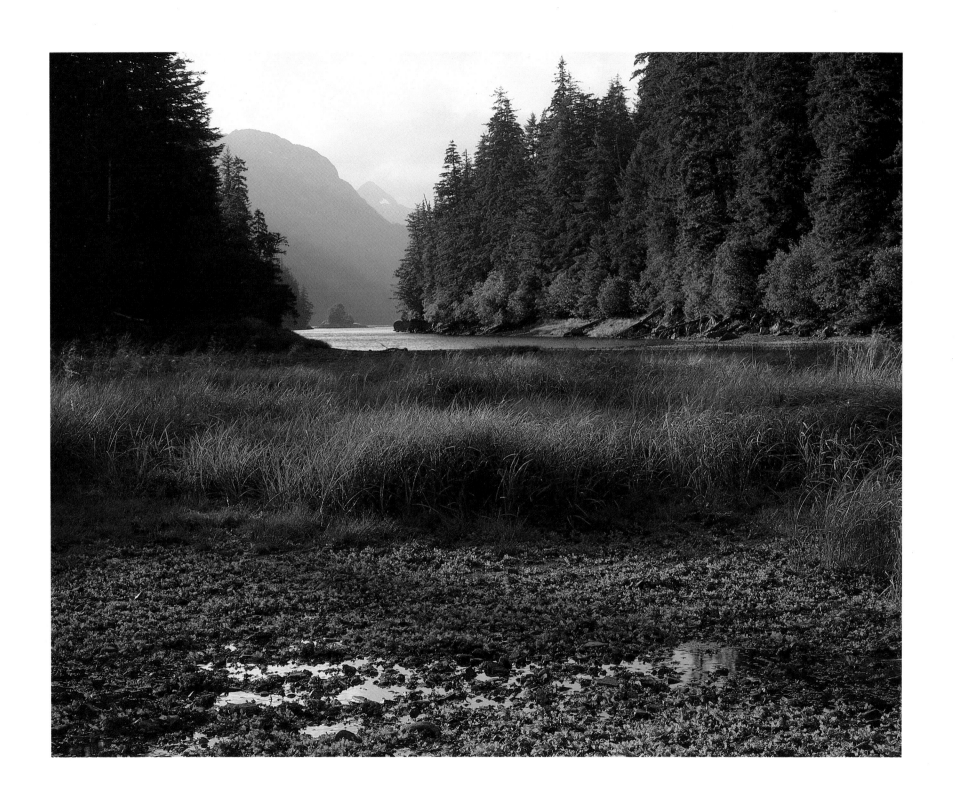

Lisianski Inlet

We acquired it on impulse, and we have been ambivalent about it ever since, torn between dark visions of howling polar wastes and bright ones of golden arctic empires. One might say that Alaska is a crossroads for America, a crossroads between dreams of an infinitely accommodating planet where any number of people can find their cabin in the wilderness and less romantic considerations.

David Rains Wallace, 1984

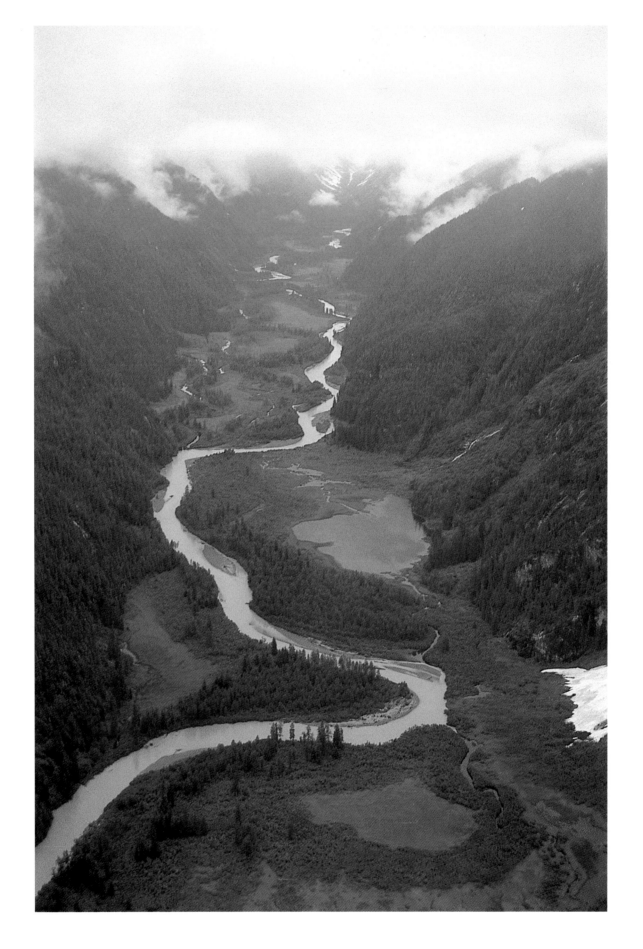

Chickamin River Valley, Misty Fiords National Monument

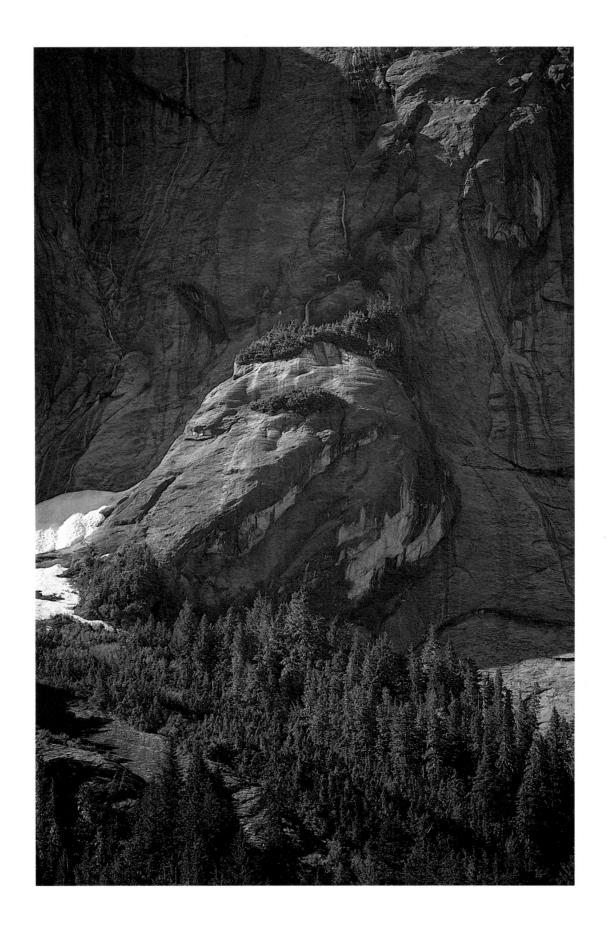

Misty Fiords National Monument

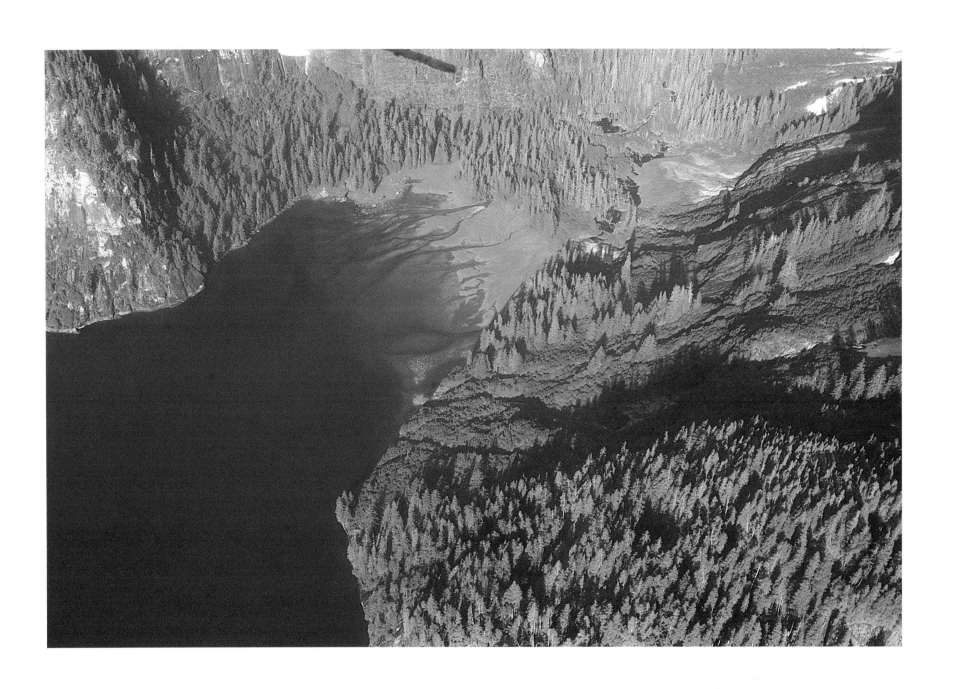

Tidal wetlands at a river mouth, Revillagigedo Island

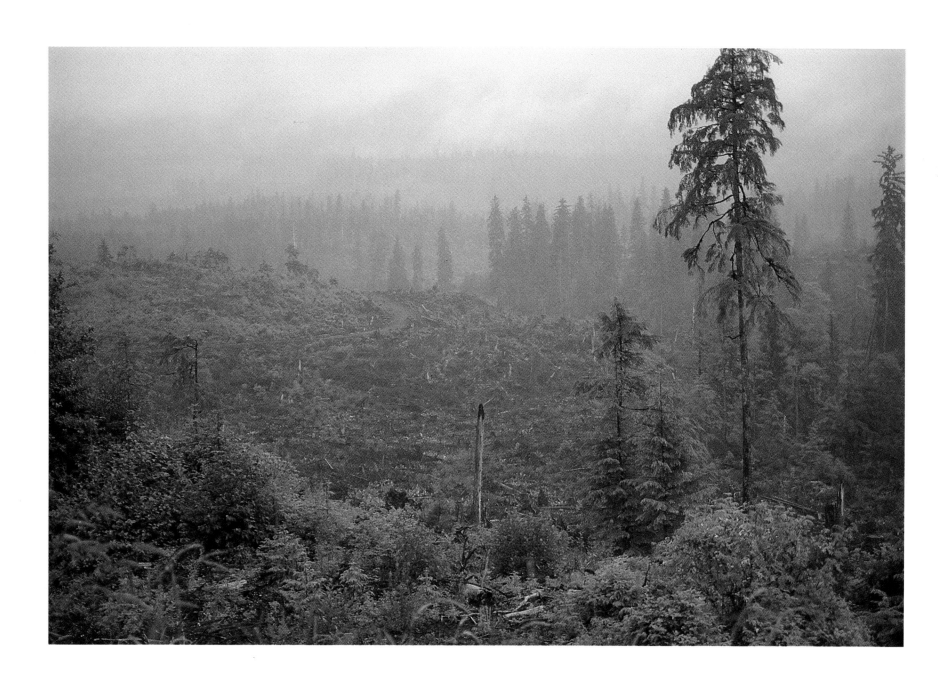

Prince of Wales/Prisoner of War (I)

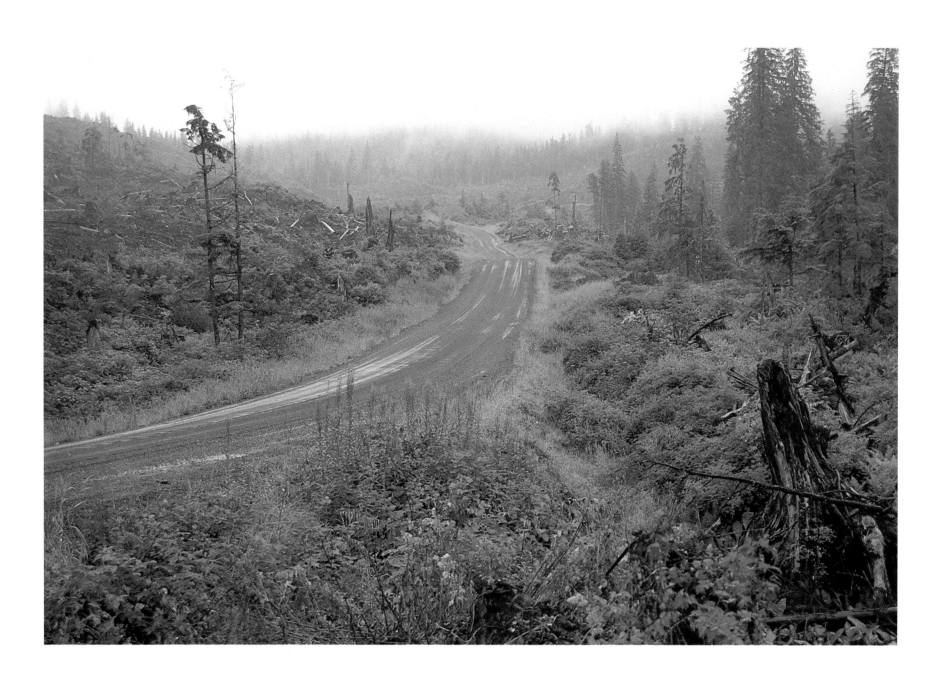

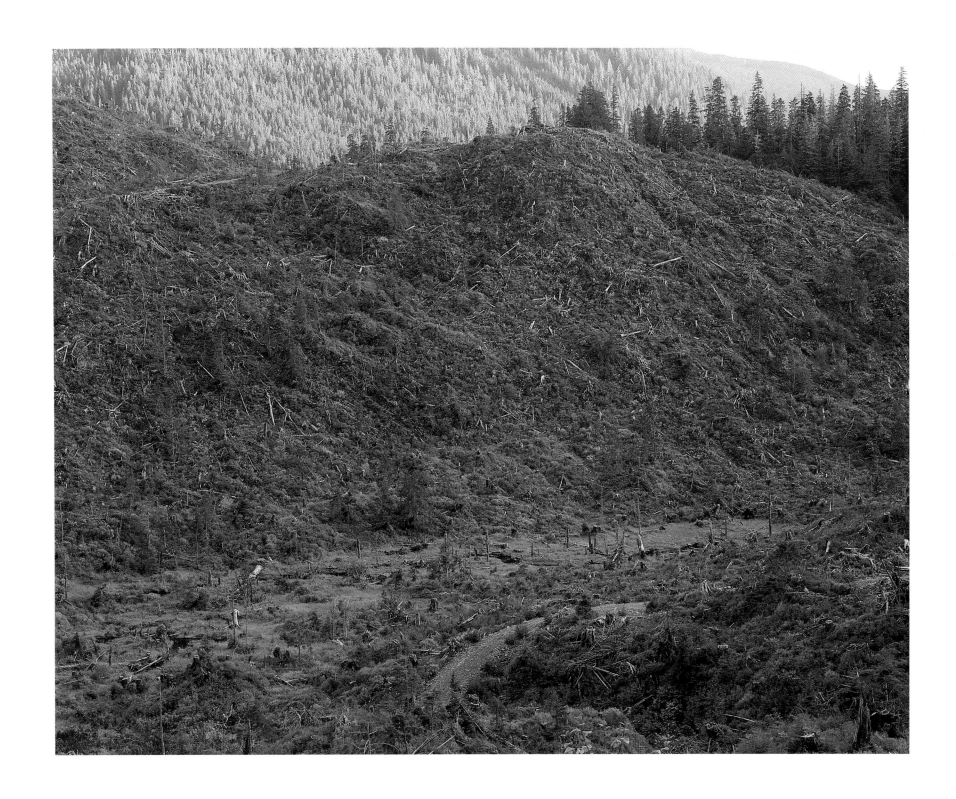

44 *"I like the look of a clear-cut"*—*attributed to a Forest Supervisor at a public meeting.*

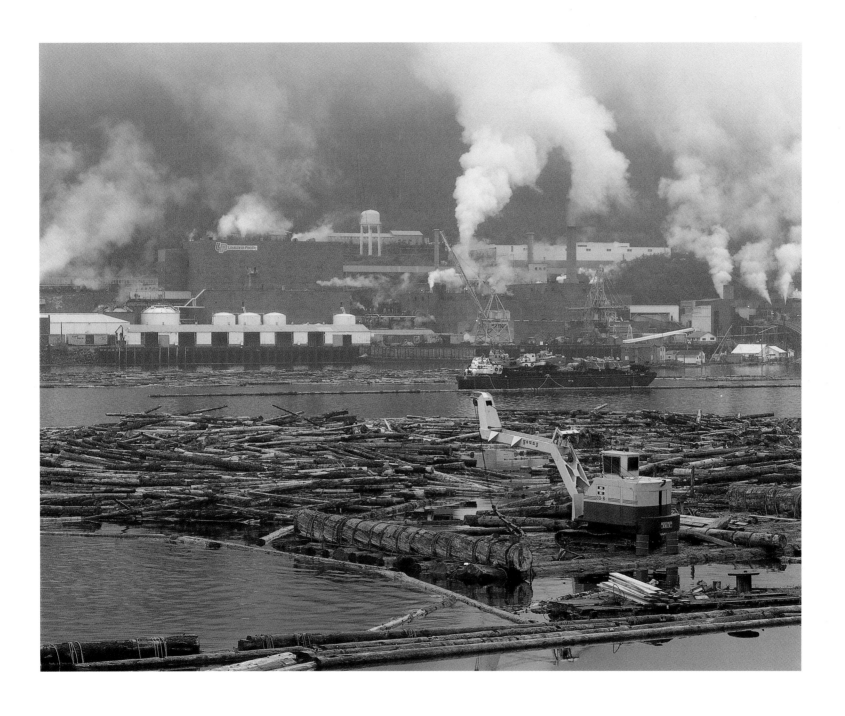

Louisiana Pacific-Ketchikan

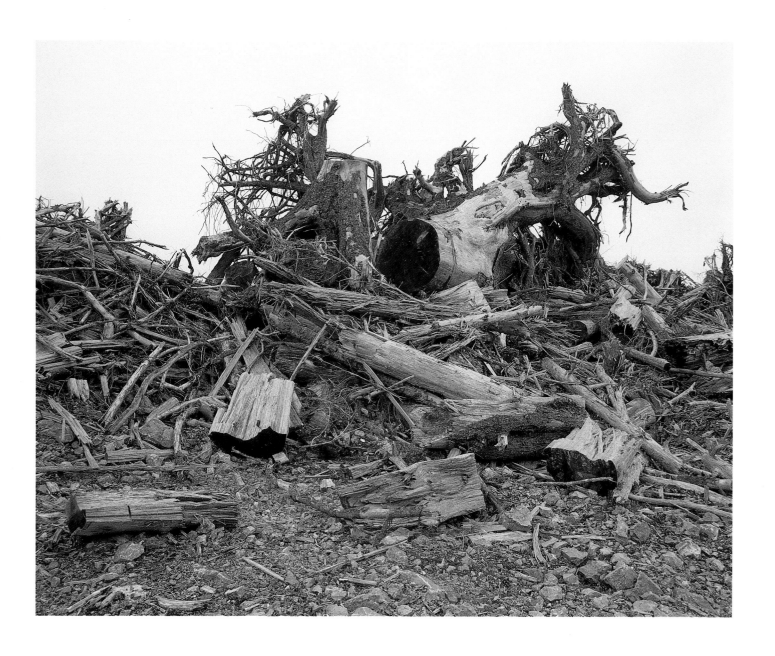

Rootwads and slash/Ode to Woodie

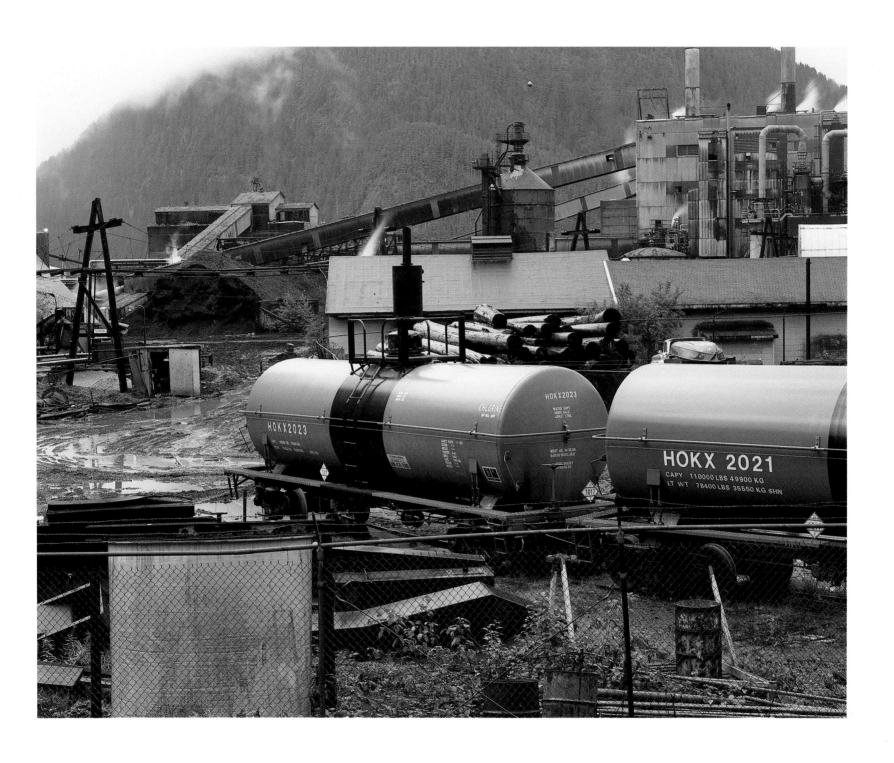

Alaska Pulp Corporation, Sitka

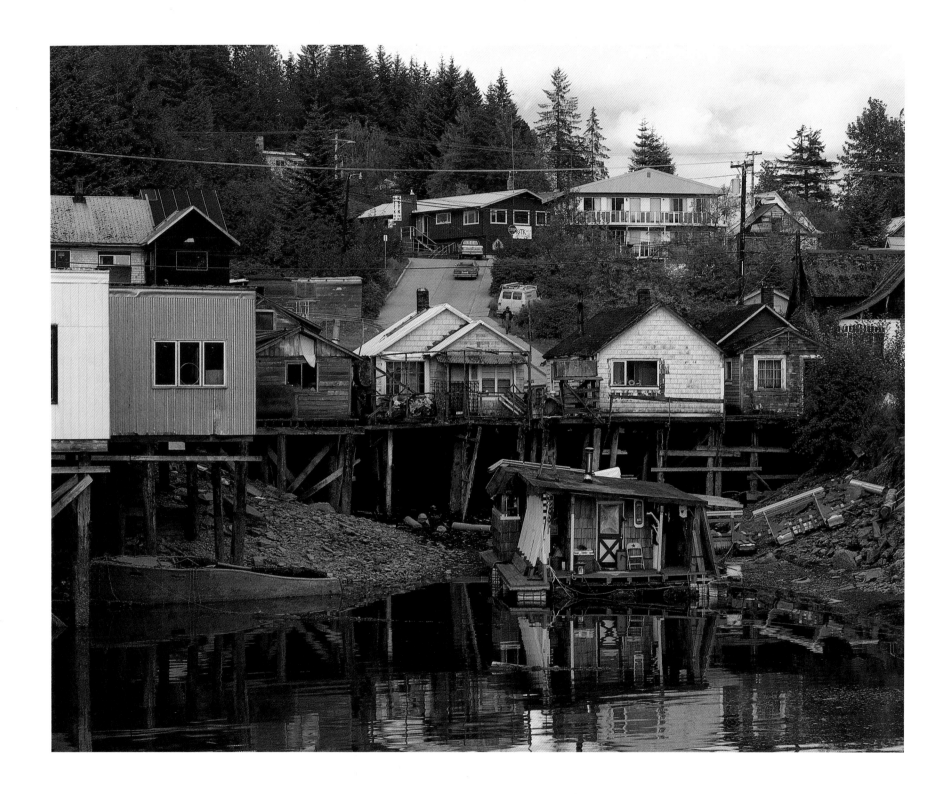

Wrangell

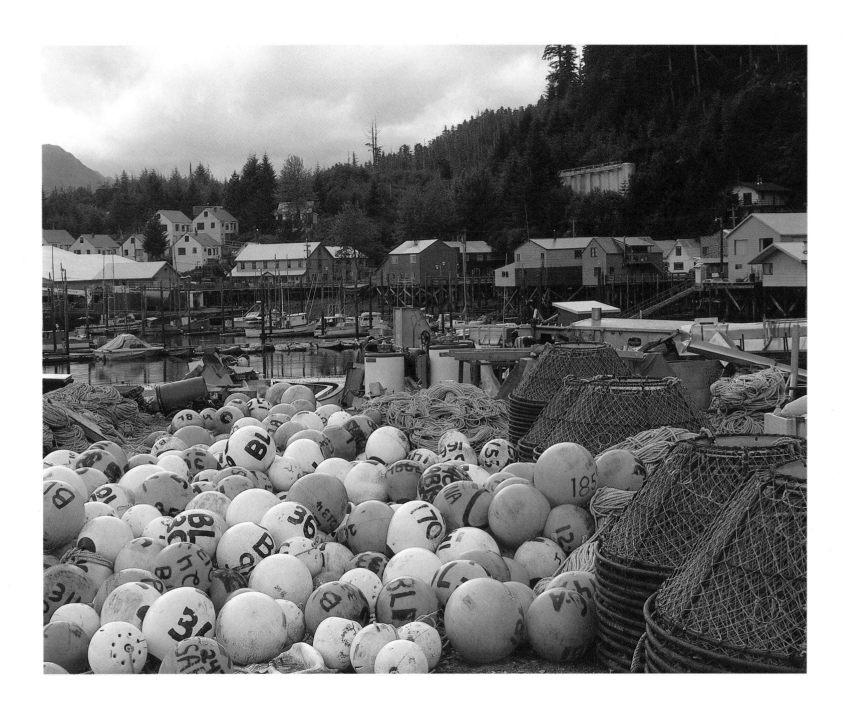

Pelican

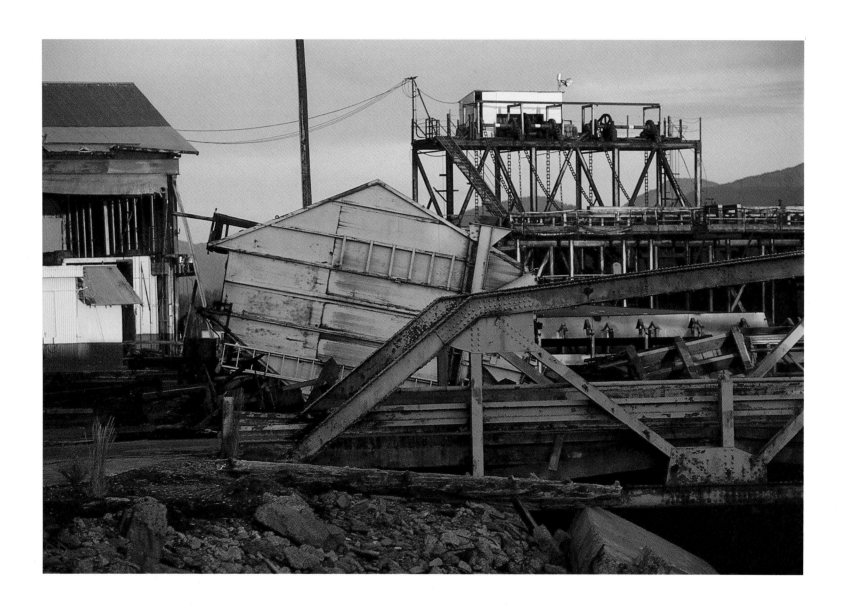

Abandoned cannery, Ketchikan

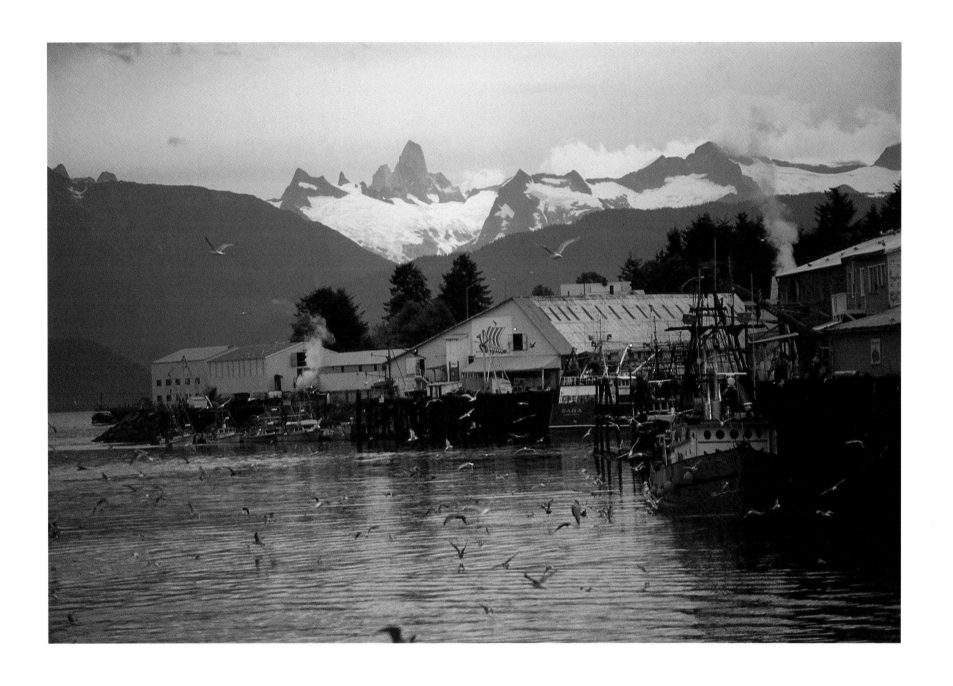

Consider the signature of ice. The moving glacier writes, and having writ, moves on, down the valleys of its own creation, dying piecemeal at the edge of the sea. Moraine and cirque, polish and striation, tell us what the ice that was had to say, but today's living ice covers its tracks with its own great body, leaving us to guess and wait—too long, perhaps, too long.

T.H. Watkins, 1984

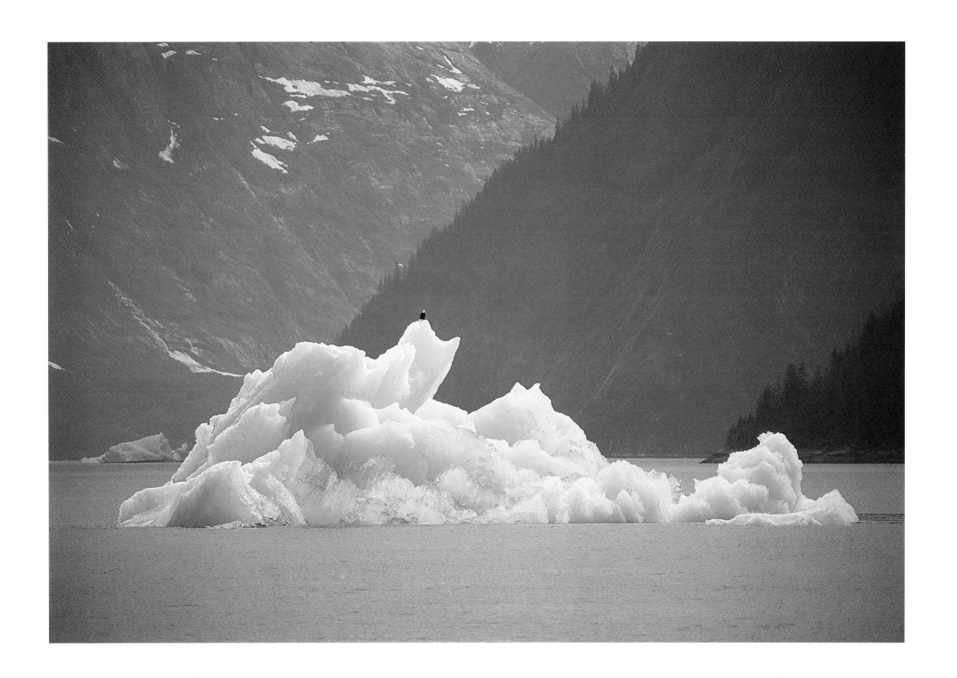

Bald eagle

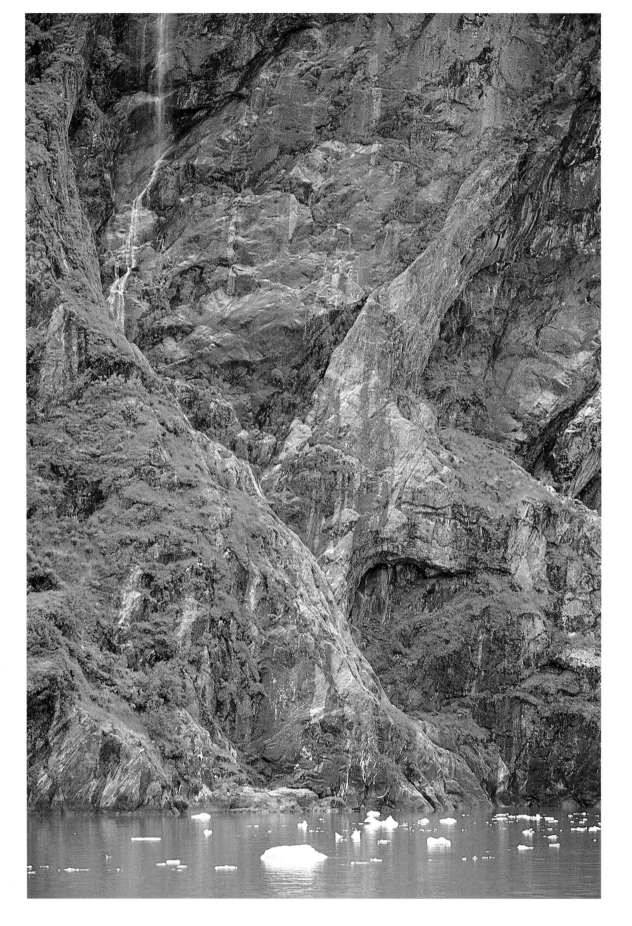

Fiord wall

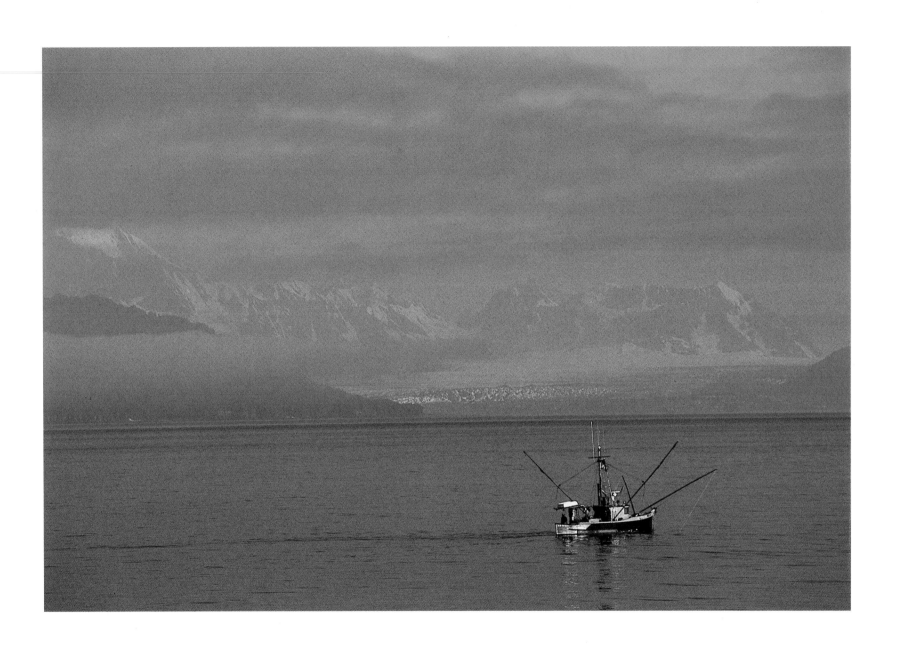

"Long-liner," offshore of the Fairweather Range 55

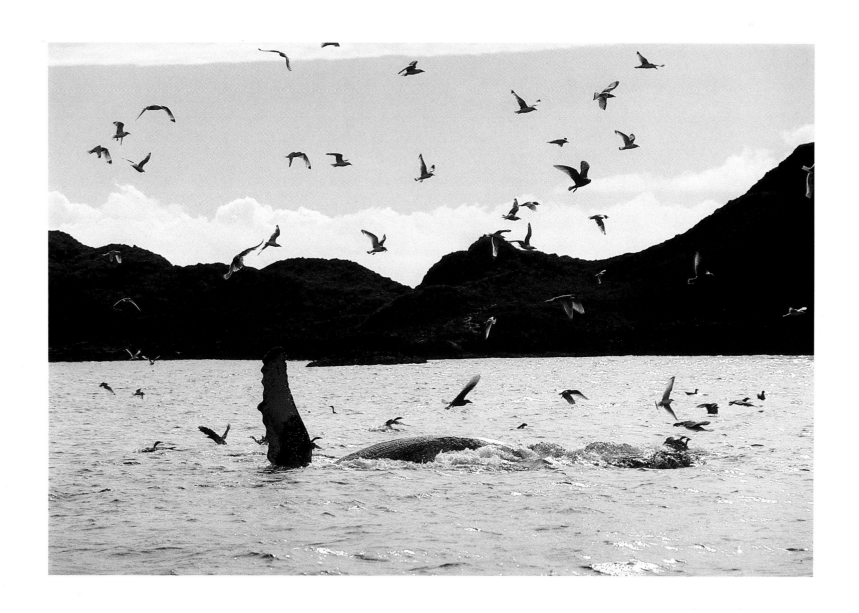

Whale feeding

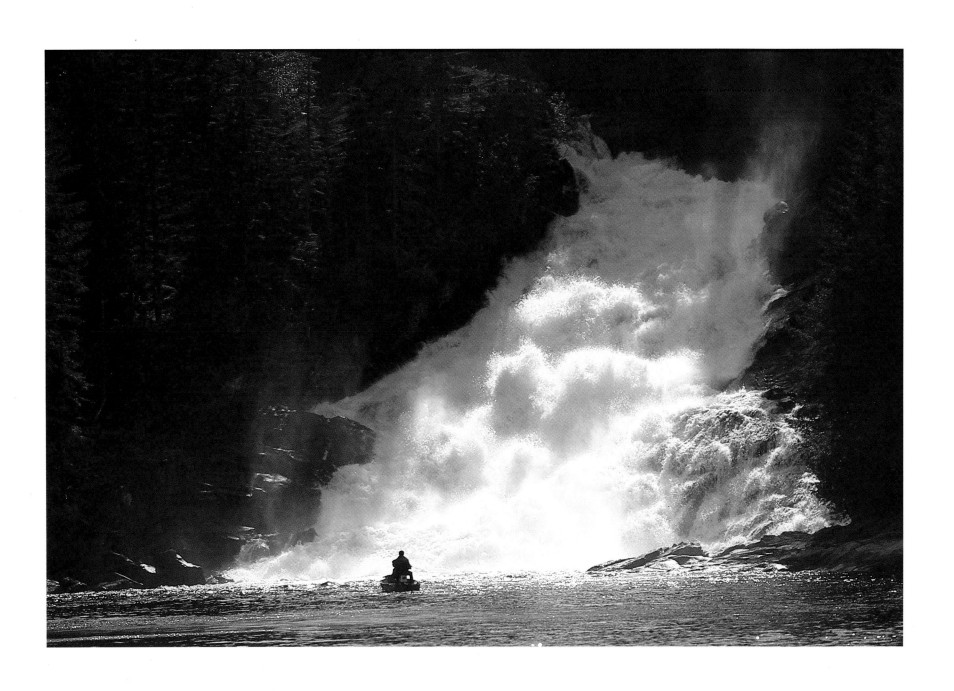

Fishing the falls at the head of Warm Springs Bay

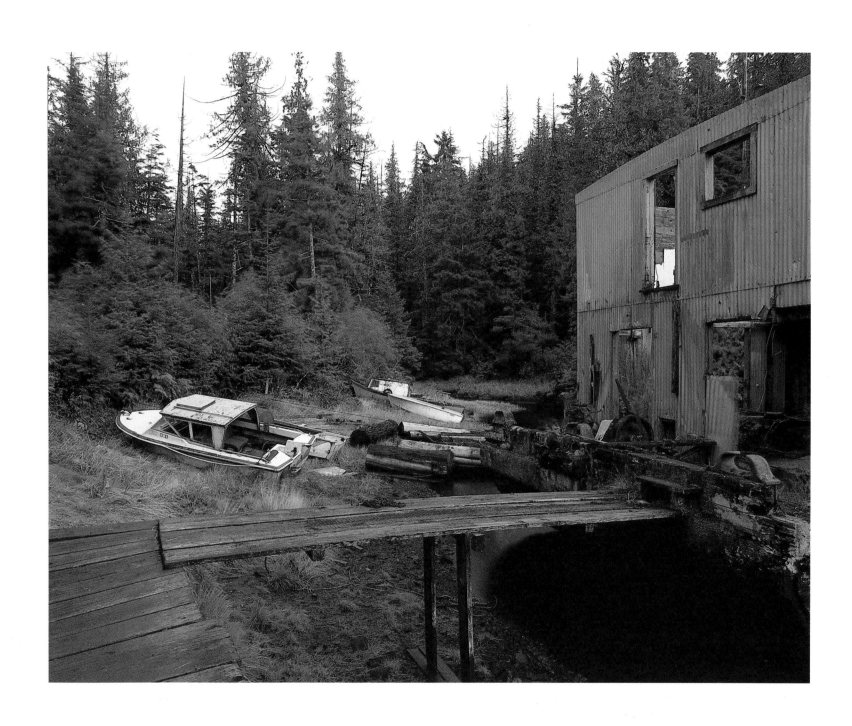

Abandoned boats, El Capitan Island

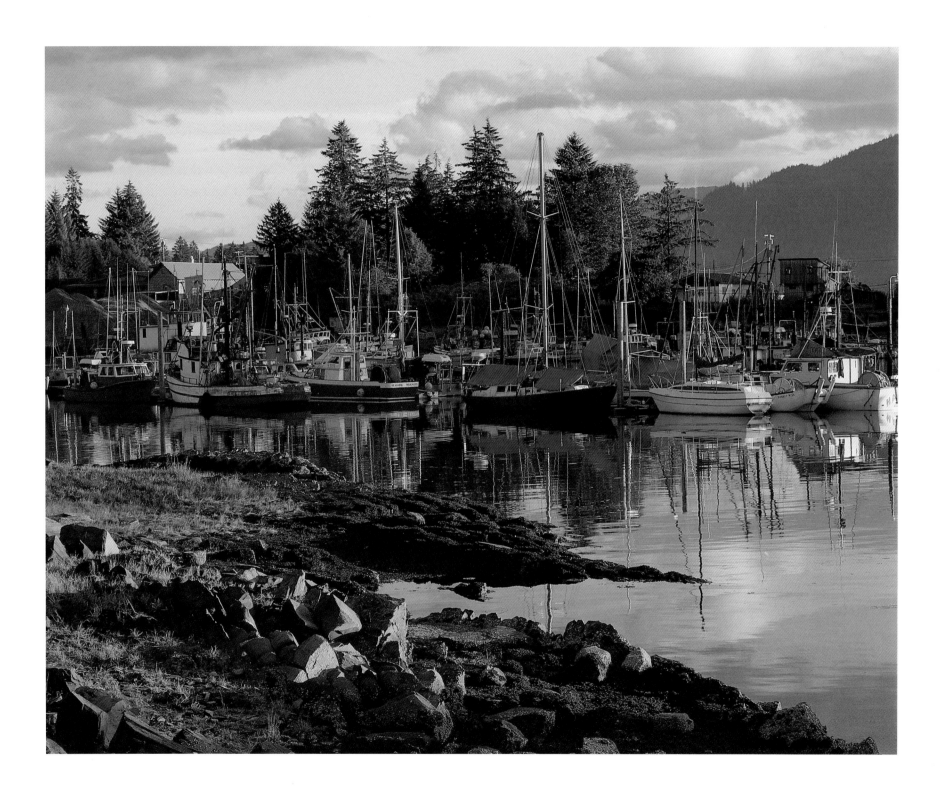

Wrangell

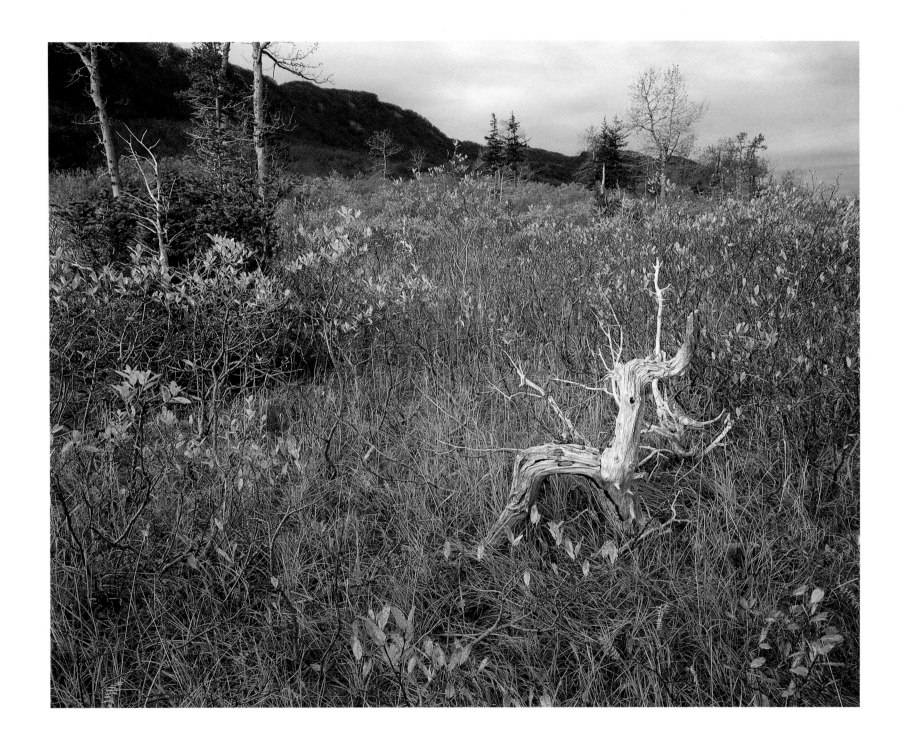

Club Yakutat

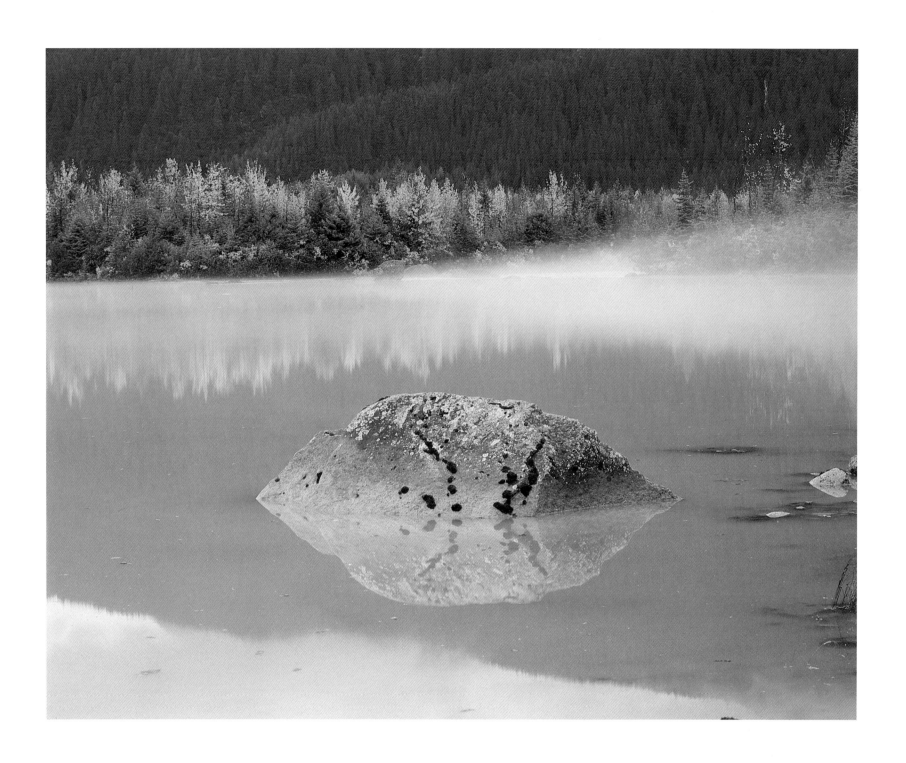

Mendenhall Lake

This immense green-and-blue world of channels, fjords, inlets, passages, coves, bays and straits looks as though it has just emerged dripping wet from the first separation of the waters at creation; in fact, it has only recently been freed from the embrace of glaciers that have withdrawn to the brooding heights of the mainland ranges.

Joseph Judge, 1975

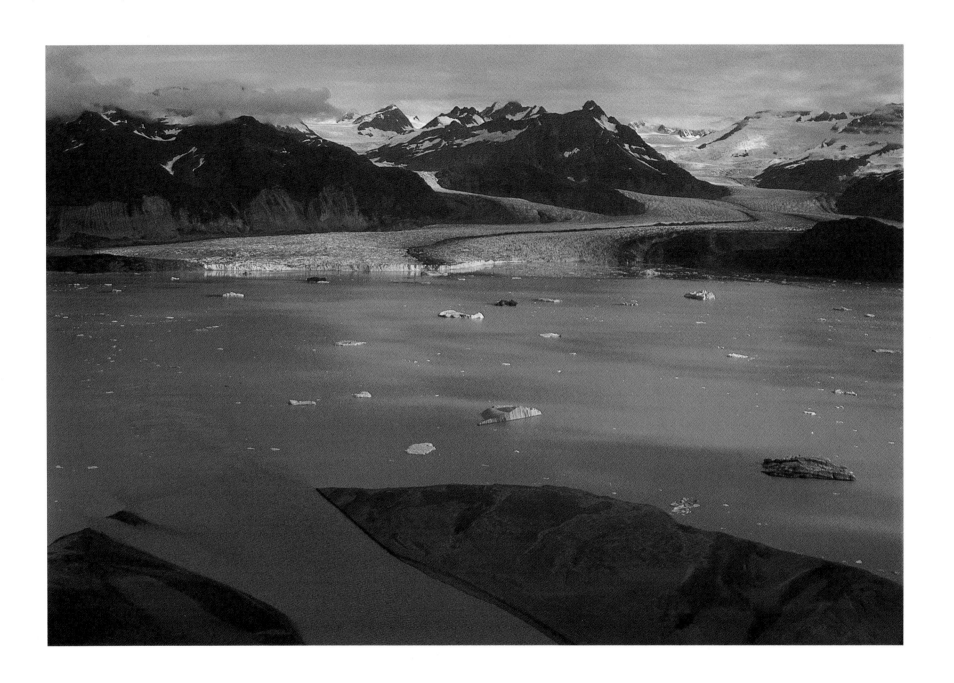

The Alsek River, Yakutat Forelands

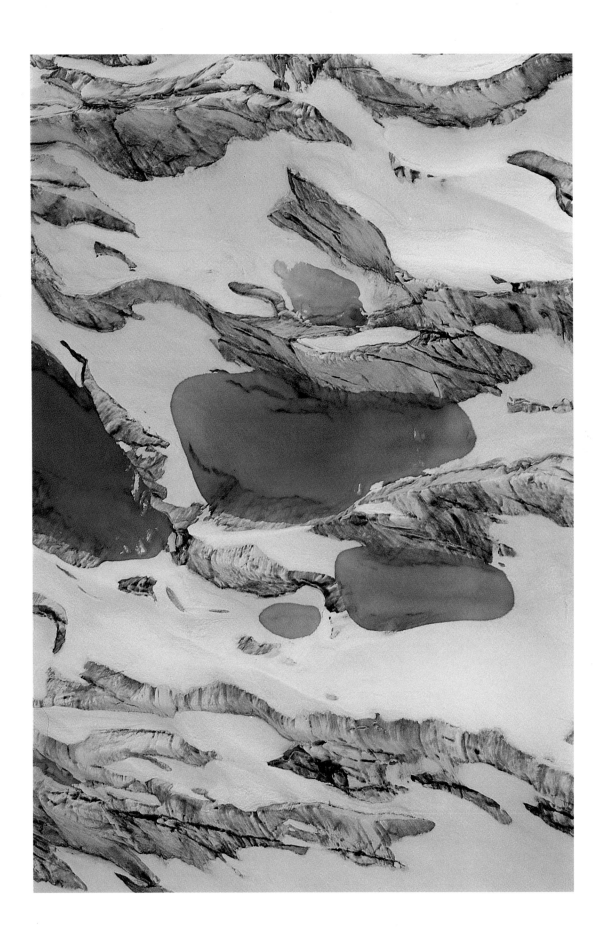

Blue pools on a glacier

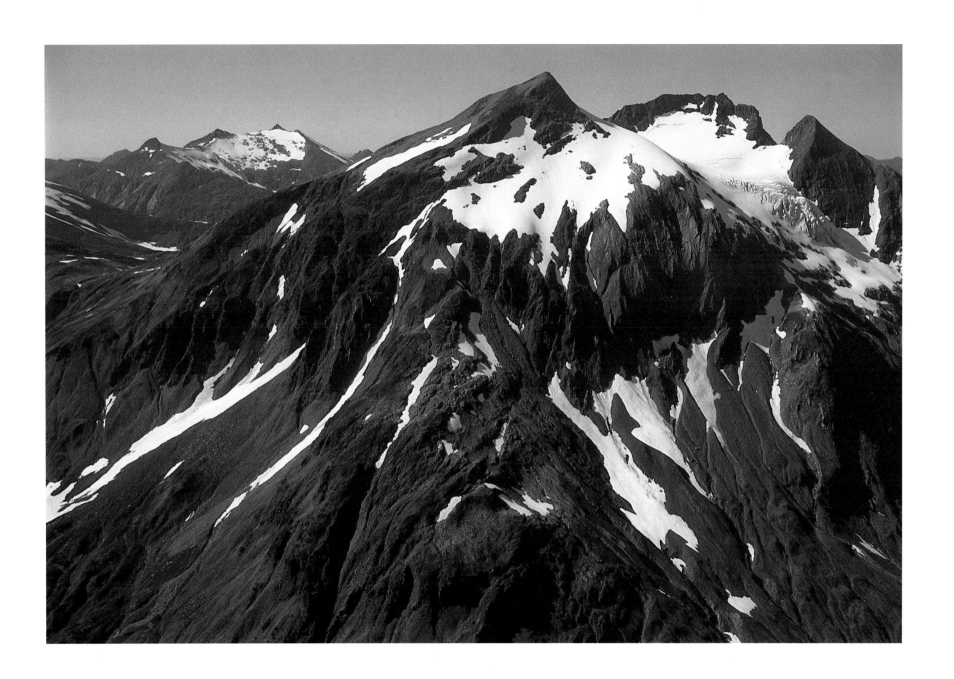

Alpine summits, Baranof Island

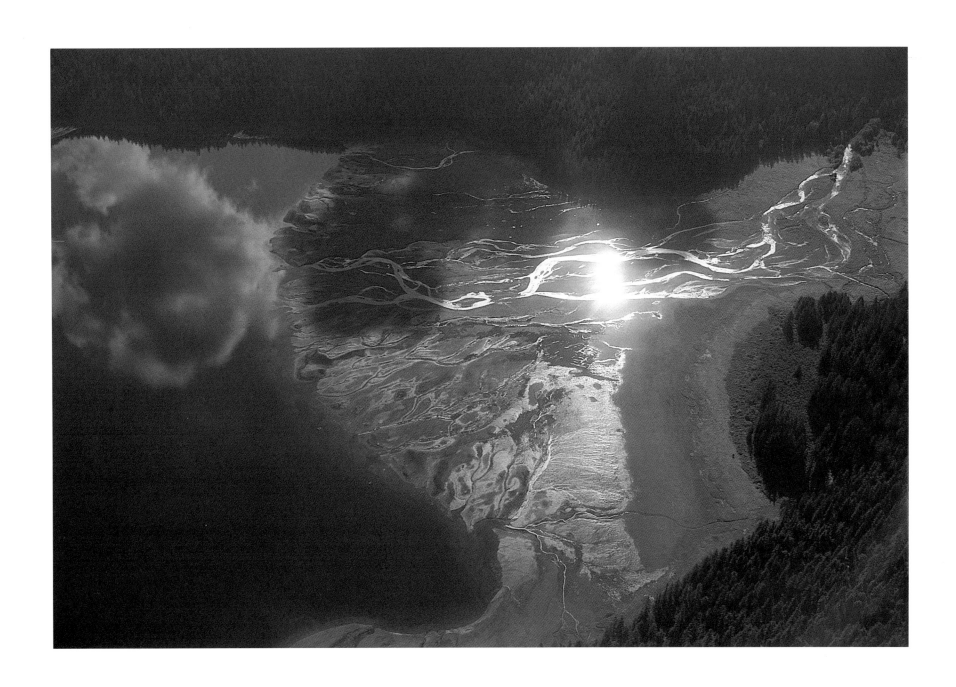

River delta at low tide, Admiralty Island National Monument

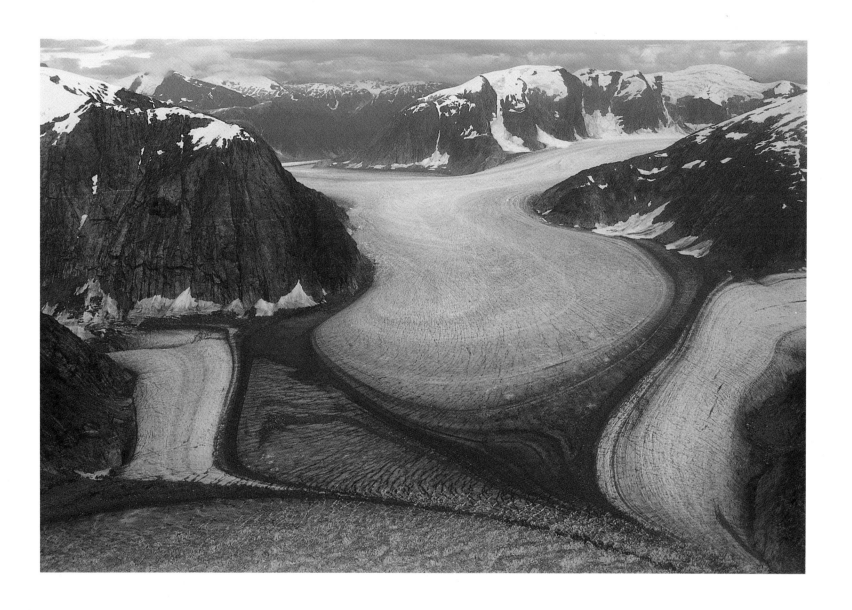

Le Conte Glacier

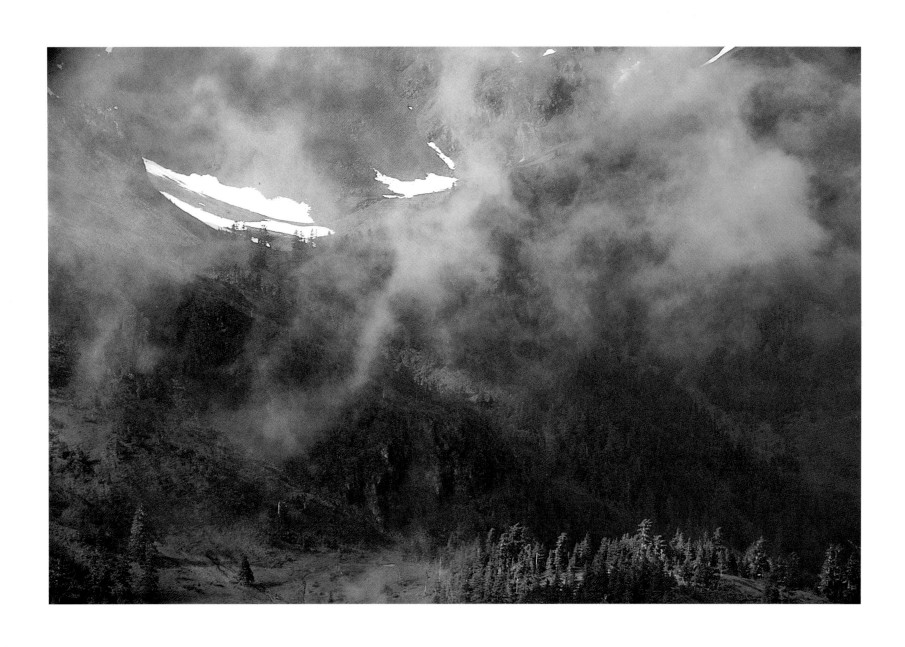

High alpine basin, Admiralty Island National Monument

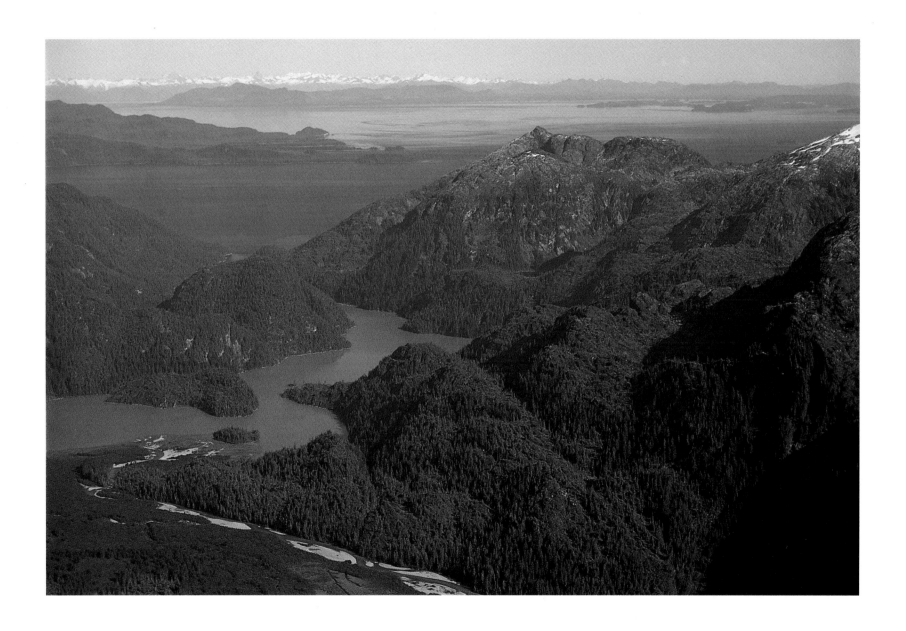

Baranof Island, looking east

The Forest for the Trees

THE TONGASS is a precisely interlocked system. The alteration of one facet of it often affects many or all of the other elements in the total ecology and economy. Present forestry practices are primary agents of such change. They are integrally connected with habitat, wildlife and fisheries management, and the lives of the human residents. It is necessary to discuss their implementation in great detail in an attempt to understand the motivation behind the present direction of the timber industry. Also, many of the decisions made by the Forest Service are grounded in a philosophy of purpose that is as old as the agency itself, and so this retrospective view will put its current planning in a more understandable light.

The harvesting of timber was an essential part of the European colonization of North America. The American Indians, who were predominantly hunters and gatherers, had practiced only limited agriculture. But the settlers of New England, who depended on farming as a food source, almost immediately began clearing the forest to accommodate fields. Beside opening up the land to planting, the felled wood built houses and heated them. Wood was also essential to the construction of ships.

By the early 1800s, the new country was rising from a foundation of wood on which cities were built. With the demands of the growing population, lumbering developed rapidly, expanding west and south from New England. The history of the timber industry in America is documented by the migration of it from one forested region to another. When productivity of the immediate resource began to decline in the Northeast, the white pines throughout the Great Lakes region and the hardwoods of Appalachia were exploited for market. Their demise shifted the concentration of cutting to the South, where the great belt of long-leaf pine stretched from Virginia to Texas. By 1920, most of that was also depleted. In search of new product, the business of forestry turned to the Pacific Coast and the Inland Empire, as the Rocky Mountain states were then called. Eventually, those reserves diminished too, and again the industry migrated, this time to the Pacific Northwest, one of the areas of its specific concentration today. From there, the vast forests of Alaska's panhandle were just a short jump away, and they were inevitably included in the goals of timber development.

Through the 1800s and into the first part of this century, most Americans viewed all of this forest-management activity as being in the interest of the developing nation. Only a relative few thought of it as destructive. Nowhere is this attitude more clearly personified than in Gifford Pinchot, the first chief of the Forest Service. In the early 1900s, a rift began to develop between the conservation factions, which supported complete preservation, and those who were committed to utilizing natural resources for the long-term needs of industrialized society. Pinchot was the voice of the latter, and his newly created position allowed him to wield substantial influence to futher the goals of the Forest Service, pertinent to society's needs as he saw them. He frequently referred to the national forests as "tree farms" and "wood factories" and persuasively argued that the responsibility for their management should be removed from the Department of the Interior and transferred to the Department of Agriculture, whose attention could most appropriately be directed toward trees as an agricultural commodity. His success in this regard helped to write the underlying principles of the Forest Service and defined their purpose as production management rather than the maintenance of steady-state systems.

At the upper management levels of the Forest Service today, the impact of this initial ideological bias is now manifest. Those making the decisions view forests exclusively as tree farms with little regard for understanding them as natural ecosystems. All too often, their fields of discipline, such as engineering, are remote from the objectives of protecting and preserving the public lands for sustainable multiple-use purposes. The dissociation of these federal stewards of public properties furthers the original dichotomy of preservation versus commodity development, and over time the Forest Service has aligned itself more closely with those it should regulate than with those it is supposed to serve. Supreme Court Justice William O. Douglas, in his 1972 minority-opinion brief regarding a Sierra Club suit aimed at the proposed Disney recreational development of California's Mineral King Valley, stated that the Multiple Use and Sustained Yield Act of 1960 provides that

[in making balanced management decisions] competing considerations should include outdoor recreation, range, timber, watershed, wildlife and fish purposes. The Forest Service, influenced by powerful logging interests, has, however, paid only lip service to its multiple use mandate and has auctioned away millions of timberland acres without considering environmental or conservational interests.

In that same brief, Justice Douglas offers the following opinion.

The federal agencies of which I speak are not venal or corrupt. But they are notoriously under the control of powerful interests who manipulate them through advisory committees, or friendly working relations, or who have that natural affinity with the agency which in time develops between the regulator and the regulated. . . . The Forest Service—one of the federal agencies behind the scheme to despoil Mineral King—has been notorious for its alignment with lumber companies, although its mandate from Congress directs it to consider the various aspects of multiple use in its supervision of the national forests.

A classic example of this kind of influence was beautifully understated by Darrel Tracy, a landscape architect working on one of the planning committees of the USFS in the Tongass, in an interview given to SEACC and published as part of a brochure entitled "The Tongass Timber Problem":

It was interesting that during the process of working on aerial photos, the Forest Service had borrowed a logging engineer from ALP [now called APC] who helped us with the technical aspects of making the areas loggable. Planning was done in a kind of "assembly line" where all the resource specialists involved in the plan would indicate their particular concerns on the map and the group would then come up with a relatively acceptable plan. But the ALP engineer was at the end of the "assembly line" and he would make recommendations to make logging easier. We argued, but he made the final decisions—though the Forest Service won't admit it.

It seems clear that the current political and environmental conflicts of the USFS in Southeast over the management issues of the Tongass are but a continuation of policies that have long been recognized as biased toward the timber industry. It should come as no surprise that what is being done with the resources of the Tongass elicits wide criticism from those who see alternative uses as more valid. Many living in Southeast feel especially exploited by the federal government and major industries that have only a small portion of their operations based in the Alaskan economy. Growing numbers of them are beginning to realize that these entities care little about the ultimate fate of the region other than as a tree farm.

Perhaps this affinity between the timber industry and the Forest Service also explains why the USFS does little to change its original goals in Southeast. Even in the face of a declining market, the Service has staunchly defended and maintained the unprecedented fifty-year contracts. This has resulted in increasingly sharp attacks on the USFS from an unlikely but growing coalition of diverse, and often opposing, constituents now united behind one cause—stopping the cut. The revisions of these contracts that have occurred have, for the most part, only proved more favorable to industry. Capitalizing on the economic downturn in the late seventies and early eighties, APC and LPK petitioned the Forest Service and received "emergency rate redeterminations" quite different from the terms of the original contracts. These changes reduced sharply the fees paid for the timber cut. For LPK the reduction was 96 percent, and for APC the fee on cedar and spruce was reduced 99 percent. For example, APC buys cedar originally appraised at $1,000 per thousand board feet for $1.22.

Perhaps what is worse is that the Forest Service continues this one-sided relationship with these two corporations after both have been found guilty of collusion and conspiracy in restraint of trade and commerce and actual monopolization of trade. The Forest Service's own lawyers concluded that the evidence in *The Reid Brothers* v. *Ketchikan Pulp Company* [LPK] *and Alaska Lumber and Pulp Company* [APC] showed that substantial material breaches of contract had occurred. Futhermore, using its own calculations, the Forest Service suspects that LPK and APC have cheated the Service out of $60–80 million by price fixing, double invoicing, and other deceptive and illegal practices. One quarter of these revenues would have gone to the State of Alaska. The Forest Service has pursued only a portion of these claims, and as the statute of limitations runs out the money will be lost forever. Still, the bond remains intact. The USFS continues to uphold the terms of the contracts, seemingly at all costs.

As must be apparent by now, the specific issues of management in the Tongass are as complex as the ecology of the forest. It is also a fact that to follow such convoluted arguments in depth requires endless research and a lawyer's grasp of the complete picture. Because of this complexity, the problems of the Tongass have remained clouded in the eyes of the public. Each grievance involved is a small text unto itself, and all of them together constitute volumes of literature, deep with statistics and figures that overwhelm the reader. Who but the most concerned and dedicated citizen could find the time to study and sort out all these issues and make an informed decision? The complicated situation is often ignored by the very public that might influence decisions.

We feel that the democracy of public participation in this planning has been subverted by the sheer weight of "facts" and the labyrinth

of terminology. So, in the remainder of this chapter, we would like to address only the most primary issues of disagreement in an attempt to make them more understandable. All these problems are closely linked with current management planning, and we think that comprehending them will make the Tongass situation clearer.

The Tongass Timber Supply Fund is one of the most controversial elements in this debate, because it finances much of the activities of the Forest Service, LPK, and APC. As stated in the Alaska National Interest Lands Conservation Act, Section 705:

The Congress authorizes and directs that the Secretary of the Treasury shall make available to the Secretary of Agriculture the sum of at least $40,000,000 annually or as much as the Secretary of Agriculture finds is necessary to maintain the timber supply from the Tongass National Forest to dependent industry . . . [and] such funds shall not be subject to deferral or recision under the Budget Impoundment and Control Act of 1974, and such funds shall not be subject to annual appropriation.

The last clause, an amazing precedent, exempts the Timber Supply Fund from annual congressional review and makes it not subject to deferral by the administration, something true of no other federal expenditures, including those for national defense. But, more importantly, the USFS has taken the meaning of the measures and conformed it to the agency's own intentions. In defining the purpose of the Fund and the reason it was drafted in the first place, Representative Morris Udall (Democrat, Arizona) stated in 1980:

Our intent is to encourage retention of old-growth forests for multiple-use considerations, rather than reduce old-growth retention in order to lower costs. . . . It is our intent to maximize protection of environmentally sensitive areas, particularly those with high fish and wildlife values.

Clearly, his words underscore that the purpose of the Supply Fund was to reduce high-volume-logging pressures on old-growth habitats. The measure was meant to protect those environments for uses other than logging while compensating the industry by subsidizing the development of more marginal timber supplies that might require additional road construction or other investments because they are harder to reach and of lower value.

The Forest Service has been using a substantial portion of this money as an unrestricted source for funding roads that have nothing to do with marginal timber stands. It seems determined to develop a land-based transportation system in Southeast, and the Fund is footing the bill at the expense of the very habitats it was established to protect. Since the passage of ANILCA, the Forest Service has projected the building of nearly three hundred miles of roads every year in unprotected drainages, most of which are to be along prime river bottoms. It annually spent more than $8 million of the Timber Supply Fund through 1985 to plan and design timber sales that did not sell. Since 1982, when the Timber Supply Fund was fully implemented, the Forest Service's expenditures for the timber program have amounted to $287 million and returned only $3 million in stumpage fees, a loss of $284 million. Even including other monies the Forest Service could consider as receipts to the Treasury—approximately $31 million—the loss still totals more than $250 million. This amounts to a cost to taxpayers of about $50 million annually since ANILCA. The USFS itself estimates that the timber program in Southest will lose $2–5 *billion* in the next five decades.

These spending practices lead to the next controversial facet of Tongass management—roading. The United States Forest Service builds and maintains more miles of road than any other agency *in the world*—all with taxpayers' dollars. Furthermore, it has either built or allowed private interests to build nearly 350,000 miles of road on the public's national-forest lands. This is eight times as many miles of road as exist in the entire Interstate Highway System. The development of the road network in the Tongass is just an extension of Forest Service planning that affects all of us on a nationwide basis. The worst part is that in many instances in Southeast there is no justification for the roads. One Forest Service official who wishes to remain anonymous, asserted, ''There's unwritten Forest Service direction to put roads or clear-cuts in every available roadless drainage by 1990.'' In that year, the Tongass Land Management Plan will be revised, so obviously the mandate is to get the roads in before anyone can alter the plans through the review process.

Preroading is an especially unusual application of the Tongass Timber Supply Fund and one of the USFS development strategies that draws the greatest criticism. The stated justification for the placement of the roads is that they will be used by the industry to gain access to timber. Elsewhere in the country such roads are built in conjunction *with* timber sales, but in the Tongass roads are often constructed *in advance* of timber sales, with the Forest Service paying entirely for the project with monies from its management budget. Many of these preroading efforts create networks of connections that lead only to unmarketable timber. Others push into high-value habitats and drainages such as the Kadashan River and thus ignore

the intention of the Timber Supply Fund's stated purpose.

The Forest Service's own research recognizes the Kadashan as one of the most important drainages in Southeast, supporting a significant bear population and a tremendous spawning habitat for three kinds of salmon. The preroading here is especially curious because the USFS could have avoided the Kadashan entirely. The agency has said that the road's purpose was to provide access to certain distant logging areas, but those they cited could have been reached using existing networks with only three additional miles of construction needed to connect them. Instead, the Service spent a large sum of money adding fourteen new miles of road which terminates in a $130,000 bridge to nowhere. All of this is within the Kadashan drainage. When an injunction finally stopped the progress of the extension, the USFS had to pay the contractor several thousand dollars every day "not to build." As of early 1987, the courts still had not reached a decision about the continuation, so no further work has yet been done. The Kadashan is but one example of many in the planning for Southeast. Portions of Hoonah Sound/Peril Strait, Tenakee Inlet, Chuck River/Windham Bay, Woewodski Island, Cleveland Peninsula, and numerous locations on Kuiu, Kupreanof, Revillagigedo, and Prince of Wales Islands will all be subject to similar preroading if this policy of development and expenditure is not stopped.

It is certain that some roads are used for logging. It is equally clear that some roads are completely unnecessary. The question that should be asked is who will maintain all of them after the timber has been taken out and how much it will cost. Because logging operations plan to make reentries to given areas when rotations occur in the cutting cycle, some of the road system will survive, but less than half the network will be used for this purpose. What happens to the rest? Jim Caplan, director of public affairs for the USFS in Juneau, told us that a portion of the roads would be transferred to the state of Alaska to become part of the statewide transportation plan, but he also admitted that the state could not possibly maintain all of them because of budget constraints, so some would just be let go. He neglected to point out that it is very expensive to take roads out once they are in place. In light of the current fiscal problems of the state because of declining oil revenues, it would seem that quite a few more than "some" will lie fallow. In an increasingly high-impact scenario, unmaintained roads in a region that sees so much rain every year quickly become choked with alders and cut with washouts. They act as nothing more than erosion corridors through the forest, from which the sediment silts up the spawning streams, damaging them and making them less productive. It should be noted that the expenses of road removal and the losses to commercial fisheries are never included in the USFS cost/benefit analysis of the timber sale plans.

Discussing these problems, Richard Billings, a former USFS watershed-program manager, stated:

There's going to be a high environmental price to pay for the construction of mid-slope roads (leading to ridge top roads). Road construction on slopes under 30% is an "overlay" which creates stable roads. Above 30%–35%, you have to cut into the slope and fill to make a balanced design. This decreases slope stability and the drainage regime of that slope.

The steeper the slope gets, the greater the instability. Any roading or clearcutting on those slopes is going to result in negative impacts—landslides, for instance, which means real trouble for fish streams.

But to get the timber out, they're needing to go to midslope roads, and the cost will be high. It'll be felt 7 to 10 years after that road goes in. When root strengths fail, the slides begin. There's only a certain amount you can do to mitigate these problems.

In an inter-office memorandum between two supervisors of the State Department of Fish and Game who wish to remain anonymous, one has been reviewing a USFS management plan draft and reports to the other that,

In general, we find that the Forest Service has tended to gloss over problems inherent in the Region's timber industry while maximizing social benefit implications. . . . Perhaps it's time for the Department to take a firmer stand in fulfilling its legally mandated obligation to protect and conserve Alaska's fish and wildlife resources. . . . The F.S. implies that pre-roading is occurring only in areas containing marginal timber, which is totally incorrect; many of the Region's prime timber/habitat areas are being pre-roaded or have been proposed for pre-roading. . . . The F.S. admits to "adverse effects of timber and other resource development activities on wildlife and fisheries." . . . Missing in the discussion and the table is the realization that the timber in a particular area is harvested just once. The value of the fish in a particular drainage probably, in all cases, vastly exceeds the value of the timber, especially when considered over a hundred year rotation [of cutting]. To risk the loss of the fish for a questionable short-term timber harvest gain should be scrutinized.

Particular note should be paid the phrase "maximizing social benefit implications" cited in this memo and used by the Forest Service in their report. In a typical summary, the USFS will suggest that the roads are for the benefit of the greater public, giving them access. But, in fact, many of the roads do not provide good public access because they are designed primarily for logging operations, and they are very roughly finished. A perfect example is a road proposed for Berners Bay, a prime recreational area for the residents of Juneau. The road was touted as giving users greater access to the resource, but then 1,200 acres of that resource were going to be clear-cut. It is unlikely that the location would have continued to have much recreational value after such impact; but more to the point, the twenty-six-mile road proposed would have been only fourteen to sixteen feet wide, about one lane. Upgrading it to minimum safety standards would have doubled the price from $5 million to $10 million.

Also, these roads regularly threaten to connect towns that wish to remain isolated and strenuously object to such connections. This is one of the most protested parts of USFS plannning, and one that irritates local people in small communities the most. We have mentioned several locations threatened by anticipated road completions, but clearly the most aggravated constituency is the village of Tenakee Springs, which has been fighting such a road intrusion in the courts and by petition for ten years. In a classic confrontation between citizens and USFS personnel, a Forest Service official at a Tenakee Springs public-comment meeting defended the administration's position by saying that his obligations went beyond the community "to the nation." As SEACC perfectly summarized when writing about the comment, "If the Forest Service has advance word of a national need to drive to Tenakee, we ought to hear more about it." The bitter irony of the Service's attempt to force these roads on small, isolated Alaskan communities that don't want them is that elsewhere American cities and towns are begging for federal funds to repair disintegrating highway bridges and repave roadways that are eroding from heavy use.

Moreover, all this is being done at the expense of other programs the Forest Service could carry out with its allotted funds, programs that would provide for greater public use and recreation and certainly cost fewer tax dollars. In 1984, the agency met only 24 percent of its national goals for trail construction, 34 percent of those for wildlife-habitat improvement, and 28 percent of those for soil and water-resource improvement. In contrast, it met 98 percent of its timber goals, and *140 percent of its goals for road construction.*

Another serious conflict of opinion exists regarding how large an annual allowable harvest the forest can sustain and what trade-offs will accrue relative to other resources. Old growth is a forest that has reached a mature steady-state condition and provides greater habitat diversity than younger forests. However, old growth is highly variable with some stands having small, low-quality trees, while other stands which grow on productive sites contain large, tall trees. Considered the most commercially valuable, these latter stands are referred to as high-volume, and in the Tongass they are relatively uncommon. They lie not only at the heart of the forest but also at the heart of the entire forest-management controversy. The current board footage the USFS suggests can be removed from the Tongass with "no significant impact" is at the center of a heated debate. Most critics feel that not enough high-quality commercial timber is there to sustain the goals, and that any attempt to meet such volume demand would exact a very high price, ecologically, from the forest.

In complete resistance to these suggestions and using their long-term-contract commitments as the whip, the industry and its congressional allies have pushed the Forest Service planners and managers to the wall in order to meet the demand. When the contracts were first signed, much of Southeast was not yet "selected," but when the state and the Native corporations withdrew a large part of this particular land base it significantly changed what was available. The state and the Native corporations both selected lands that contained substantial quantities of timber with commercial value. As those subtractions from the overall timber availability occurred, the USFS found it difficult to meet the goals of the fifty-year contracts. The agency's response confirms its intention to continue to cut at all risks in order to accommodate the contracts, rather than to revise the contracts based on a realistic assessment of what is available, incorporate broader planning uses requested by the public sector, or to cancel the contracts outright. Concern that these goals of timber extraction are unreasonable is expressed frequently, and often from sources acting as advisers to the Forest Service. Cynthia Croxton, a USFS forestry technician, sums it up nicely: "People in the field try to protect the other resources, but they have handicaps, the greatest being the volume of timber they had to cut. On the four major sales I worked in laying out, there were always marginal areas where we found ourselves saying, we shouldn't really be going near this wildlife corridor, or, we shouldn't be cutting on this slope, or, we shouldn't be anywhere near this stream. But the cut was considered all important.

"The decision making process is compromised by the demand to cut timber in such high volumes. Everyone I spoke with who had field experience agreed that the cut was too high to allow for pro-

tection of other resources."

Don Williamson, a former USFS wildlife biologist, observed, "The only thing I can say about the 450 million board foot cut is that the timber is not there. Everybody knows it, but the FS won't admit it publicly. I think a long-term management plan would verify it, and I think that is one of the reasons a long-term plan has been avoided. I know that the timber people working on the '81–'86 ALP plan, checking the photos against what they found on the ground, would say that the timber wasn't there."

Only 4 percent of the Tongass is considered by industry to be commercially useful, and, of this, the highest yield in board feet is found in high-volume, old-growth stands along low elevation drainages and river bottoms. In light of growing pressure to stop the cut and protect these areas, industry and the USFS are pressing to get the most timber out as fast as they possibly can, and these areas have become the victims of the intended goals. The USFS is allowing the contractors to "high-grade," concentrating cuts only on these areas because they have the greatest commercial value and highest board footage. In doing this, the agency has abandoned the original conditions of the Tongass Land Management Plan and the Environmental Impact Statement determinations, citing the failing timber economy as the necessity that dictates such alterations. The truth is that the industry wants to maximize its profit and has little concern for environmental-impact considerations or long-term sustained yield/multiple use.

The Forest Service personnel in Southeast, in order to continue their in-grade promotions, are under terrific pressure to meet the "targeted goals" of the agency. A consequence of this pressure significantly affects the factual research used in making decisions. In the words of a professional biologist employed by the state of Alaska who asks anonymity: "In Alaska [national forest management] is extremely political. I can't think of anywhere else, except for a few small isolated areas, where there is so much political pressure on the forest managers. And so what you have is a situation where biologists' reports, biologists' assessments, specialists— whether it's soil scientists or hydrologists or whatever they are— their assessments are very carefully edited by the line officer who may or may not have the expertise to do that. And where the results are not acceptable with the party line, they are either edited or deleted. There are a number of occasions where wildlife or fisheries specialists have quit after long-term involvement with the planning process, simply because their standards were compromised so many times that they just gave up in frustration." We were also told by this same person that he had his own reports treated in this way by

his state department because some of his conclusions would have "created problems" for the USFS.

Forest Service policy is not the only cause of this pressure, however. Historically, the state has exerted powerful pro-development pressure on all its agencies. Under this influence, the Department of Fish and Game has never strongly challenged the Forest Service on its management practices, even when research demonstrated conflicts of interest between logging and the department's mandated purpose to protect wildlife and habitat resources. This was especially true under the administration of Governor William Sheffield (1982–86). Senator Ted Stevens and Representative Don Young have always been recognized as powerful friends of the timber lobby. What is under way in Southeast is not only a highly debated forest-management plan but also a controlled-information campaign. The USFS uses substantial money from the taxpayers to thoroughly research all of the possible effects of management on the forest system, and then shelves research that does not accommodate its preconceived intentions. Perhaps worse, it also uses tax dollars to defend those decisions. This process costs the public, literally, and robs the public and others reviewing the material of the complete facts.

At the core of all forest/habitat issues is the value of preserving old growth and its associated ecological values, as opposed to logging it for wood fiber and timber. The USFS front office and the public brochures it generates would have you believe that with good management, old growth can be replaced. Apparently, however, many of its own biologists disagree and have done so for years, but the objections seem to be falling on deaf ears. The Forest Service-APC 1986–90 planning-process draft cost close to $2 million and took countless staff hours over a five-year period. This effort was also augmented by private citizens and other federal and state agencies, but the result is still clearly industry biased and ignores many of the finer research points that these combined advisers contributed.

It is difficult for most of us to appreciate how completely different a second-growth forest is from an old-growth forest without first-hand experience or pictures to compare them, such as the ones on pages 34 and 35. Most of us who live in the Lower Forty-eight think of forests with trees up to two hundred years old as old growth, but they are not. In fact, many of them are second- or third-growth stands. The mature old-growth forest of the Tongass, by contrast, has great numbers of trees that are three hundred to a thousand years old, and the complex ecosystem that is characteristic of such stands also needs considerable time to become established.

The paucity of old growth nationwide has limited research; except for the Tongass and a few other sites, there is little old growth left

in which researchers can make firsthand observations. For this reason, eminent research biologist Olaf Wallmo came to Juneau in 1976 to study the relationship of Sitka black-tailed deer to the Southeast forest. He was later joined by biologists John Schoen and Matt Kirchhoff of the Alaska Department of Fish and Game, and the three worked together until Wallmo retired in 1980. In a paper written by the three and issued in 1984 on their research on old growth, they succinctly summarize the impact of logging on habitat, especially as it relates to their study species, deer: "In southeast Alaska, deer and timber production cannot be maximized simultaneously on the same area. Even moderate timber harvesting can have adverse effects on deer in a greater proportion than the area harvested if particular forest stands [high-volume old growth] are harvested. . . . Whatever approach is taken to maintain habitat for deer and other fish and wildlife on the Tongass National Forest, major trade-offs are inevitable if the proposed level of nonrenewable old-growth habitat is extracted from the forest."

In "Old-Growth Forests: A Balanced Perspective," a paper presented to a scientific panel considering the potential of re-creating old-growth wildlife habitat characteristics in young second-growth stands, Wallmo pointed out that only 2 percent or less old growth was left in all the United States. He concluded that it should be preserved for its uniqueness and scientific value, and said, "For this conference to offer an honestly balanced perspective, it should consider the probability that any effort to exploit, then re-create, old-growth forest ecosystems will fail to restore their original ecological identity within the foreseeable future."

This position is also held by the Society of American Foresters, a professional organization for foresters in North America. One of its publications on management of old growth acknowledges that it is nonrenewable and states that "the best way to manage for old-growth is to conserve an adequate supply of present stands and leave them alone."

Experience indicates that in some cases it is possible for selected wildlife and forestry to coexist, but this does not appear to be the case for old-growth forests in coastal Alaska. Here the animals have evolved within a unique biological system and their survival is inseparably involved with this, *and only this,* kind of forest habitat. Sitka black-tailed deer, bears, and martens are particularly vulnerable to the removal of old growth. Deer are especially dependent on old-growth stands in winter because the protective cover helps to provide forage. The consistent high-grading of old growth is rapidly eliminating this important survival habitat and in turn wildlife populations will decline. The Forest Service has suggested in public hearings

that increased deer populations can be found near clear-cuts. What is ignored in this statement is the long-term, cumulative effect of the cut on the continued existence of those populations. While it is true that forage is abundant in clear-cuts during the summer months, snow accumulation during the winter makes this food source inaccessible.

The USFS and industry often assert that the rapid rate of regrowth in a clear-cut is a barometer of success for the management program. We were often told that the trees come back so quickly and so densely that after forty years it is hard even to get into the forest. Such regrowth may be fine for tree farming purposes, but it is devastating for most wildlife. This thick regrowth and the accompanying slash left from the previous cutting makes such an area difficult, if not impossible, to navigate by both man and animal. In fifteen to twenty-five years, the dominant conifers emerge from the regrowth and form a dense, dark canopy over the forest floor. These trees, all approximately the same height, are referred to as *even*-aged. Although wildlife can now return and move about, sunlight cannot penetrate to the forest floor, and consequently there is no vegetation for deer to feed on. Scientific evidence indicates it would take more than two hundred years for forest succession to return the stand to a condition that would support current populations of deer and other animals. Such recovery times invalidate the mistaken premise that logging will not impact wildlife because, under current plans, all of the cuts will be re-entered in a hundred-year rotation cycle and be cut again. This planning, in disregard of the research evidence, negates any hope for the successful reestablishment of species that are lost to clear-cutting activities.

The USFS has established numerous programs that attempt to recreate old-growth conditions in second-growth stands and rehabilitate spawning streams damaged by logging practices, but these, too, draw considerable criticism and are seen as ineffective. Thinning, for example, attempts to reduce regrowth density by the removal of select trees, thus allowing more room for animals and preferred tree species. Some thinning cuts are also being used to experiment with the establishment of corridors through the regrowth for wildlife use. LODing is a term applied to the placement of *l*arge *o*rganic *d*ebris, such as branches and stumps, into a stream that has been impacted, in the hope of stimulating the reestablishment of natural conditions. Both of these experiments, as well as many others, are expensive, and many feel that they are just further programs to justify increased USFS personnel and budget requests. No doubt such research is valuable, for its results may suggest how we can ultimately rehabilitate what has already been cut, but because this

research is ongoing and as yet unproven, it should in no way be used as justification for further destruction of old growth.

The 1985 position statement of the Alaska Chapter of the Wildlife Society summarizes the value of old growth as opposed to enhanced second growth most clearly: "Clear-cutting replaces diverse, uneven-aged stands having high habitat value, with clearcuts and even-aged second-growth stands of low diversity and low value for many wildlife species. Based on present knowledge, it is not possible to significantly enhance second-growth for wildlife; 200 to 300 years are needed for second-growth to acquire old-growth characteristics naturally. Old-growth is essentially a nonrenewable resource."

Perhaps at the core of all of these controversies regarding old growth is the overall perspective with which the Forest Service views this particular part of the forest. Biologists and others studying old growth feel that it is the fruition of a long evolution that has finally reached steady state—the point at which it will sustain itself in this form forever, barring major environmental changes. At the opposite extreme, USFS public-relations brochures displayed and handed out freely in airports and on ferries, as well as many other locations, often refer to old growth as overmature trees and suggest that the Tongass is an old forest that is dying. Various USFS papers have referred to the "collapse of old-growth," and imply that the trees are being wasted if they are not cut. This phraseology has also been used by protimber Alaskan politicians, who have argued that the trees are rotting away in the forest and need to be put to good use so that the value of the resource is not lost.

We hope that through all this the reader can also detect a certain attitude on the part of the USFS, implied by its position on these issues. We would best describe it as arrogance, and we feel the attitude permeates the agency's policies because it assumes to edit its own scientists and talk down to the public as though we were incapable of understanding these issues. We spoke with the USFS public-affairs director Jim Caplan just after the *Reader's Digest* published an article about the Tongass entitled "Time to Ax This Timber Boondoggle." The Forest Service was stung by the criticism and was particularly upset that so many people would read the magazine, so Caplan worked very hard to discredit any sources of further negative critical information with whom we might have spoken. To support USFS policies, he assured us that the article was fraught with error and was irresponsibly published, and then he sought to refute numerous points we brought up as questions. He was very animated and personable, but in the end we realized he was treating us as if we knew absolutely nothing about the issues and he could tell us whatever outrageous thing he wanted to.

In response to our questions about clear-cuts affecting the deer population and subsistence use, he told us that "a lot of people" thought subsistence use was nothing but legalized poaching and that there were plenty of deer. He also referred to the "deer problem" as the "Bambi syndrome," saying that it was merely environmentalist propaganda. He suggested that the image of a skinny deer in a clear-cut was just being used by them as a manipulative tool to arouse public indignation. Coming from the agency that gave us Smokey the Bear and Woodsy Owl, this seemed especially amusing, but more importantly, because venison is an essential food source for many Southeast residents, we doubt that any of them think about Bambi when they have a deer in the crosshairs of a rifle.

When we turned our discussion to roading, preroading and clear-cutting critical habitats, we mentioned Point Baker/Port Protection and Tenakee Springs/Kadashan. Caplan suggested that we should question those communities' needs for isolation and cited the agency's problems in California with illegal marijuana cultivation on Forest Service land. We also brought up the salmon-habitat concerns of the Petersburg fishermen who see the Chuck River cut as threatening, and Caplan responded that those fishermen work sometimes for thirty hours straight, taking "who knows what kind of stimulants to keep going," and that their commentary should be considered in that perspective.

He concluded our talk by stating that southeast Alaska was a forgiving place and assured us that the forest regenerates quickly, swallowing up even large mistakes; if some of the theories the USFS was applying in clear-cutting proved to be incorrect, time would eventually heal those mistakes. Most informed sources believe that high-grading, destruction of habitat, and the ensuing complete alteration of the natural forest environment will cause damage that cannot be repaired for centuries, if ever.

It would be unfair to accuse all USFS personnel of holding such positions. We spoke with many who were direct and honest about these problems. A substantial number oppose the present management position but remain guarded publicly because they fear for their jobs. This is also true of many employees in other agencies with whom we spoke. Nonetheless, the problem remains that many of those in the most responsible and powerful positions within the USFS operate with such attitudes and are perpetuating the policies we have been discussing.

The following exchange between the former USFS manager of Admiralty Island National Monument, K. J. Metcalf, and then-Deputy Regional Forester David Hessel at a public forum in Juneau epitomizes the agency's administrative arrogance. Metcalf: "One

of the first stages in issue resolution has to be some kind of agreement on what the problem is. Am I correct, Mr. Hessel, that you say you see no major problem on the Tongass?'' Hessel: ''Yes, that is correct.'' It should be noted that Hessel was subsequently made director of timber management for the entire United States.

Beyond these primary subjects of debate are myriad lesser issues. Waste of cut logs is one. A statistic extracted from the Point Baker suit to stop the cut on Prince of Wales indicated that 39 percent of all timber harvested was left on the ground to rot, or lost from the log rafts during shipment to the mills. Now that the Native corporations have entered the market, their additional cuts, and timber coming out of Canada, have contributed more timber than the market can use, depressing the price. Because what they have cut is now not economical to take to market, it, too, has been left on the ground to rot. Logs that break free from rafts drift onto beaches, and the Forest Service estimates that near Ketchikan there is a hundred thousand board feet per beach mile. The agency also says it is not responsible for the logs because it just plans the cuts. The mills say these logs belong to the state because they are on the high-tide line. Yet when Chuck Johnstone of Sitka began salvaging them for the use of the residents, the mills moved in to claim them, citing the fact that they were marked with the mill's brand.

The failure of USFS programs to enforce complete incineration of trash in logging camps is also a source of criticism because such management efforts are essential if bear confrontations are to be avoided. The elimination of open-pit garbage and the burning of all refuse has proved successful. But some camps, such as Corner Bay in Tenakee Inlet, neglect this kind of maintenance, inviting roving bears which they then want to have destroyed as a ''control'' measure. Enforcement at this camp cannot be blamed on insufficient personnel because the USFS maintains an office there.

The weight of every Tongass issue falls on the shoulders of USFS regional personnel who are sent to Southeast in a kind of test by fire. A great proportion of these employees turns over every two years. This makes it impossible for them to ever get a complete grasp on the problems; it gives no continuity to administration; it frustrates communities that are hoping to establish working relationships with knowledgeable, long-term field representatives; it allows decisions to be quickly rescinded by the next generation of employees. Many Southeast residents feel that these shortcomings are intentional, aiding the Forest Service's attempts to foil their opposition to the planning process now under way.

By continuing unabated in its pursuit of the timber goals mandated by the fifty-year contracts, the Forest Service has created a fiscal and managerial firestorm around itself that is rapidly gaining national attention. In June 1986, Senator William Proxmire (Democrat, Wisconsin) gave his Golden Fleece Award jointly to the USFS and Congress. His press release reads, in part:

I am giving my Fleece of the Month for June jointly to the U.S. Forest Service for spending $51 million preparing for Alaska timber sales and to Congress, which makes them do it. Over the last five years the Forest Service offered for sale 2.36 billion board feet of the timber in Alaska's Tongass National Forest but only sold 43.7%, spent $116 million building 225 miles of new roads to service the sales, and lost on average 83 cents on the dollar for every sale they made.

Talk about a classic case of logrolling. The taxpayers get rolled while the timber companies get the logs. Only the federal government could defy the laws of nature by planting a pinecone and growing a deficit. These sales prove the government has truly gone nuts.

At Couverden in 1984 and 1985 the Forest Service spent over $5½ million putting in almost 30 miles of road and eight bridges in advance of a sale which drew no bidders. In Yakutat, the Forest Service built a ''bridge to nowhere'' across the Dangerous River where no timber sales have been offered or planned for in the near future. No road connects to the far end of the bridge. From the taxpayer's viewpoint this river certainly deserves its name.

It's time to reform the Tongass program.

Roads to Nowhere

THE PASSAGE IN 1976 of the National Forest Management Act gave the nation high hopes for a new era of Forest Service planning and operation. NFMA stressed long-range planning for our national forests, with emphasis on multiple use and clear guidelines for habitat protection. In a departure from custom, the general public was encouraged to participate in the planning. It was intended that official acknowledgment of the public's concern over the use of the national forests would ease the conflict between developers and preservation interests. Plans would be drawn site by site to take into consideration each area's special economic and aesthetic needs.

In addition to this national edict, the passage of the Alaska National Interest Lands Conservation Act in 1980 found Congress recognizing the special needs of the rural residents of the states. For Native and non-Native alike, it was decided that the continuation of the opportunity for subsistence uses was essential to physical, economic, traditional, cultural, and social existence. The situation in Alaska is unique in that, in many cases, there is no practical alternative to wild foods. The act required that an administrative structure be established to enable rural residents who have personal knowledge of local conditions and requirements to have a meaningful role in the management of subsistence-resource uses in the public lands of Alaska. However, these regional fish and game councils are being rendered ineffective by the elimination of their funding due to budget cuts, while at the same time timber industry subsidies remain intact. This is contrary to the mandates of ANILCA, which authorized up to five million dollars for the implementation of these councils.

Now, a few years down the road, the charges against the Forest Service have piled up like a logjam as citizens everywhere have grown frustrated with the planning process. A recent article in the *Los Angeles Times* pointed out:

Once upon a time, that old forest spokesman, Smokey the Bear, warned: "Remember, only you can prevent forest fires." Today the Forest Service declares: "Use preventability indices, initial attack objectives and burned acreage targets to hold unplanned ignitions within tolerable numbers or loss limits."

One must be highly motivated to plow through this obfuscating language. One also needs plenty of time. A mailing of the final Environmental Impact Statement for Alaska Pulp Corporation's 1986–90 operating-period plans included four separate books totaling more than 1,500 pages, sixty full-color foldout maps, at least ten planning alternatives, and supportive commentary. Not exactly casual reading. More importantly, the text downplays logging and roading costs and concerns and overemphasizes public benefits.

Few forest plans issued have not been appealed, and many will lead to lawsuits. Critics from inside the Forest Service and out claim that despite much public opposition, commodity production has continued to be the agency's goal. Public involvement is seen as a nuisance at best, and from more organized sectors as a serious impediment to the true USFS mission—cutting the trees.

Here is a selection from a long and eloquent letter, written in the eleventh hour by Larry Edwards, owner of Baidarka Boats in Sitka,

requesting an extension of the public-comment period from the Regional Forester concerning APC's Environmental Impact Statement for their 1986–90 operating plans.

During my involvement it has become increasingly apparent that the USFS has very little interest in meaningful public involvement and that "public involvement" is merely a hoop which must be jumped through in order to get along with the real (read "hidden") agenda. In fact, there is strong evidence that the USFS fears high-quality public involvement and thwarts it at every opportunity.

In the beginning, our citizens group had very great difficulty in obtaining access to relevant planning documents, and only through strong resolve were we able to do so. Once access was obtained we were placed under a series of arbitrary and very tight time constraints for delivering to the USFS planning team a "finished package" as our alternative. USFS was unwilling to prepare an alternative with our guidance; we had to prepare our own with very limited manpower on a very tight time schedule, putting our alternative at a disadvantage in many respects.

At every step of our involvement in the planning process the USFS planning team seemed to hold these concerns foremost: 1.) document that assistance was given to the citizen group, 2.) confuse, stall, and frustrate the efforts of that group at every opportunity in any way which cannot be easily documented, 3.) provide a bare minimum of assistance, 4.) assure that the Citizen Alternative has unequal footing with the other alternatives by refusing to put any USFS planning team effort into [it] . . . , 5.) have the group "sign-off" (this was done under duress) on maps depicting the alternative we had been forced into preparing so hastily. . . .

Now the Draft EIS is before the public for review. It is a time when many Alaskans are too busy earning a seasonal living to put much time, if any, into reviewing and commenting on the EIS. Fishermen are at their busiest right now. . . . Releasing this document at this time of year with a mid-July deadline for comments is either the height of idiocy or is planned to circumvent meaningful comment from a major group of forest users, and is absolutely inexcusable in either case.

Fisherman Sig Mathisen voiced the same concerns. He and others believe that when the Forest Service wants to avoid their comment, they release critical planning documents during fishing season, whereas "when they want you to comment, they'll come right to your door."

Despite the promises of ANILCA, a great number of Southeast's

rural residents feel their subsistence needs are not being properly addressed by the planning of the Forest Service. A letter from the Sumner Strait Fish and Game Advisory Committee to Mike Barton, Regional Forester, states:

Our advisory committee includes the two subsistence communities of Point Baker and Port Protection. Never in the entire planning process for this proposed harvest was either the advisory committee or either of the two villages notified and asked for input. We did not receive a scoping document. We did not receive the plan itself, or the revised EA [Environmental Analysis]. No hearings were held here, nor were we notified of hearings elsewhere. No one came here to inquire about our subsistence land-use needs.

We listened to a tape of a contentious meeting between the village of Tenakee Springs and the Forest Service that went nowhere. Residents claim it was a fairly average example of the meetings they have endured for years. Craig Courtright, the USFS District Ranger, began the meeting by introducing team leaders, silvaculturalists, engineers, and wildlife biologists. He assured the townfolk that these specialists could answer questions and "deal with just about any issue you might have." Clearly unified by their concern, residents began to ask their questions:

[Tenakee:] One of your findings is that based on previous discussion and evaluation, none of these alternatives would result in significant restriction of opportunities for subsistence use. . . . In the documents here, you say, "Extensive timber harvest has been conducted in Southeast Alaska for the past thirty years without benefit of current management direction to manage resources for subsistence purposes. During the period, no documented evidence has indicated that subsistence resources or opportunities have decreased." Well, [have] there been any studies to show [that]?
[Forest Service:] Basically we probably have close to all-time numbers of deer right now.
[Tenakee:] So have you done studies to show there has or has not?
[Forest Service:] No.
[Tenakee:] O.K., because in the next paragraph you say, "Based on past activity and current management direction, it is unlikely that activities proposed for this five-year operating period will decrease resources to the extent that there will be any significant effect on subsistence use or the ability to subsist." So, in other words, you haven't shown one way or the other whether it does affect sub-

sistence, but yet you are saying that, based on that—no studies— that there won't be.

It is important to remember that subsistence users in bush towns are not demanding a game supply because they prefer venison to beef; they simply have few alternatives.
Tenakee resident Bob Parish offered the meeting an opinion based on years of experience:

For forty years I have hunted here . . . [and] for a guy to say you can go in that country [the Pavlof Harbor area] and it's like it was even ten years ago, when you go up and you hear the sound of motors . . . and there is a logging truck with ten or fifteen deer piled in the back, these guys riding up from Kennel Creek, shooting deer, don't tell me that don't impact something.

Ironically, logging-camp residents also see themselves as subsistence users. Hunting and fishing supplement their wages, the free food source allowing them to save money that they would normally spend on supplies at the company store. Although this is a complex subject, it is only fair to point out that loggers are, for the most part, temporary residents and do not have the vested interests of established families in protecting a sustainable food source. Alaska Public Survey data show that residents of logging camps take and use more of the wild resources per capita than does the average person in most other Southeast communities.
To return to the meeting, Tenakee citizens again stated their opposition to the impending road connection. Courtright responded:

What Ken [Ken Roberts, Forest Supervisor] and I are trying to tell you is that it wouldn't be appropriate for him or I . . . to come in here and make any promises about any long-term commitments on that road. It would be foolish for us to do that, because if I did that, . . . five years from now, somebody else is going to be in here talking the same story with you, and you're going to say "they promised." It's not practical and it's not legal.
[Tenakee:] What about a contract between the city and the Forest Service, so that if you get transferred or something, then we have a contract that is legally binding.
[Courtright:] There'd have to be some kind of a legal instrument like that, it would be the only possible way that that could be done. And frankly, you aren't going to get anybody to agree to any kind of a contract for any long period of time because things change over time, and I don't want to make a decision for something that

is going to go on fifty years from now, because the likelihood of my making an accurate interpretation of what's going to be needed fifty years from now is not very [good].

[Tenakee:] But it's O.K. for you to make a contract with a private corporation [for fifty years].

Without meaning to, Courtright spelled out exactly what is wrong with the unprecedented fifty-year contracts between the Forest Service and the pulp mills. Things have changed over time—everything, that is, except the Forest Service's unwavering commitment to APC and LPK. Bob Parish later summed up the situation by reciting an old poem to us: "The law locks up both man and woman/Who steals the goose from off the common,/And turns the greater felon loose/ Who steals the common from the goose."

A failure to achieve concrete results through participation in planning has led many individuals to dig deeper into Forest Service procedure, only to discover inconsistencies at every turn. In brochures distributed to the public, the USFS states, "Meeting our nation's increasing demands for recreational opportunities in a pleasing forest environment is a major aim of forest land managers." Does it seem logical then that with tourism increasing 85 percent from 1980 to 1985, the portion of the Forest Service budget in Southeast dedicated to recreation decreased from 6.3 percent in 1985 to 5.6 percent in 1986? In that same 1986 budget, fish and wildlife allotments increased slightly, by .8 percent. The combined total of these two outlays (recreation and fish/wildlife) still amounts to only 12.1 percent of the USFS expenditures. The rest went to timber management.

As we have already pointed out, old growth is essential to the survival of the animal populations it harbors. The Forest Service likes to counter critics of its management plans by stating that there are 5.4 million acres of designated wilderness in the Tongass, sufficient to support healthy animal populations. Unfortunately, 70 percent of those wilderness lands consist of rock, ice, battered coast, and scrub timber. Forest creatures cannot live on a glacier. Only 3 percent of the timber in wilderness is considered commercially valuable. Fewer than ten thousand acres of the best old-growth forest are protected by wilderness status. To understand what this means, see Warren Island on the map of Southeast (page 8). This small island is one thousand acres larger than all the prime old-growth protected as wilderness. Most critical wildlife habitat is scheduled for cutting. Biologist John Schoen of the Department of Fish and Game states:

The current timber management policy on the Tongass is analogous

to cutting the "heart" out of the forest. The forest is a mosaic of different quality stands. Within watersheds available for timber harvest, the highest quality stands (high-volume old growth) are being clear-cut in much greater proportion than their occurrence. These same stands are the most rare and constitute some of the most valuable wildlife and fish habitat in the forest.

The Forest Service accepts that

as new forests replace the harvested old-growth, some wildlife species associated with old-growth forest habitat may be replaced *[emphasis added] by species adapted to younger forests. . . . It must be recognized that some decreases in wildlife species dependent on old-growth habitat will occur in some areas of the national forests in Alaska. Population levels that meet the public demand for hunting and viewing need to be determined for the* more important wildlife species *[emphasis added].*

More important than what? Is the Forest Service playing God? Worldwide, plant and animal species are disappearing at one thousand to ten thousand times the normal rate. Should we really trust the Forest Service to determine biological balances for large sections of North America when its admitted priority is tree farming? As early as the 1940s, in his essay "The Round River," Aldo Leopold warned us about such attitudes:

The outstanding scientific discovery of the 20th Century is not television, or radio, but rather the complexity of the land organism. Only those who know the most about it can appreciate how little is known about it. The last word in ignorance is the man who says of an animal or plant: "What good is it?" If the land mechanism as a whole is good, then every part is good, whether we understand it or not. If the biota, in the course of aeons, has built something we like but do not understand, then who but a fool would discard seemingly useless parts? To keep every cog and wheel is the first precaution of intelligent tinkering.

Forest Service literature plumps its policy with patriotism. "These commercial forests help furnish the nation with the lumber and plywood needed"; "This careful planning and implementation of resource management programs assures a continued sustained flow of goods and services for the national forests in Alaska to meet local and national needs." Ninety-five percent of southeast Alaska's cant and log production and 80–85 percent of its pulp go to Japan. Perhaps

the Forest Service should clarify which nation it is referring to.

Jobs are ostensibly the reason for the government subsidies to the timber industry: "Alaska needs jobs!" It is time to look beyond bureaucratic definitions of need. The Forest Service states that ANILCA "recognized the importance of maintaining industry employment in southeast Alaska by establishing a prescribed level of timber harvest. . . . This will maintain about 2,700 industry jobs." Starting in the mid-seventies, jobs in Southeast's timber industry have been gradually declining. Since 1980, the decline has been 40 percent, due to lack of demand in the pulp market. This reflects an international shift from products made from dissolving pulp—rayon and cellophane, for example—to products such as wool, cotton, and petroleum-based polyesters. The Alaskan pulp mills must also compete with newer, more efficient foreign mills that take advantage of cheap labor and close proximity to plantations of fast-growing trees such as eucalyptus. Accordingly, the market value of Southeast's pulp exports has declined 49 percent since 1980. A recent Forest Service report concludes that "unless a major new market can be found for southeast Alaska's pulp and/or its lower grade logs, a long-term decline in Alaska's timber industry is anticipated, even with short-term improvement in pulp markets."

An Alaska Department of Revenue memo states, "The logging of old-growth is a mining operation. Timber in Alaska means coastal old-growth. And old-growth is not a renewable resource. There is no reasonable possibility of a second-growth industry in Alaska." Thus the continuation of subsidized clear-cutting and high-grading ruins any hope for a sustained timber industry on a small scale as existed in the Tongass for many years before the introduction of the fifty-year contracts. Many long-term observers of the timber industry believe that the reestablishment of local mills, cutting a portion of the prime spruce and cedar for local needs and export, would be more appropriate than current business practice. As it stands, small mills cannot get started because they cannot be guaranteed a supply of prime wood, thanks to the LPK–APC stranglehold. Thanks also to the "emergency rate redeterminations" granted these two corporations U.S. taxpayers are paying to have prime spruce and cedar given to the pulp mills. What do prime spruce and cedar have to do with the low-grade-pulp market? Why are we squandering these valuable, nonrenewable resources on two huge corporations that take millions in government subsidies and still claim they cannot make a profit? Theories abound in southeast Alaska. Could these money-losing branches of huge, multinational corporations exist mainly for tax purposes? If not, how long should such incompetence be buoyed up by taxpayers? It was suggested to us that Southeast could support

a well-run pulp mill to utilize timber waste products and abundant low-grade trees, but the existing mills are technically obsolete and not worth bringing up to EPA standards. The cost of maintaining the current pulp industry is out of proportion to the benefits. Yes, timber operations inject wages into the economy, but, as of 1984, about 24 percent of those wages went to out-of-state residents. Many of those further drained the Alaskan economy by collecting unemployment insurance from Alaska after they returned home.

Another aspect of the wages argument was posed by a Tenakee Springs businessman, speaking to the Forest Service during the town meeting.

I can talk . . . as a businessman here in town. . . . We hear constantly from their [the logging industry's] PR people what good neighbors [they] are and how [they] help the economy. Well, this is probably real true in Sitka, but it is not helping us very much. We have two people working in . . . the forest, and that is good because it helps at least two families, but there are a lot more families here than two. We don't do any business with the logging companies. In fact, the logging company that just left here [had given] direct orders to [their] people not to shop in Tenakee. Now, that's what we call good neighbors. We've never done any business, by the way, with the Forest Service. Your boat comes through here. You must need fuel once in a while. You never buy any here. How are you helping the economy here? What do any of these plans do for Tenakee?

For the sake of Southeast's future, for the relief of taxpayers and the national deficit, the best and brightest minds should be planning uses for the Tongass that are complementary to its character, and sustainable. If, as many believe, there is no reasonable possibility of a second-growth industry in Alaska, then the accelerated cutting we see today virtually assures that the Southeast timber industry will eventually go the way of the sea-otter harvest and the gold rush.

In a USFS brochure, in a paragraph entitled "Cooperative Management," the Forest Service implies that good management of the Tongass requires close coordination between the USFS and interrelated agencies, such as the Alaska Department of Fish and Game. In reality, many Fish and Game biologists are quick to dissociate themselves from Forest Service practices. In a Fish and Game memo, a research supervisor made this comment: "It [the Forest Service] cites interagency cooperation. We find this 'cooperation' curious, as our agency's mandated direction is in complete opposition to that of the F.S."

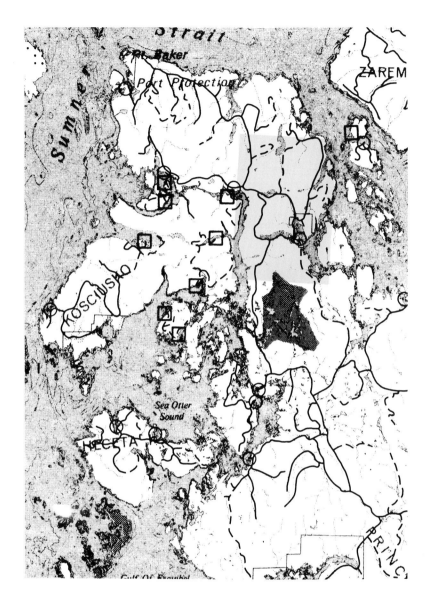

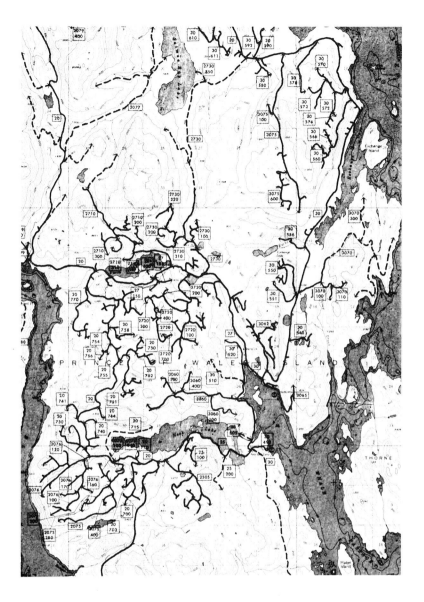

Tongass National Forest—Road Transportation System, 1986. Map distributed to the public by the USFS qualified by a legend noting: "Major roads less than two miles in length are not shown due to map scale." Shaded area is shown, enlarged, at right.

Petersburg (A–4) Quadrangle, U.S. Department of Interior Geological Survey, Modified for USDA Forest Service Use, 1984. The unedited version.

Professional biologists from various state and federal agencies and public-interest groups are not the only ones at odds with the Forest Service over Tongass management. There is also much dissent within the ranks. One ranger, insisting on anonymity, told us that, without a doubt, "except for the areas that are withheld, the Forest Service sees the Tongass as a tree crop, a tree farm to be cut, every last stick." In a series of interviews in the paper "The Tongass Timber Problem," Forest Service professionals had some equally interesting comments:

Kurt Becker, USFS Supervisory Wildlife Biologist:

Listen to what the specialists are trying to tell you! They are highly trained professionals who are trying to help, not hinder, progress. Instead of defying, ignoring or twisting their advice, staff should heed their suggestions. That's the only way we'll solve the problems that face the forest. By giving more power to the interdisciplinary teams and by taking some of the pressure off them to meet timber targets, Tongass resource management would be improved dramatically. As it is now, foresters are evaluated for their ability to come up with assigned timber volumes—and we're painting ourselves into a corner.

Don Schmiege, USFS Research Leader, Forest Science Lab:

There has been resistance to information that would mean drastic change in management direction. Our research on the Sitka black-tailed deer, for example, was considered by some managers as a problem because if the public learned about the deer's habitat need they might put pressure on these managers to reduce the timber cut.

We have been met with a continuous reluctance to accept our deer research. We do our work very carefully, and it's subject to peer review. The best wildlife biologists in North America and, in fact, the world reviewed it before we published it. So I stand behind it one hundred percent. But this deer habitat information, or information that clearcutting causes increased slope instability, is received very reluctantly. In some ways you can see why: Tongass managers feel they are under great pressure. Some managers say, "All you are doing is causing more problems." And, in a way, they're right: but in the long run, they're wrong.

And Cynthia Croxton, USFS Forestry Technician, whom we have quoted before:

The majority of people in high-level positions in Alaska are "timber beasts"—it's not a flattering term, but that's what their training is in—timber management—and they're in high positions because they're good at getting the cut out. We can't expect Congress to decrease the cut of its own volition, and we can't expect the top officials in the Forest Service in Alaska to diminish their own power by suggesting such a thing. What we can expect is that the vast majority of people who work for the Forest Service—especially those that work in the field—would say "Cut the cut" if they could speak their minds. Time and again talking with Forest Service people they'd say we're taking too much, we don't know enough to take this much.

A large proportion of southeast Alaska's Forest Service budget—more than one-half—goes to roads: planning, construction, and maintenance. There is an ambitious plan for a land-based transportation network in the Tongass. As much as three hundred miles of permanent and temporary roads a year is scheduled for development. However, the Forest Service will not disclose its Tongass Transportation Plan to the public. In response to inquiries, the public has been sent a generalized and incomplete map of the existing road system. The USFS qualifies this map by saying that due to scale, major roads under two miles are not shown. The explanation sounds innocuous, but comparing this map with USFS detailed quads of the same sites is startling (see accompanying diagrams). Clearly, far more roads in the form of short spurs and two-mile sections exist than the public is being shown. Consider the additional impact these "real" roads have on the forest environment. Imagine what the proposed 130 miles of road would do to the pristine Yakutat Forelands, a narrow coastal strip about 50 miles in length. Consider what the "real" roads would do to any of the high-value forest habitats through which they are planned.

One may choose to explain away the Forest Service's constructing roads to nowhere as simple bureaucratic excess, the prodigal use of a fat budget. But many see those roads leading in an insidious direction. According to yet another USFS Forestry Technician quoted in "The Tongass Timber Problem," who prefers anonymity:

It became apparent to me that our job was to get as many timber sales layed out as possible. They [the administrators] were concerned that some lands would be excluded from timber harvest if they were designated as wilderness, so some mark needed to be made on the land. Our activities were switched from going into one area and laying out some units to flying all around the island into remote areas.

I remember particularly the Sarkar area which had been recommended for wilderness designation, but they wanted it for timber. So a road was put in.

This kind of calculated objective, quite contrary to the supposed purpose of roading, was also confirmed in a Fish and Game memo we must quote anonymously:

The F.S. is pre-roading areas in which no commercial interest has been expressed. Some F.S. officials have even admitted privately that much of the work is designed to keep their staffs busy, and to prevent the area from being designated as "Wilderness" in the future. . . .

It appears that the Forest Service, with the apparent blessing of the Reagan administration, found a loophole in the law just large enough to drive a log truck through. As summarized by Dennis Hanson in *Sierra*:

. . . there is a more substantial issue here, one that some critics say makes the agency's avowed need to get at the timber a first-rate red herring. Under the Wilderness Act of 1964, primitive areas of national forests are eligible for designation as wilderness only if they are roadless. Each new mile of logging road thus removes tens of thousands of acres from the pool of potential wilderness. If construction proceeds at the current rate, new roads may total 100,000 miles or more in the next 15 years, a distance two and a half times the length of the Interstate Highway System. If left unchecked, the program would open up much of the 47 million acres of federal roadless land not yet designated. . . .

In the words of Tom France, attorney for the National Wildlife Federation, "with a few thousand dollars and a few bulldozers, they're deciding the wilderness question"—without Congress or the public ever having any input.

These roads to nowhere *are* going somewhere. They are going to eliminate wilderness.

Ground Zero

In the course of the next five years and beyond, many critical areas will be affected by proposed clear-cutting and roading. This chapter describes some of the most important of those places, and the accompanying pictures show what will be lost. Changes in planning are constant, but more often than not the changes only sacrifice one area for another.

Tenakee Inlet

Tenakee Inlet is one of the largest such bodies of water in all of Southeast. Its deep fingers penetrate to the heart of Chichagof Island from the eastern shore. In a small boat out on the waterway, you have the sense that you are in the open ocean between two islands. Tenakee Springs, the only established village on the inlet, occupies a tiny portion of the eastern shore near the mouth of the inlet where it opens onto Chatham Strait. A large logging camp at Corner Bay lies almost directly across the water from the village. The lush old-growth forest that blankets the surrounding land includes some of the most productive habitats in Southeast. Indian River, Crab Bay, Saltery Bay, John Muir Portage, Corner Bay, Trap Bay, and the Kadashan drainage harbor large populations of grizzly bear, Sitka black-tailed deer, and a variety of other species, all of which are threatened by logging.

The hundreds of streams and rivers that drain down through the forest and into the inlet support astounding concentrations of spawning salmon. The tidal deltas and estuaries that these rivers form serve as rookeries for crab and shellfish, and a myriad of sea life also uses the waterway extensively. During our visit, we saw a very large pod of orca feeding and playing and had the amazing experience of hearing humpback whales communicating with one another as they encircled their meal with "bubble nets" near Trap Bay.

Because most of the drainages in the inlet are quite extensive, so are the meadows they support. In some drainages, like that of the Kadashan, the river braids create a labyrinth of water, grass, and sedges in which especially diverse animal populations thrive. Massive trees, some of the largest still left in Southeast, punctuate the floor of the adjacent forest, and tremendous skunk cabbages and alders that disorient one's sense of scale rise from boggy blackwater swamps. Walking here is like stepping back in time to a primal world where systems have operated in a balancing struggle that seems prehistoric under its layers of moss and decay. Almost all of this will be sacrificed for pulp.

Corner Bay is just a hint of things to come. The uniformity of the forest cover in the drainage behind the logging camp has been destroyed, and numerous denuded pockmarks have spread up the valley. These clear-cut sections will be expanded in time, both by blowdowns now that the forest cover has been destabilized and by later logging entries into adjacent cutting units. Eventually, most of the watershed will be consumed in this fashion, driving the wildlife into the neighboring drainages of the Kadashan and Trap Bay. But really, there is no refuge. Already, miles of road stretch out from Corner Bay, around the point, and into the Kadashan, cutting through the flesh of the forest like a knife. If left unchecked, the Forest Service will allow the Alaska Pulp Company to take nearly everything in the entire inlet, because most of it has been designated "management emphasis on timber harvest."

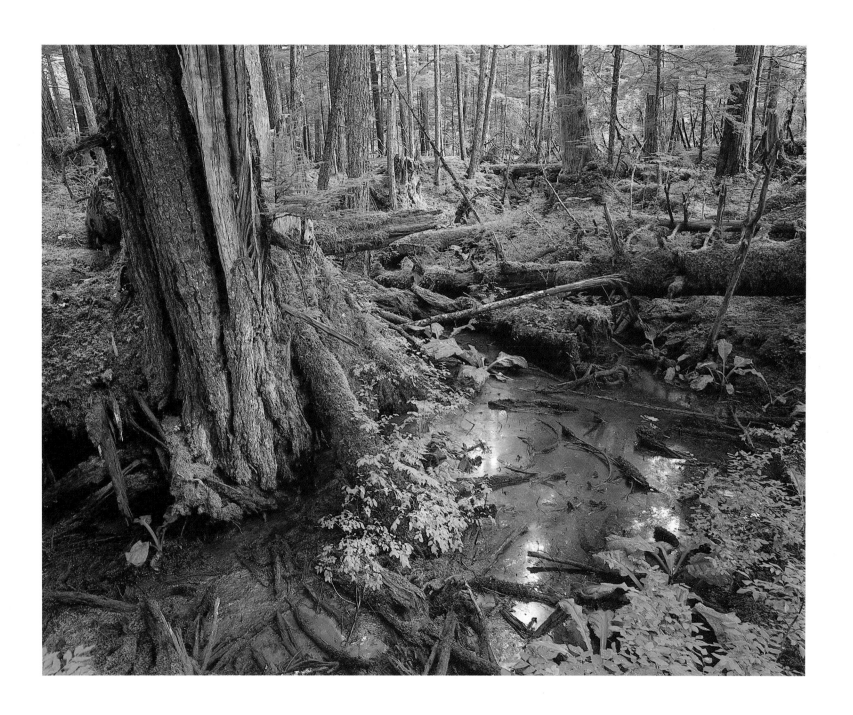

Old growth, Trap Bay

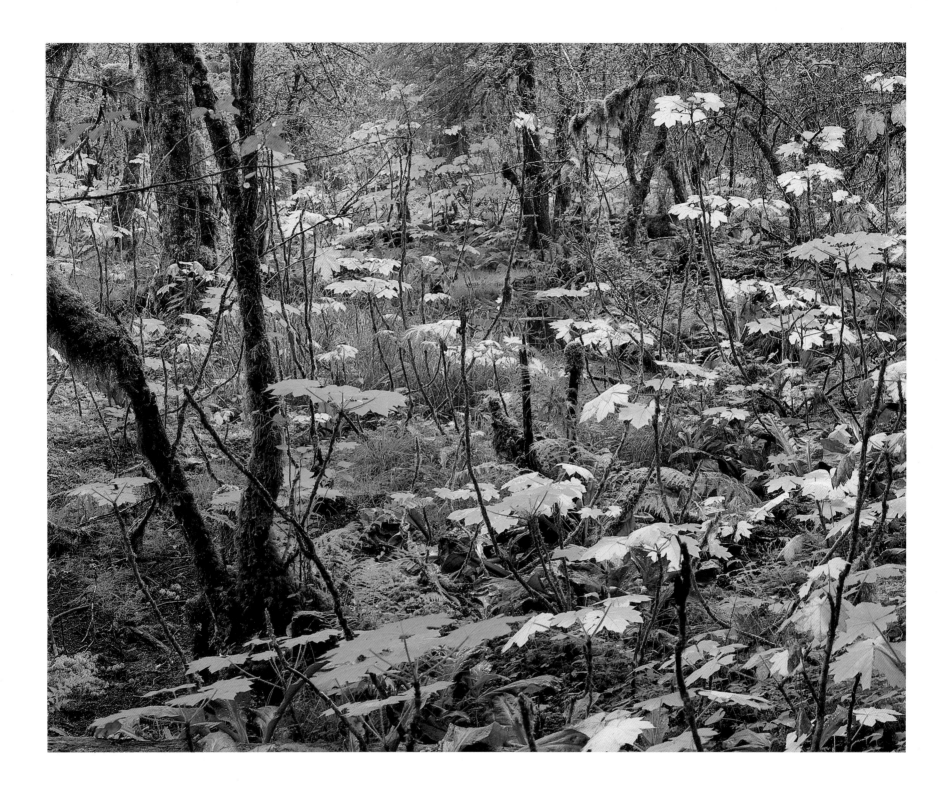

Kadashan (devil's club) I

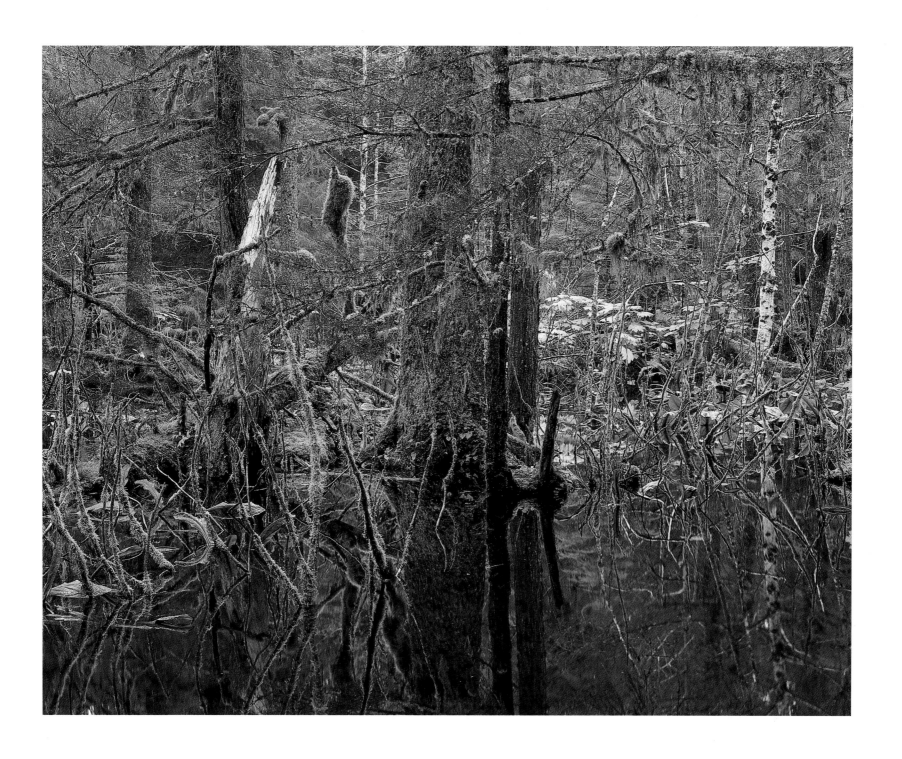

Kadashan (blackwater) II

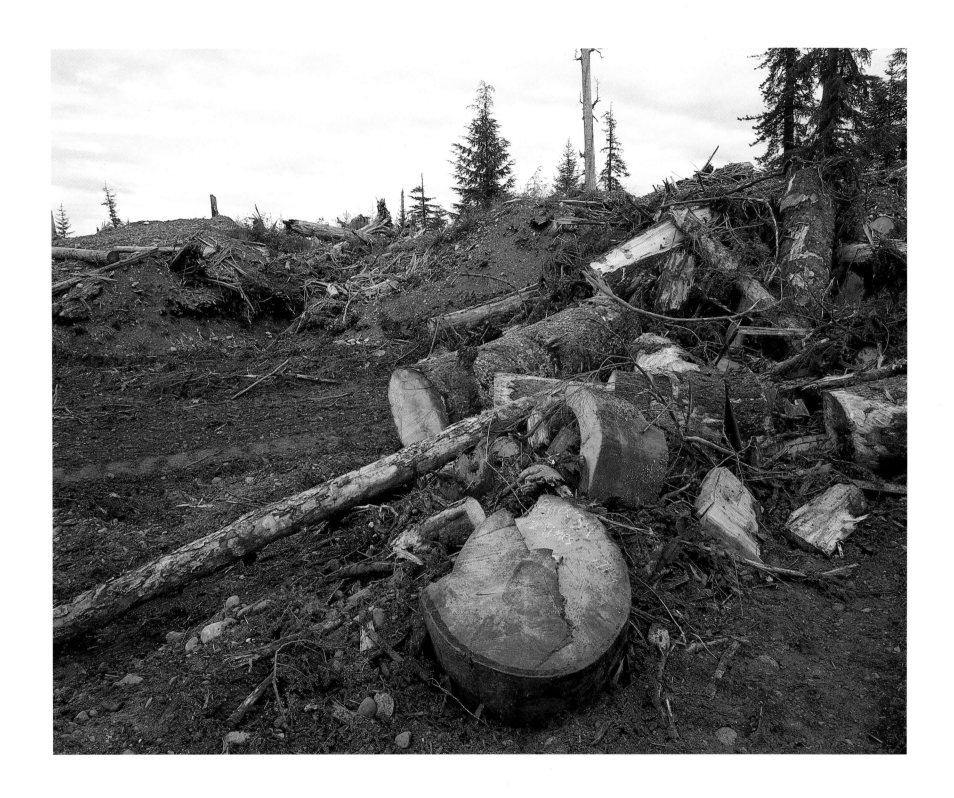

Terminal *transfer facility*

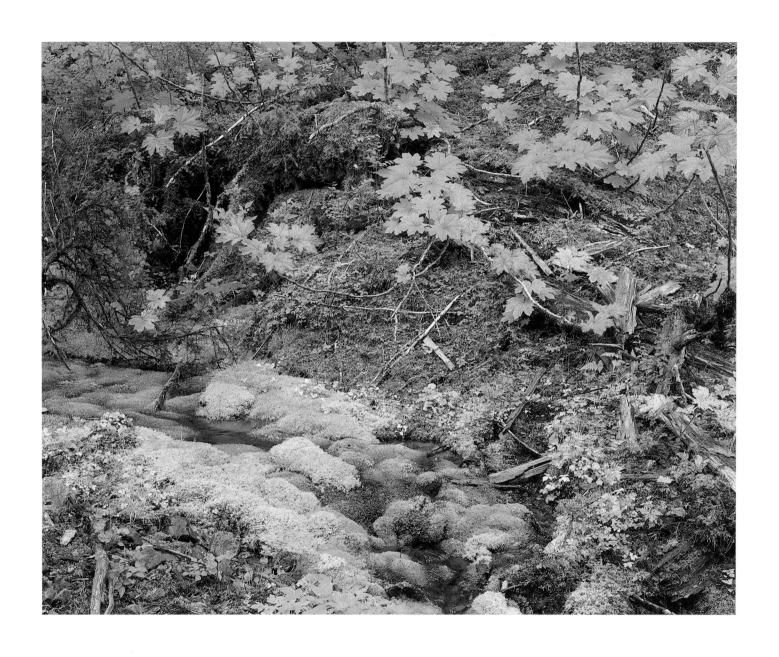

Devil's club and moss floor

Hoonah Sound and the Lisianski River

THE PERIL STRAIT, just south of Tenakee inlet, passes between Chichagof and Baranof islands and serves as the only major boat passage from inside to the Pacific that does not require circumnavigation of one island or the other. The mouth of Peril, where it meets Chatham Strait, is quite wide, and the mountains are low and heavily forested. They have also been cut to shreds, and locations such as Sitkoh Bay are some of the most heavily logged and damaged areas in Southeast. In the other direction, west and north, Peril's narrow connecting channel to the Pacific side doglegs south. The body of water continuing to the northwest becomes Hoonah Sound.

Like Tenakee Inlet, Hoonah Sound is a haven for fish, shellfish, and whales of every description. Several of the bays opening onto it are the last remaining major king-crab rookeries in Southeast. The surrounding land is covered by primary forest, and rivers tumble down from the mountains, spilling into the sound through rich deltas supporting vast numbers of birds and a huge animal population. From a more encompassing perspective, the eastern shore of the sound is simply the western slope of the mountains and forest that stretch to Tenakee Inlet. If the inlet were devastated by clear-cutting, the animals would be driven here, and vice versa.

The north arm of Hoonah Sound is marked by an intricate maze of tidal flats fed by waters flowing down from a slight rise in the Lisianski Valley behind them. Farther up that valley is a small lake, the source of the Lisianski River. The river meanders northwest through a beautiful valley floor and into Lisianski Inlet, several miles south of the fishing village of Pelican. Most of the Lisianski Valley and surrounding mountains are covered by marginal trees and muskeg, but a concentration of old growth next to the river is a perfect target for high-grading.

Forest Service plans call for continuing the roading and massive clear-cuts of the lower Peril Strait right up the eastern shore and into Hoonah Sound, taking almost everything; it is all designated for intensive harvest. At the head of the sound, the cuts will continue to the west, following the shore around and down the western side, consuming and destroying great bays like Patterson, Ushk, and Deep. Originally, the plans called for roading and cutting the Lisianski Valley as well, threatening to connect Pelican with a road coming through from Hoonah Sound. Many people opposed this proposal, and in the final EIS of the USFS five-year plan, cutting in the Lisianski Valley was "deferred."

Remember, though, this is only a five-year plan, and at the end of that time the roading and cutting could be reconsidered and reinstated as part of the next five-year proposal. Further, in order to compensate APC for the potential timber loss due to the plan alteration, the USFS has traded them additional cutting units in Trap Bay/Tenakee Inlet and enlarged cutting-unit sections of other bays around Hoonah Sound. If current planning becomes reality, well more than half of Chichagof Island will be clear-cut. Animal populations will be decimated. Numerous primary salmon habitats and crab rookeries will also be critically affected, requiring expensive rehabilitation and enhancement and certainly reducing the fisheries potential of the area. Most of this extensive and interdependent wild system would be transformed into a tree farm with a regrowth cycle of a hundred years. Once logged, the forest might never return to its present biologically productive state.

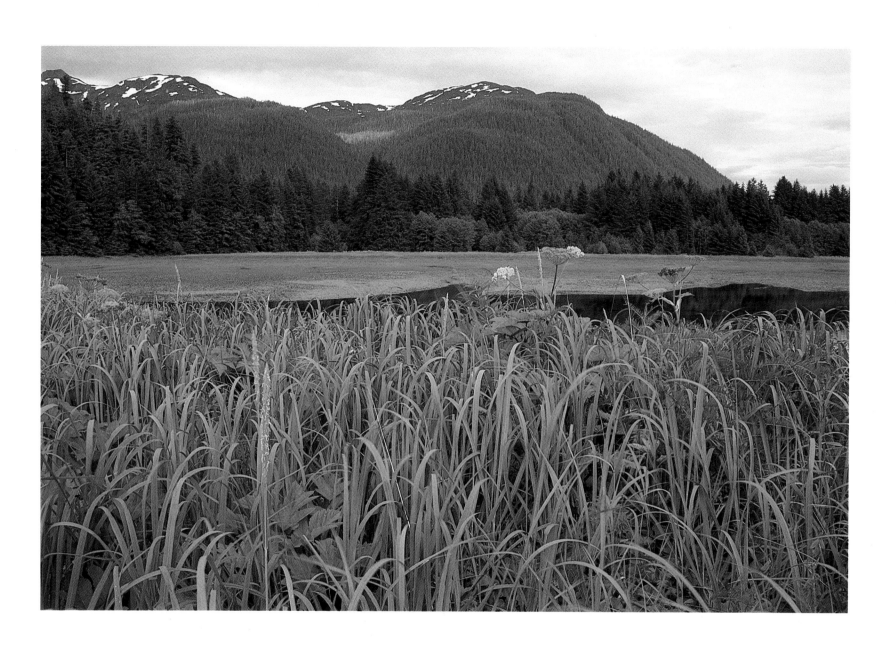

Finger Mountain and The Finger River estuary, Hoonah Sound (site of proposed terminal transfer facility) 93

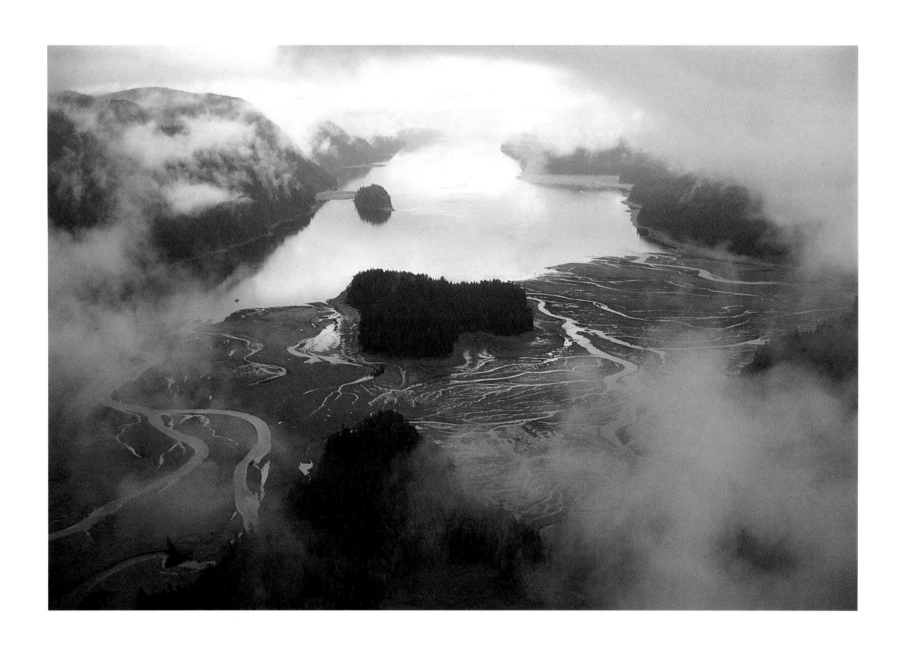

North Arm, Hoonah Sound

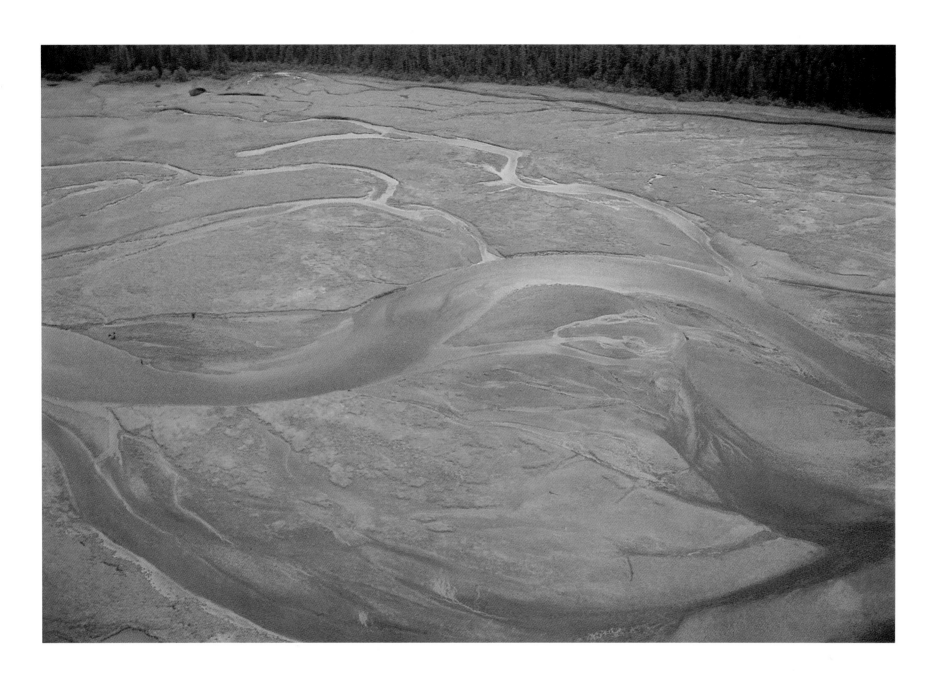

Braids and meadows, Lisianski River mouth

The Stikine River

THE STIKINE is one of the great rivers of the world and the largest undeveloped, intact watershed in North America. It is also one of the few rivers that penetrate the Coast Range, connecting the interior of Canada to the ocean. Anthropologists believe that natives from the interior first reached Southeast by traveling down the Stikine, and since the gold rush of the 1800s the river has been considered a major highway.

We traveled the Stikine in kayaks from Telegraph Creek, British Columbia, to the river's mouth, about 160 miles, retracing a similar canoe trip that John Muir had made. He commented that the experience was one of his most profound in all of Southeast and compared the Stikine to a hundred-mile-long Yosemite Valley. We found the walls less close and steep, but the proximity of major peaks and glaciers makes the area far surpass Yosemite. The river is considerably greater than the Merced as well, and just navigating its braids and snags is an adventure.

Rich with wildlife, the river traverses incredibly diverse topography, from a gorge cut in volcanic lava to deep forest. Its mouth expands into the largest tidal estuary in Southeast and supports an astounding bird and marine habitat. The voluminous amount of sediment it carries to the sea turns the ocean channels near the river a different color. The wide strait into which the river empties is so choked with silt and sediment that it goes dry at the lowest tides.

The threat to the Stikine lies in its great size. So much power surging along its course attracts hydroelectric development, and there are numerous Canadian plans to build several dams for that purpose. The American portion of the river is designated wilderness, but even here there is a catch. When the river wilderness was created by ANILCA, a provision for a potential transportation corridor was included. Admittedly, it would be a relatively narrow strip appropriate for such a use, but it could bisect the entire wilderness area. Even worse, because the river valley itself is quite narrow when it passes through the mountains, any such road would come perilously close to its shore, compromising the original purpose of wilderness designation.

Of course the primary managing entity, the Forest Service, has said that it is very unlikely that such a road would be built in the near future, but it is disturbing that it might happen at all. In fact, sources from Wrangell, the Alaskan town closest to the river mouth, told us as this text was being written that USFS personnel were in the river wilderness, surveying and flagging what looked suspiciously like a roadway.

If the drainage is to be used as a transportation corridor, continuing the historical use of the river as a highway would be the most appropriate way to preserve its pristine values. But, more important, as it is the last great undeveloped waterway on this continent, the United States and Canada should give very serious consideration to preserving the entire watershed. Here lies a chance for both countries to accomplish something unique, the protection of an unmatched and intact ecosystem. In the long run, the intelligence of such an endeavor would prove far more useful and enlightening than all the electricity we could squeeze out of the river at the cost of its wonderfully diverse habitat.

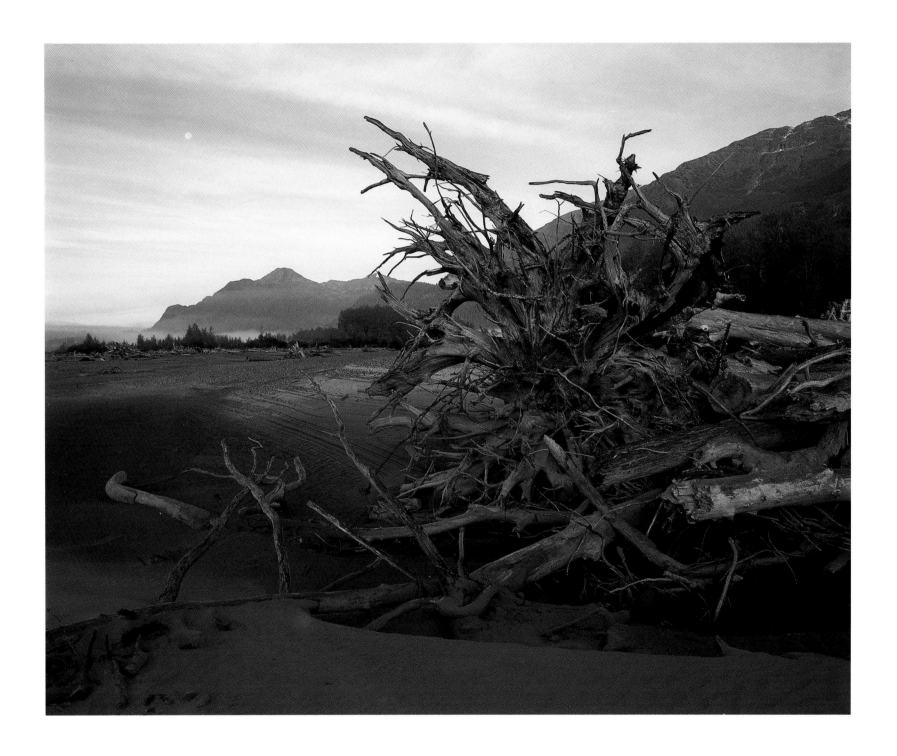

Hydropool around a snag, exposed at low water

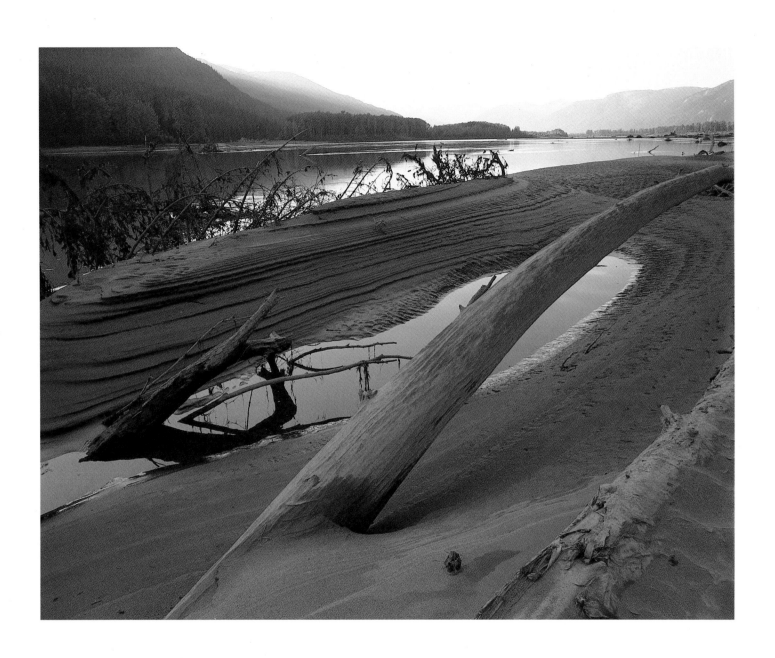

Debris logs and sandbars

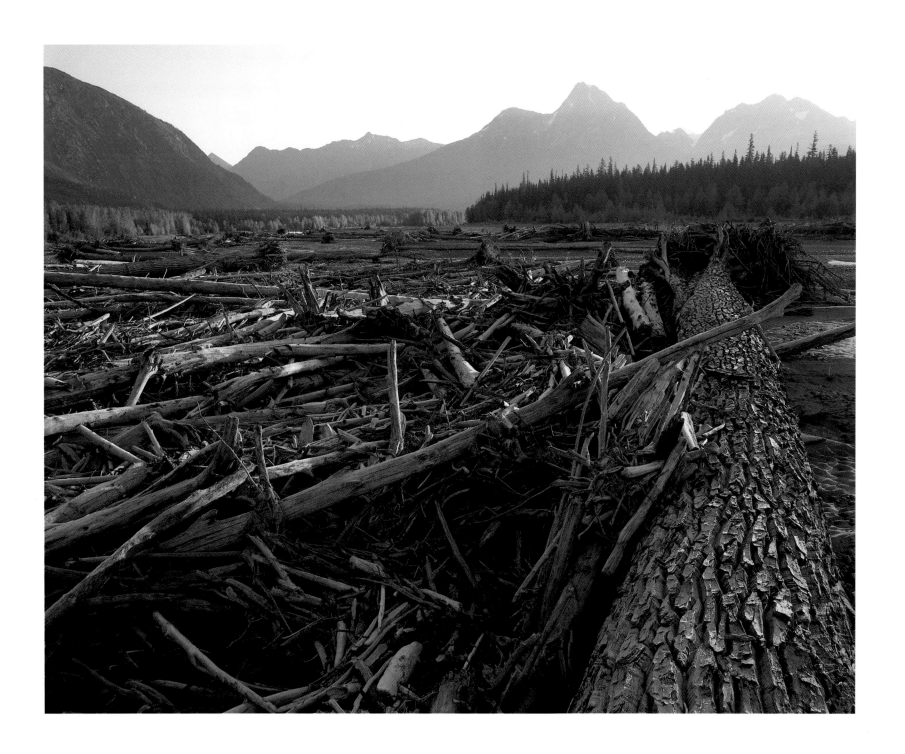

Massive debris, low water

The Yakutat Forelands

YAKUTAT, THE FORELANDS, and the surrounding mountains are the northernmost edge of the Tongass. Although the forest here is extensive, it is relatively recent and little of it is old growth. Yakutat, at the mouth of a huge bay bearing the same name, is primarily a native fishing village. To the south, along the great beaches, a handful of seasonal fishing camps are concentrated primarily at the mouths of the numerous rivers that cross the Forelands. No protective islands buffer the coast in this part of Southeast. This is the raw edge of the continent, the mainland; it faces directly into the Gulf of Alaska and the weather coming out of the Pacific. The Forelands is a mere strip of relatively flat land seldom more than twenty-five miles wide that stretches about fifty miles from Yakutat Bay in the north to the borders of Glacier Bay National Park and Preserve in the south. All of it lies at the feet of the highest coastal peaks in the world, the St. Elias Mountains.

This is a land of great extremes, literally being created year by year in an ongoing process so apparent that the very air seems charged with its dynamics. It is believed that the ground on the Forelands is rising as it is relieved of the weight of retreating glaciers. Frequently rattled by earthquakes, including the largest ever recorded anywhere, battered by high winds and crashing surf, it is a place of physical wonder. From the shore, a clear day provides a view of one of the greatest vertical displacements in the world. Looking up from this sea-level position, 18,008-foot Mount St. Elias forms the northern terminus of your vision. To the south, 15,300-foot Mount Fairweather dominates the skyline. Between them and directly in front of you rises the Brabazon Range. Serving as the foothills of the greater summits, they rise to six thousand feet. The immediate proximity of the Pacific and the abrupt rise of the mountains create abundant precipitation year round, and snowfall averages over two hundred inches, with some years recording over three hundred.

Immense ice fields have accumulated, generating some of the world's greatest glaciers. The Malaspina and Bering glaciers each total more than two thousand square miles, and they are but two of the glaciers active in the area. In the summer of 1986, the ninety-two-mile-long Hubbard Glacier, which had been advancing at the astounding rate of seventy-four feet a year, made world news when it surged several feet across the mouth of Russell Fiord, sealing it off from the sea. This momentary creation of "Russell Lake" trapped numerous salt-water species such as seal and porpoise for several weeks before the ice dam broke and retreated.

The Forelands itself has little elevation and a limited topography accentuated by a few moraine knolls. It is covered with wet muskeg, dense willow, sedge, and heather. Cottonwood trees grow along the changing river courses, and small lakes and bogs dot the landscape. Moose and bears are plentiful and goats thrive in the higher elevations. The Situk, Ahrnklin, Dangerous, Italio, Akwe, Ustay, Tanis, and Alsek, all rivers of significant scale, cross the Forelands, draining from the mountains and inland lakes to the sea, and support very productive spawning and rearing habitats for anadromous fish. Along with the game, salmon, steelhead, cutthroat trout, and Dolly Varden make Yakutat one of the most popular sport-fishing and hunting destinations in all of Southeast.

The young trees here, primarily Sitka spruce, have established themselves in scattered stands that are greatest in density close to the foothills but stretch down toward the shore and dissipate where the beaches form. Most of them are not more than three hundred years old and are hardly comparable to the trees of the mature forest found in the more southerly parts of the Tongass. Yet it is this very newness that makes the entire ecosystem of such scientific value, for here the growth and transition of succession vegetation can be studied and observed.

There are few roads in the area, but the Forest Service would like to change that. Their plans call for one long road stretching from Yakutat south to the Alsek, bridging all the rivers. Including spurs that would connect to this main road, the current USFS transportation plan estimates that 130 miles of roadway will be constructed. The youth and flatness of the Forelands may also condemn it. There is no dense old growth here to champion, and roading won't destructively cross marginal gradients. Minuscule, and somewhat lost between the more obvious wonders of Wrangell–St. Elias National Park and Preserve and Glacier Bay National Park and Preserve, the Forelands may well be the loveliest and least noticed ecosystem in all of Southeast.

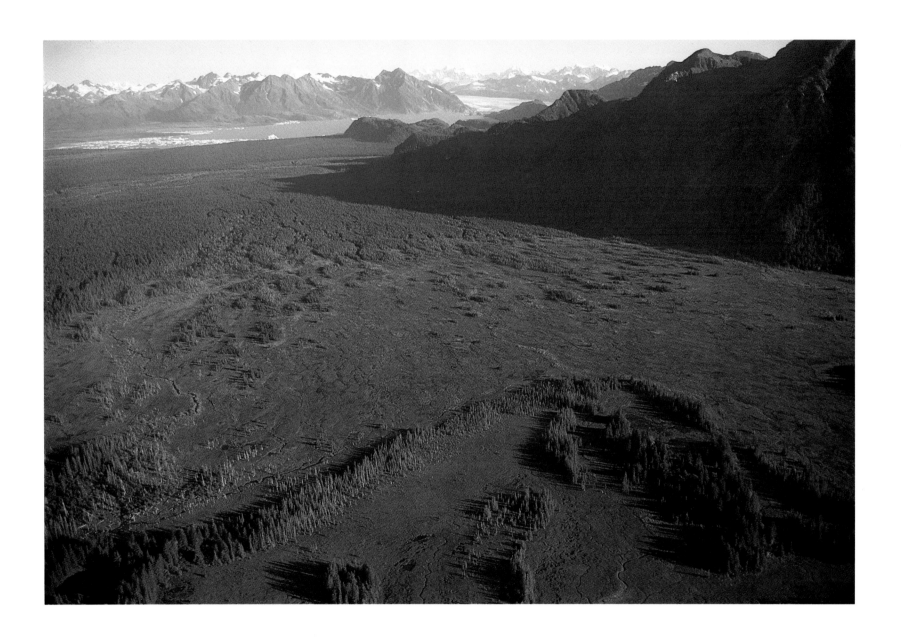

The Brabazon Range and Harlequin Lake

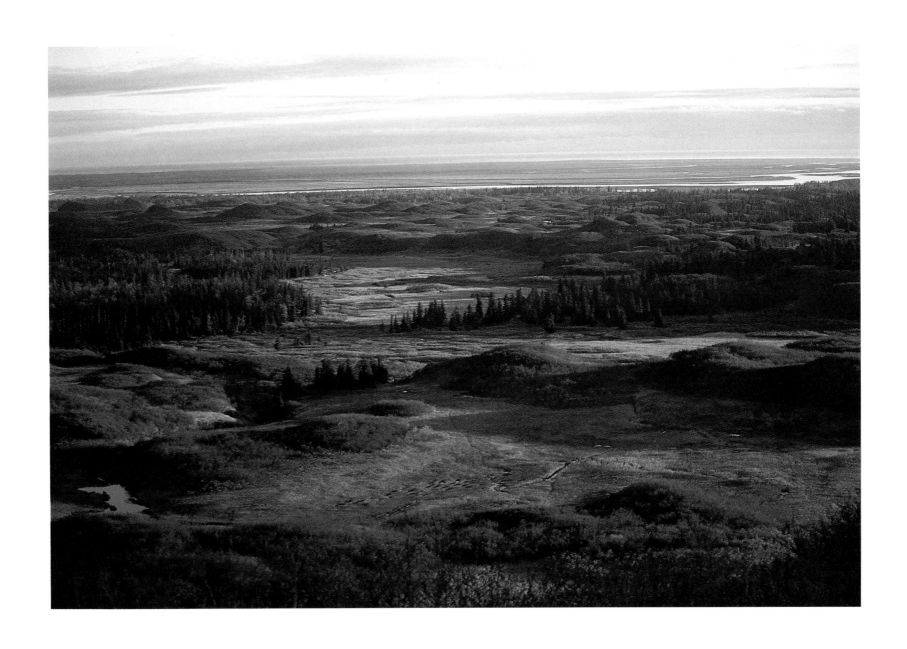

The Forelands, the Alsek River, and the Gulf of Alaska from the Brabazon Range

Drift logs on the beach, Gulf of Alaska

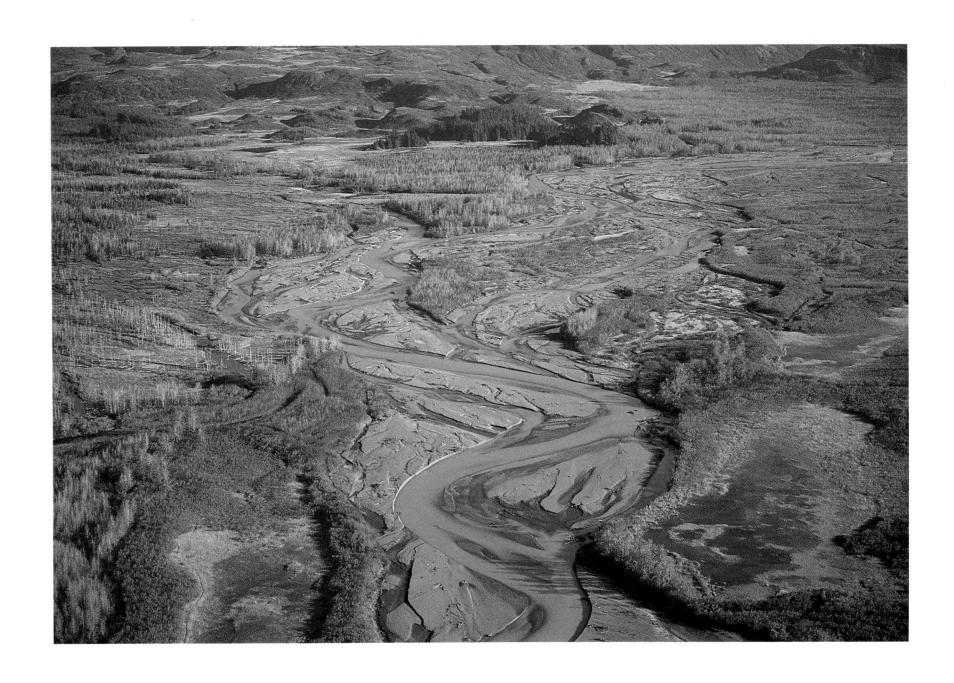

The Alsek River

Intertidal beach sedges

The Last Stand

To SEE WHAT CONSEQUENCES the destruction of the Tongass has for non-Alaskans, the nationwide programs of the United States Forest Service should be given some very serious scrutiny. The 191 million acres under the jurisdiction of the agency include 186.6 million acres of national forest, 3.8 million acres of national grassland, and 471,405 acres of Land Utilization Projects, Purchase Units, and Research and Experimental Areas. Although the Tongass arguably boasts the rarest and most pristine habitat in the system, as well as the greatest economic losses in its timber program, varying degrees of abuse occur on national-forest lands across the entire United States. In addition to below-cost logging, the Forest Service, along with the Bureau of Land Management, has allowed gross overgrazing of western forests and rangelands for a hundred years. Although watershed protection was one of the primary reasons for establishing national-forest lands, nothing threatens watersheds more than erosion, which is often caused by such overgrazing. This destruction of public lands by poorly regulated private interests is, once again, financed by taxpayer subsidy. Fortunately, this practice has been recently challenged in court.

Although both these agencies have been accused of failing their intended management purposes for some time, their disregard for environmental stewardship in favor of commodity development and use by private enterprise has always been relatively low profile. In the last six years, however, all of that has changed significantly. During the Reagan administration, there has been a blatant increase in the prodevelopment bias within these agencies, and a decrease in violations enforcement. In many cases, the problems have doubled or tripled since 1980. What is worse is that the same managerial irresponsibility is manifest not only in the USFS and the BLM but also in the Department of the Interior, the Office of Surface Mining, and the Environmental Protection Agency. In a relatively short time, and with the approval and encouragement of our present leadership, these agencies have taken perilous directions with regard to the public lands and safeguards they were originally empowered to maintain and protect.

The appointments of James Watt and Anne Burford, among others, ushered in devastating policy changes that were firmly rejected by the public. Although we all breathed a sigh of relief when these officials left office, their policies live on, carried out by tight-lipped men who better appreciate the advantages of low-profile procedure. And can it really be that we are so easily misled and placated by industry PR people who tell us what we want to hear while they sell our future for their own profit? We think not. But citizens must examine public policy and question its effects in long-term application.

As forests fall, habitat is lost, and species disappear, scientists and the public protest and the policy makers cry for further research. Acid rain is destroying forests and lakes, eating away at our buildings and monuments, and again the cry rings out—more research. According to the *Amicus Journal*, three thousand scientific papers documenting the causes and effects of acid rain have been published in the last fifteen years. The response of the policy makers? More research. A 1986 Harris survey found that 79 percent of Americans are convinced that pollution from acid rain is a serious problem, yet those whom we have elected to address such problems stall the necessary solutions with the excuse of needing more research, and the environment continues to deteriorate. Meanwhile, industry profits as it pollutes the air and water and gobbles up the habitat. What is lost during this maneuver is unrecoverable time, and ecosystems that may be vital to our life support. We must realize that there will be no golden scientific remedy that is painless to industry and society. We have been frivolous in the passing years, and now we must bear the burden of our actions before they sweep us into history.

Industry is quick to recognize scientific findings when they may prove profitable. In the current battle over drilling for oil in the Arctic National Wildlife Refuge, the only remaining wilderness on the Arctic coastal plain, the Department of the Interior estimates that only a 20 percent chance of finding economically recoverable quantities exists. That is good enough for industry, however, and they want in, despite the substantial impact their activities would have on this singular environment. Scientific findings also suggest that these intrusions would do irreversible harm to wildlife and habitat, but industry downplays these implications—and asks for more research.

There is an unspoken principle at work in our growth-based economy that manipulates our quality-of-life safeguards. Whether the issue is clean air and water, mercury levels in tuna fish, or damage to natural habitats, the response is the same. If the standards cannot be met, lower the standards. Standards are compromised in the name of economics. Our economic system is based on our uncritical wor-

ship of the gross national product. In our lust for improved stock profits, we drive the very companies that should be researching solutions to ignore the real issues and forge ahead with business as usual for our short-term needs, not the needs of the future. While the GNP reflects our social gains, it fails to consider many factors, among them sustainability, resource depletion, pollution damage, cleanup costs, where the money is going, who is getting wealthy. In the same way, the Tongass timber industry fails to balance the meager economic gain in wages against the region's losses to the fishing industry and future tourism, the destruction of rare habitat and irreplaceable resources, and the degrading of native culture and rural lifestyle.

Then there is the unexamined future cost of such wholesale alteration to the environment. Christopher Stone in *Should Trees Have Standing?* succinctly reminds us that "our experience in environmental matters has been a continual discovery that our acts have caused more long-range damage than we were able to appreciate at the outset." The Japanese owners of APC, while operating their Sitka mill under waivers of federal pollution-control requirements—deals made no doubt by their American managers—have in their own country a system of "net national welfare" that deducts various environmental damage and resource depletion from their measurement of gains. Apparently the Japanese have learned more from their own gross environmental errors than the rest of us.

Throughout Southeast, and especially among fishermen and striketorn towns like Sitka, racism directed at Japanese exploitation is a way of venting frustration but avoids the fact that the problems are home grown. Japan is not the culprit. The Japanese are simply good businesspeople with no more concern for Alaska's environment than American businesses have for environments they exploit and damage worldwide. Places like São Paulo, Brazil, and Bhopal, India, are populated with American chemical companies that have fled the stricter regulations of the United States and relocated their plants in countries that do not have safeguards for their workers or their environments. When DDT was banned in the United States, its manufacture was not stopped but was simply moved elsewhere. And DDT is still marketed worldwide by American firms, even though it has been identified as having severe adverse effects on life forms.

Whether at home or abroad, only a very small portion of industrial manufacturers seems to be the least bit concerned about the environment and the quality of life. Is this the inevitable cost of our demand for more jobs, higher wages, and more goods and services? The Tongass is being destroyed despite laws created to protect it because too many Americans value profit over everything. Though

we may not wield the axe, our acquiescence to the system rewards the man who does. As more people desire more material goods, the natural world is being hacked away by the sharp blades of technology.

At the real root of most environmental problems is an unchecked and ever increasing world population, and society feels the growing pains. It took thousands of centuries for the world's population to reach one billion, in 1830. The second billion took only a hundred years. The third billion took thirty more years. The fourth billion, fifteen years. If we reach five billion in 1987 as predicted, only twelve years will have elapsed. As if the sheer numbers of this explosion in population were not enough, it has occurred simultaneously with technological gains almost impossible to comprehend. The side effects of both these rapid accelerations plague us today. Our unfailing belief that technology could remedy our shortcomings as we expanded allowed it to develop far faster than our abilities to monitor its consequences or remedy its failures. As a society, we are slowly awakening to the truth that the price of the conveniences technology provides is high.

Clear-cutting is not science but technology. The people who oppose it are not idealists but grim realists. The values they seek to preserve are not anachronisms but basic rights. The same value system that hopes to keep roads out of Tenakee Springs already keeps cars off Mackinac Island in Michigan, skyscrapers out of Santa Fe, and geothermal plants out of Yellowstone Park.

The loss of natural things is to a large degree inexpressible. The average person defends his or her instinctual environmentalism with sentiment. The wish for teeming trout streams and the chance to see a leaping deer, the desire to leave wild places for future generations, these are feelings we all share. Prodevelopment forces, on the other hand, attempt to polarize public opinion by tagging those with environmental concerns elitists or, in the case of the USFS, victims of the "Bambi syndrome." Indeed, to set aside wilderness areas solely for the relatively small numbers of people who visit them, or to protect animals only because they are cute, *would* be elitist. The greater justification for such preservation, though, makes any such considerations trivial. The importance of preserving the integrity of an ecosystem has much larger implications for humanity.

Since earliest time, man has speculated on the workings of the planet. At one time, he held angry gods responsible for flood and drought, but science has long since displaced their authority. Initially, science splintered into specialization, learning more and more about less and less. Recently, though, there is a growing awareness that knowing the parts is relatively useless without understanding the whole. Biologists point out that while the loss of species, such as

the grizzly, is unconscionable, we could exist without grizzlies; but when we destroy entire ecosystems, we lose the unspectacular organisms that make up our life-support system. The earth's great fertility, built up over thousands of centuries, is a result of these organisms recycling soil, air, water, and each other. Insects, predators, and disease are all part of this system as well. Man has not improved on nature's balance. In the process of treating land in purely economic terms, we carve out a few scenic spots for aesthetics and manage a herd of animals for sportsmen and a fish population for anglers; the rest is plowed, grazed, mined, logged, or built over. We pour on the fertilizers and pesticides, practice predator control and flood control, and then howl about insect damage and erosion. bemoan the loss of fertility and stability, and wonder whatever happened to the original integrity of the land. We can no longer abandon the land and move on as in days past, for there is no more frontier. Thus, more and more, management barely keeps up with a series of diminishing returns.

As the world grows more aware of the international aspects of ozone depletion, toxic waste, acid rain, the greenhouse effect, and deforestation, science bravely attempts to tie it all together. With satellites and computers, we collect more information and process it as never before. There is a growing realization that we need to comprehensively understand the workings of the planet before we can solve the tremendous problems that threaten its survival.

The trend in evolution has been to elaborate and diversify the biota, but we are now deevolving. Before even a small portion of the earth's species has been inventoried, catalogued, and studied, they are eliminated—and at an alarming rate. In the Tongass, the Forest Service seeks to replace dominant hemlock with spruce because the latter has greater market value, thus altering an entire natural system, not just eradicating one species. The National Environmental Policy Act asks that we "recognize the worldwide and long-range character of environmental problems and, where consistent with foreign policy of the United States, lend appropriate support to initiatives, resolutions, and programs designed to maximize international cooperation in anticipating and preventing a decline in the quality of mankind's environment." In doing so, we warn developing nations about the dangers of deforestation, erosion, and environmental manipulation, but we are sending mixed signals. In Puerto Rico, the only tropical rain forest in the national-forest system is on the cutting block, and biologists are outraged. The rain forest is populated with numerous rare and threatened endemic species. Considering all the untapped knowledge that lies within, Stanford University biologist Paul Ehrlich has stated, "What the Forest

Service is planning is equivalent to pulping the Library of Congress." How can we expect those observing our actions to respect our advice when it is fraught with such contradictions?

The Forest Service biologists, as always, have come up with a "finding of no significant impact." But let's recognize the conflict of interest here once and for all. The prescriptions of biologists edited and controlled by the Forest Service are as dubious as the prescriptions of doctors controlled by the major drug manufacturers. We need independent counsel. We need a second opinion. We need a comprehensive awareness that the value of land goes beyond the crops and recreation it can provide. Wild lands are vast laboratories in which to study natural systems, and enable us to compare cultivated to uncultivated, to see where we went wrong and where we are headed. By streamlining crops and animals to a select few, we lose the earth's genetic diversity forever. What is worse, there is no guarantee that our initial selections were the most appropriate or sustainable. We took a fertile, strong, diverse, drought-tolerant system like the Great Plains and turned it into the Dust Bowl. The eroded, water-hungry system we have replaced it with is now depleting underground reservoirs far faster than rainfall can refill them. Have we learned nothing from these mistakes?

As we replace diverse, stable forest systems with monocultural tree farms, eliminating natural checks and balances, insects like the pine beetle rage out of control. Instead of turning to the original systems for study and solutions, we tear them down. Industry, with its eye on the bottom line, looks for the cheapest, quickest and most profitable management methods. The majority of the populace, seemingly dependent on jobs, goods, and services, has traditionally not questioned these goals. But, as Aldo Leopold noted, "We fancy that industry supports us, forgetting what supports industry."

As our finite resources shrink, we could be mitigating our consumption through recycling, less wasteful extraction methods, water and energy conservation, and habitat restoration, but we hesitate, trusting the politician's call for more research. Are we really that naïve? We lack responsible leadership that will acknowledge these growing problems and unite us in a determined effort to address them. We cling to our high standards of living without examining either the trade-offs or the results. Have we gone from a society that wanted a chicken in every pot to one that wants a VCR in every living room? What have all our goods brought us? Personal happiness? Closer families? Better-educated children? Clean air and water? A nonviolent society? World peace? What kind of ultra-urbanized humans are we creating when a child would rather stare at television than look for birds in the trees? As we all stare at our

televisions, do we hear the forests falling and know the great bird flocks are declining?

If the government began systematically destroying the great works of art and literature for the sake of economics, would we be so complacent? And yet our unique natural places, like the Tongass, and the creatures they harbor are as much a part of our heritage, and every bit as priceless. While the defense budget grows ever larger, funds for environmental protection remain at a standstill. But, with the increase in cancers and viral diseases linked to environmental factors, in the long run a good natural defense may be our best national defense. A symbiotic relationship with our environment, rather than a careless, destructive one, may serve us far better, restoring resources like water and air—restoring *our* total habitat. But our priorities are skewed. What is the value of a powerful, great nation on a dying planet?

It is time to clean our house. Someone is attempting to rewrite the rules for the benefit of too few. Why are former executives of the oil, coal, and timber industries often now found directing the regulatory agencies of those industries? Violation enforcement on coal mines by the Office of Surface Mining is a farce. Noncompliance with water-pollution laws is estimated at 80 percent. Oil and gas exploration and drilling threaten our coasts and wildlife refuges as never before. In the meantime, citizens groups are forced to spend precious months and dollars in court to uphold the laws that are supposed to protect the environment. We have been victimized by the very system we have struggled to work within. Is it any wonder that radical environmentalists have emerged, taking direct action? What has been gained by playing by the rules?

In fact, something has. Citizen/environmental coalitions have learned to monitor and research problems for themselves. A disgruntled public is awakening to corporate and political deception. There is growing bipartisan support in Congress to deal with problems such as acid rain, regardless of the ''more research'' stance of the administration. And recently, the members of Congress have truly begun to address more environmental issues. Even though the survey polls indicate that 93 percent of the population believes that pollution of lakes and streams by toxic substances is a serious problem, President Reagan vetoed the renewal of the Clean Water Bill. Decisively, both houses of Congress overrode that veto, and when the Superfund for the cleanup of toxic sites approached renewal, they saw not only that it was renewed but that its budget was increased. Clearly, we have the will to face the tasks before us.

A recent poll found that the majority of Canadians believe that, despite a sagging economy, the risk of pollution is not worth the benefits to society. On an even stronger note, a 1985 Canadian Law Reform Commission recommended reclassifying environmental offenses as ''crimes against the environment.'' Christopher Stone suggests that trees, and much else in the natural world, should have legal protection. American courts are attempting to address these issues. We must stop surrounding ourselves with politicians who tell us what we want to hear. They distract us with promised financial turnarounds and with threats of world domination from abroad and immoral decay from within. Those are certainly issues, but one of the most immoral acts of the last century has been the environmental degradation of this planet. Those who have no concern for any future but their own take advantage of a public that will not inform itself. We have the option of not being victims.

As the present administration preys on the natural world, a new form of predator control stalks them, not with guns but with lawyers. Nonprofit organizations like the National Resources Defense Council and the Sierra Club Legal Defense Fund have worked diligently and with great success at the job the EPA has failed to do—enforcing the nation's environmental laws. Lawsuit after lawsuit seeks to restore integrity to the environmental legislation gutted by the budget cuts of Reaganomics. Such groups deserve more credit and need more support from the public.

The fate of the Tongass, along with much other critical environmental legislation, is now in the hands of Congress. On March 10, 1987, United States Representative Robert J. Mrazek (Democrat, New York) introduced H.R. 5291, the Tongass Timber Reform Act. It quickly gained wide bipartisan support. William Proxmire introduced similar legislation in the Senate. For most members of Congress, changes in current Tongass management will be an issue of budget rather than environmental concern, but if that is what it takes to stop the destruction, so be it. Budget slashing has proved to be a powerful and successful tool. Inform yourself, and let your representative know your position. Find time to study the critical issues and know what they are. Only if we are well informed will we recognize that we are selling short our priceless natural world. We need a place like the Tongass where ancient trees tower over streams thick with salmon. A place where bears can be bears, and eagles are as common as crows. An essential place where plants and organisms live in undisturbed settings, where moss swallows our footsteps as we attempt to unlock the mysteries of the forest and find our own place in this world.

O pardon me, thou bleeding piece of earth, That I am meek and gentle with these butchers!

William Shakespeare

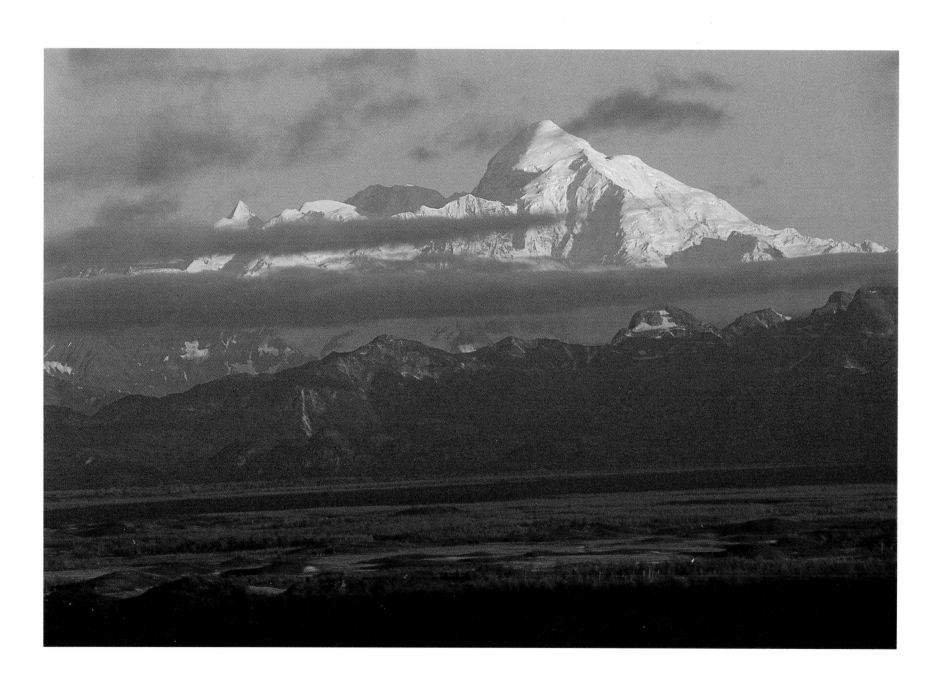

Mount Fairweather from the Forelands

References

Alaska Department of Fish and Game, *Status of Measures to Protect Fish and Wildlife in the Tongass National Forest: A Report on Section 706(b) of the Alaska National Interest Lands Conservation Act* (Juneau: Alaska Department of Fish and Game, 1986).

Alaska Department of Labor, *Nonresidents Working in Alaska: A Special Study to Measure the Economic Impact of Nonresidents on Alaska's Economy During Calendar Year 1984* (Juneau: State of Alaska, 1986).

Alaska Geographic, *Sitka and Its Ocean/Island World*, Vol. 9, No. 2 (Anchorage: Alaska Geographic Society, 1982).

Alaska Geographic, *Southeast: Alaska's Panhandle*, Vol. 5, No. 2 (Anchorage: Alaska Northwest Publishing Company, 1978).

Beach, Bennett H., "Time to Ax this Timber Boondoggle," *The New Republic* May 26, 1986.

Berger, Thomas R., *Village Journey: The Report of the Alaska Native Review Commission* (New York: Hill and Wang, 1985).

Callison, Charles, "Cowed by the Cowmen," *The Amicus Journal*, Summer 1986 (New York: Natural Resources Defense Council, 1986).

Callison, Charles, "The Great Lands," *The Amicus Journal*, Spring 1985 (New York: The Natural Resources Defense Council, 1985).

Callison, Charles, "The Shambles at OSM," *The Amicus Journal*, Summer 1986 (New York: The Natural Resources Defense Council, 1986).

Cashman, Ty, "Think Little," *Utne Reader*, No. 19 (Minneapolis, Lens Publishing Company, 1987).

Cousteau, Jacques-Yves, *The Cousteau Almanac: An Inventory of Life on Our Water Planet* (Garden City, N.Y.: Doubleday & Company, 1981).

Ehrlich, Anne H., and Paul R. Ehrlich, "Needed: An Endangered Humanity Act?," *The Amicus Journal*, Spring 1986 (New York: The Natural Resources Defense Council, 1986).

Hanson, Dennis, "The Rise and Demise of Forest Planning," *Sierra*, Vol. 71, No. 1 (San Francisco: The Sierra Club, 1986).

Heacox, Kim, "In Alaska, Hard Times for Humans and Caribou," *Los Angeles Times*, February 15, 1987.

Hinrichsen, Don, "Waldsterben: Forest Death Syndrome," *The Amicus Journal*, Spring 1986 (New York: The Natural Resources Defense Council, 1986).

Holmes, John, "More Oil Rigs Among the Caribou?," *Insight/The Washington Times*, February 9, 1987 (Washington, D.C.: News World Communications, Inc., 1987).

Koehler, Bart, "Written Statement for the Record on Oversight Hearings Concerning the Status of Management on the Tongass National Forest of Southeast Alaska," May 8 and 9, 1986 (Juneau: Southeast Alaska Conservation Council, 1986).

Leopold, Aldo, *A Sand County Almanac with Essays on Conservation from Round River* (Oxford, England: Oxford University Press, 1966).

McKinney, John, "Brave New Forest," *Los Angeles Times Magazine*, October 19, 1986.

Mills, David D., and Anne S. Firman, *Fish and Wildlife Use in Yakutat, Alaska: Contemporary Patterns and Changes*, Technical Paper 131 (Douglas: Alaska Department of Fish and Game, 1986).

Schoen, John W.; Matthew D. Kirchhoff; and Olof C. Wallmo, *Sitka Black-tailed Deer/Old-growth Relationships in Southeast Alaska: Implications for Management* (Juneau: Symposium, "Fish and Wildlife Relationships in Old-growth Forests," American Institute of Fishery Research Biologists, 1984).

Schoen, John W.; O. C. Wallmo; and Matthew D. Kirchhoff, *Wildlife–Forest Relationships: Is a Reevaluation of Old-growth Necessary?* (Washington, D.C.: North American Wildlife and Natural Resources Conference, 46: 531–44, 1981).

Shabecoff, Philip, "Timbering Called Threat to Vast Forests in Alaska," *New York Times*, October 5, 1986.

Sheiman, Deborah A., "Facing Facts," *The Amicus Journal*, Spring 1986 (New York: The Natural Resources Defense Council, 1986).

Sisk, John, and Bart Koehler, *The Citizens Guide to the Tongass National Forest* (Juneau: Southeast Alaska Conservation Council, 1985).

Southeast Alaska Conservation Council, *Last Stand for the Tongass National Forest* (Juneau: Southeast Alaska Conservation Council, 1986).

Southeast Alaska Conservation Council, *The Tongass Timber Problem* (Juneau: Tongass Accountability Project, 1984).

"A Special Issue: The Public Lands of Alaska," *Wilderness* (Washington, D.C.: The Wilderness Society, 1984).

Stone, Christopher D., *Should Trees Have Standing?: Toward Legal Rights for Natural Objects* (Los Altos, Cal.: William Kaufmann, 1974).

Thunderstorm, Lynne, "Growing Food: The Daily Round," *The New Catalyst*, Summer, 1986 (Lillooet, B.C., Canada: The Catalyst Education Society, 1986).

"Turning Point," *The Amicus Journal*, Spring 1986 (New York: Natural Resources Defense Council, 1986).

United States Department of Agriculture: Forest Service, *1986–90 Operating Period for the Alaska Pulp Corporation Long-term Sale Area*, Final Environmental Impact Statement: Record of Decision; Summary; Maps (Juneau: U.S. Department of Agriculture, Forest Service, 1986).

United States Department of Agriculture: Forest Service, *What the Forest Service Does* (Washington, D.C., 1983).

Wallmo, Olof, "Managing Forests to Retain the Wildlife Habitat Characteristics of Old-growth" (Dissertation).

The Wilderness Society, *America's Vanishing Rain Forest: A Report on Federal Timber Management in Southeast Alaska* (Washington, D.C.: The Wilderness Society, 1986).

The Wildlife Society, *Position Statement of the Alaska Chapter of The Wildlife Society: Old-growth Forest Management in Coastal Alaska, June 1985* (Juneau: The Wildlife Society, 1985).

The authors would like to note that articles in numerous issues of both *the Ravencall* and *In Brief* were also used in their research. *the Ravencall* is published by the Southeast Alaska Conservation Council in Juneau, and *In Brief* is published by the Sierra Club Legal Defense Fund in San Francisco.